The Smithsonian
America's Treasure House

The Smithsonian

AMERICA'S TREASURE HOUSE

by Webster Prentiss True

ILLUSTRATED

M. EVANS

Lanham • New York • Boulder • Toronto • Plymouth, UK

Evans

imprint of The Rowman & Littlefield Publishing Group, Inc.
1 Forbes Boulevard, Suite 200, Lanham, Maryland 20706
ɔ://www.rlpgtrade.com

Thornbury Road, Plymouth PL6 7PP, United Kingdom

tributed by National Book Network

ary of Congress Cataloging-in-Publication Data Available

N 13: 978-1-59077-472-4 (pbk: alk. paper)

The paper used in this publication meets the minimum requirements of
rican National Standard for Information Sciences—Permanence of Paper for
ed Library Materials, ANSI/NISO Z39.48-1992.

ed in the United States of America

To

E. B. *and* J. B.

Foreword

The subject of this book is an organization that belongs to the people of the United States of America. It was bequeathed to them by a far-seeing Englishman in the hope of benefiting all mankind. The outward, visible signs of Smithson's gift are widely known, but few are aware of the strange story behind it or its present extensive ramifications.

Most Americans plan to visit Washington some time during their lives, and nearly all those who do so include the Smithsonian in their sight-seeing. They see the public exhibits in its various buildings and go home thinking of it as a great museum of science and art. It is that—but it is also much more. For the Smithsonian Institution is primarily a research organization set up to increase man's existing stock of knowledge. This it does through bureaus devoted solely to research and through behind-the-scenes investigations in other bureaus which are labeled "museums" and "art galleries."

The author's hope in offering this volume is threefold: first, to provide for those who have seen the Smithsonian a record in type and pictures of its wealth of exhibits and to give some idea of its unseen researches and other activities; second, to furnish for those who plan definitely to visit the Smithsonian a glimpse of what they may expect to see, which may help them derive greater enjoyment and benefit from their visit; and

Foreword

third, to create a visual image of a world-renowned American institution for those Americans who for various reasons do not expect to see it through their own eyes.

The list of those who have been of assistance in furnishing and checking information is far too long to cite here. The author can only express his sincere thanks to practically all Smithsonian officials and scientists, without whose generous help the book would not have been possible.

W. P. T.

The Smithsonian Institution,
Washington, D. C.

Contents

Folios of Plates

Folios of Plates

I. *A Lonely Man and His Will*

In cheerless bachelor lodgings in London a frail man of sixty sat before his desk, quill poised over a blank sheet of paper. A British scientist of note and a man of wealth, he had reached the point in the lives of humans when realization comes that the drafting of a final will is an urgent matter.

"I, James Smithson," he began, with firm strokes of his well-sharpened quill, "Son to Hugh, first Duke of Northumberland, and Elizabeth, Heiress of the Hungerfords of Studley and Niece to Charles, the proud Duke of Somerset, now residing in Bentinck Street, Cavendish Square, do on this twenty-third day of October, one thousand eight hundred and twenty-six, make this my last Will and Testament."

These were noble names that flowed from his pen. James Smithson, born in 1765, was the natural son of Sir Hugh Smithson and Elizabeth Keate Macie, a widowed country gentlewoman. As James Lewis Macie he lived his early years. He was never secretive about the circumstances of his birth, but always

keenly sensitive and retiring, feeling deeply the injustice of the bar sinister on his crest. At the same time, this feeling may have spurred on his ambition to achieve for himself a name worthy of honor and respect in its own right. It is certain that in Pembroke College, Oxford, which he entered in 1782, he was industrious and studious, developing there a taste for scientific research which dominated the rest of his life.

His father, Sir Hugh Smithson, was a man of great ability, achieving through his own efforts the transition from private gentleman to the exalted status of one of the leading peers of England. He was buried in Westminster Abbey, where he is thus modestly described: "The most high, puissant and most noble prince, Hugh Percy, Duke and Earl of Northumberland, Earl Percy, Baron Warkworth and Lovaine, Lord Lieutenant and Custos Rotulorum of the Counties of Middlesex and Northumberland and of all America, one of the Lords of his Majesty's Most Honorable and Privy Council, etc., etc." Sir Hugh's son, Lord Percy, half brother of James Smithson and a British Army officer of distinction, is credited in history with preventing the complete annihilation of the Red Coats in the retreat from Concord in 1775.

With a father politically prominent and a half brother highly esteemed in the military world, James Smithson, with no leaning toward either type of eminence, went forward in his own way to hew for himself a niche in the hall of fame. Shortly after the death of his mother he applied to the Crown and was granted permission to take his father's name but with no right to the title. The injustice of this rankled in him and fostered an overwhelming desire not only to make that name one of

distinction, but in some manner to perpetuate it for generations to come. His feeling is recorded in his own words: "The best blood of England flows in my veins; on my father's side I am a Northumberland, on my mother's I am related to Kings, but that avails me not. My name shall live in the memory of man when the titles of the Northumberlands and the Percys are extinct and forgotten."

Shortly after his graduation from Oxford in 1786 he was admitted to membership in the Royal Society of London. Between 1791 and 1825 he published in the *Philosophical Transactions* of the Royal Society and in Thomson's *Annals of Philosophy* twenty-seven scientific papers, all except two, pertaining to mineralogy and chemistry. The two mavericks conveyed information on "Some Improvements in Lamps" and "The Art of Making Coffee."

He discovered new minerals, created new compounds through chemical research, and became adept at working with minute quantities of substances. He once caught a tear from a lady's cheek, and although he lost half of it, yet succeeded in analyzing chemically what was left. Chemistry in his time was hardly recognized as an exact science—in fact, had advanced but little from the alchemy and witchcraft of the preceding centuries. The dream of the early alchemists was to turn the baser metals such as lead or mercury into gold, but of course their dreams never materialized. In the chemistry of today, the converting of one element to another has become commonplace, and indeed is used in the creation of fissionable material for the production of atomic energy. It is somewhat ironic that one of the latest transmutations of elements is actually the reverse

15

of the alchemist's dream—that of gold into a rare isotope of mercury. This is being done at one of our great atomic energy plants because the mercury isotope produces a sharp wavelength pattern which it is proposed to use as an invariable international standard of all measurements of length.

Despite the difficulties of poorly equipped laboratories and crude and clumsy apparatus, Smithson achieved some outstanding analyses, and in his publications are found passages which show not only a thorough understanding of his subject, but also breadth of outlook and a vision of what chemistry would come to mean in the future of the world. "Chemistry is yet so new a science," he wrote in one paper, "what we know of it bears so small a proportion to what we are ignorant of; our knowledge in every department of it is so incomplete, consisting so entirely of isolated points, thinly scattered, like lurid specks on a vast field of darkness, that no researches can be undertaken without producing some facts that extend beyond the boundaries of their immediate object."

Little is known of James Smithson's personal life—definitely a lonely one without the solace of family or a real home. It is known, however, that he was a quiet, studious person, shy and modest by disposition and in his way of living. He traveled widely throughout Europe, and his contacts with research men of other nations brought home to him the realization that science has no political boundaries. The prevailing ambition of his life came to be the increasing of existing knowledge for the benefit of man wherever man might be. He lived his life according to a creed of his own: "No ignorance is without loss to man, no error without evil."

A Lonely Man and His Will

A great deal of Smithson's scientific work was done in Paris, where he spent most of the later years of his life. Never a robust person, he taxed his strength and vitality to the utmost in conducting his researches. As his health began to fail, he sought relief from suffering in gambling at the casinos. When a scientific friend showed him mathematically that he could not win, he thereafter allotted more modest sums of his own money for indulgence in his favorite games of chance.

Back in London, lonely and broken in health, he felt the urgency of making a will. His illusions were gone as to the possibility of immortalizing the name of Smithson through his own work. His efforts to increase man's knowledge through his own scientific researches had not been enough to satisfy his ambition; his last opportunity to do this, as well as to take measures to perpetuate his name, lay in the words to be penned on the sheet of paper he had before him. It does not appear likely from the text of the main body of his will that any clear, well-defined plan for doing this was in his mind as he resumed the writing of this legal document.

A keen appreciation of loyalty and faithful service dictated annuities to two former servants. Then, having no immediate family of his own, he seemed to feel the ties of blood and gave sentimentality full rein, as he bequeathed to his nephew, Henry James Hungerford, the entire income arising from his property after the payment of the above annuities.

"Should the said Henry James Hungerford have a child or children, legitimate or illegitimate, I leave to such child or children, his or their heirs, executors, and assigns, after the death of his, or her or their father, the whole of my property of every

kind absolutely and forever, to be divided between them, if there is more than one, in the manner their father shall judge proper, or, in the case of his omitting to decide this, as the Lord Chancellor shall judge proper."

In his careful phrasing James Smithson had taken pains to recognize that the rights of an illegitimate child should be protected, having himself a very sympathetic understanding of the many difficulties such a child is sure to encounter in his journey through life. He had been fortunate in not suffering from lack of property—inheriting from both his father and mother, wealthy in their own rights—and he desired protection for some less fortunate child who might be born under a shadow similar to his own. In some stratum of his brilliant, scientific mind the pain of his heritage still lingered, but instead of making him bitter and hard in his later years it had given him a deep feeling of human responsibility and kindness.

He scanned carefully that which he had written, then slowly the scratching of his quill pen was resumed to put on paper more important words than had ever been a part of his scientific treatises—words that were to have an influence in every part of the world for ages to come; words that would perpetuate his name for countless generations.

"In the case of the death of my said nephew without leaving a child or children, or the death of the child or children he may have under the age of twenty-one years or intestate, *I then bequeath the whole of my property* subject to the Annuity of One hundred pounds to John Fitall, and for the security and payment of which I mean Stock to remain in this Country, *to the United States of America, to found at Washington, under the*

18

name of the Smithsonian Institution, an Establishment for the increase and diffusion of knowledge among men."

With a firm hand he signed, "James Smithson. (L. S.)"

No one will ever know just why the United States of America was named as James Smithson's legatee. He had lived extensively in France, in Germany, and in Italy; he had never visited this country. One possible explanation might be that at this period in history there were many wars and rumors of wars among the European nations. He could have remembered the friendly attitude his father had manifested toward the colonies. He had felt bitterness over the denial of any right to his father's title in England and shown it by his disinclination to spend any more time in the country of his birth than was necessary in his youth for educational purposes, in spite of the honors he had received from the Royal Society.

America was a young and growing country, a country of peace; it was a country with almost untouched natural resources which would require study and development. It may have been, too, that George Washington's *Farewell Address* to the people some years before had inspired him and made a lasting impression on a mind that thought along the same lines: "Promote then," spoke Washington, "as an object of primary importance, institutions for the general diffusion of knowledge."

It was a completely unrestricted gift which James Smithson made to the people of America. Beyond the general statement of purpose, there were no qualifying clauses or directions as to how, when, or where the money was to be used. The headquarters for the administration of his gift was to be in the capital of the United States, but scientific researches and explorations for

19

the advancement of knowledge could be carried on in any part of the world. Seldom is a legacy left with such freedom for its administration.

It was a gift the influence of which has been, and is being, felt in all parts of the world. Whether it was the inspiration of a moment that guided his pen in the framing of the final paragraph of his will—that paragraph which has benefited millions of people everywhere—or his subconscious mind taking over and dictating from stored memories of things read pertaining to the new country, it is certain that James Smithson could not have found a better way to carry on the increase of knowledge or the perpetuation of his name.

He died in June, 1829, in Genoa, Italy, where he was buried in the Protestant Cemetery overlooking the harbor. His nephew, though at that time but twenty-three years old, survived him by only six years; he had never married and died without heirs. Under the terms of the will it would seem that the transference of Smithson's property to the United States could be easily accomplished. However, this unprecedented bequest to another country entailed unforeseen complications.

In September, 1835, a dispatch to the Secretary of State from the American Embassy in London brought the surprising news to Washington. The amount of the bequest was roughly half a million dollars—a modest sum today, but a great fortune in Smithson's time. President Jackson, who was in office at the time, referred the matter of the legacy to Congress, which, after several months of debate passed a bill directing the prosecution of the claim in England. The Committee report reflects the silver-tongued oratory of the day:

A Lonely Man and His Will

"Should it be faithfully carried into effect, with an earnestness and sagacity of application, and a steady perseverance of pursuit, proportioned to the means furnished by the founder, and to the greatness and simplicity of his design as by himself declared, 'the increase and diffusion of knowledge among men,' his name will be hereafter enrolled among the eminent benefactors of mankind. Let the result accomplish his object and a wreath of more unfading verdure shall entwine itself in the lapse of future ages around the name of Smithson than the united hands of tradition, history and poetry have braided 'round the name of Percy through the long perspective in ages past of a thousand years."

The man appointed by the Secretary of State to journey to London and prosecute the United States' claim to the estate was Richard Rush, a former Secretary of the Treasury and United States Minister to England for eight years. Upon arriving in London, Rush was advised that it would be necessary to file a claim on behalf of the President of the United States and to enter suit in the Court of Chancery. This was discouraging advice. A suit before the Court of Chancery was likely to be argued indefinitely, with many counsel employed, involving heavy expenses. Some had been known—friendly suits, at that—to drag along for more than twenty years, and the Smithson case ran the chance of meeting strong opposition to prevent a fortune such as this from leaving the country. Mr. Rush lived up to his name, however, and less than two years after his arrival, he was happy to inform the President that a judgment had been made in favor of the United States. He then converted the entire estate into gold sovereigns and arranged for its transportation on

the packet *Mediator,* which would sail shortly for New York. After a stormy voyage the *Mediator* arrived in New York Harbor on August 29, 1838. By stage coach Rush proceeded to the Mint at Philadelphia and received from its Director a receipt for $508,318.46, the amount equivalent to the English sovereigns.

In spite of Mr. Rush's swift success, eight more years were to pass before the Smithsonian Institution became a reality. For it took Congress that long to agree upon the best and most practical way to employ the bequest, and at the same time to use it as prescribed by its donor. Many proposals were put forward—an astronomical school, an agricultural school, a super-university, a meteorological bureau—but on the whole a broad and open-minded view was maintained. The Act of Incorporation, as finally passed, provided simply for an Establishment composed of the President and his Cabinet, an eminent Board of Regents, a Secretary to be the executive officer, a suitable building, a museum, art gallery, chemical laboratory, and library. Further details it wisely left in the hands of the Regents and Secretary. On August 10, 1846, President James K. Polk signed a bill creating the Smithsonian Institution, finally putting into operation the intention James Smithson had penned in the final paragraph of his strange will.

So today, in Washington, a colossus sprawls across the Mall, and visitors from every part of our country pour eagerly into the buildings of the Smithsonian Institution, the visual symbol of the compelling dream of a lonely man. It would surely not have been possible for James Smithson, as he sat in his bleak London lodgings studying the words he had written, to visualize

the vastness to which his establishment for the increase of knowledge among men would grow, encompassing ten bureaus widely diversified in their interests, but all directed toward the one main object, the pursuit of knowledge. Starting with an initial capital of half a million dollars, the Institution now has collections worth half a billion alone, without even reckoning the many specimens beyond price and the inestimable value of the new knowledge it has created. Other gifts and bequests have come in, until today the Smithsonian's private endowment stands at several times the original fund.

In beautiful Smithsonian Park in Washington, between Independence and Constitution Avenues and extending from 9th to 12th Streets, stands the original Smithsonian Building. Designed by James Renwick, Jr., the structure was begun in 1847 and completed in 1855. The architecture is that of an English castle of the Norman period, and it is in this castle that the remains of James Smithson, brought over from Genoa, rest today. In a small room just off the main entrance, as a fitting memorial to the man who made the Institution possible, stands the tomb of the son of Hugh Smithson, his name to live forever. Denied the right to his father's castle in England, James Smithson has come to his last repose in one of his own, well-earned and well-deserved.

For nearly a quarter of a century this Smithsonian Building proved adequate for the museum feature specified in the Act of Incorporation. Then, as the collections began to increase and overflow the floor space, the Regents found it necessary to promote the erection of a building for what by then had become known as the United States National Museum—a branch of the

Institution. Plans were drawn up, and work on the new building was begun in 1879. In 1881 it was so nearly completed that the Inaugural Ball for President Garfield was held in its spacious halls, for the red brick building covered two and one-third acres of land. Congress appropriated $250,000 for its construction, but so economically was it planned that some of this money was returned to the United States Treasury. In view of present-day costs it is interesting to note that the expense of erecting what is now known as the Arts and Industries Building was but six cents a cubic foot.

Rapidly expanding collections, however, soon outgrew this new building. Congress had, in 1880, passed an Act stipulating the deposit of "all collections of rocks, minerals, soils, fossils, and objects of natural history, archeology and ethnology, made by the Coast and Interior Survey, the Geological Survey, or by other parties of the Government, when no longer needed for investigations in progress," in the National Museum. Floods of material came pouring in, and once more the Regents found it necessary to appeal to Congress for another building. Natural history, in all its branches, in particular, needed additional room for exhibit and study. Congress, toward the close of the 19th century, appropriated $3,500,000 for this additional structure, and in 1909 the doors were opened to the public of a Natural History Building that ranks among the world's finest museum buildings.

The treasures the public sees in the National Museum are by no means mere curios. They are arranged and labeled to provide a liberal education. They present the pageant of the animal and plant life of the world today and of past eons of time even to the

pre-Cambrian of half a billion years ago when living things began crawling on the sea beaches of a weird manless world. They show the races of man in startlingly lifelike groups. They tell the story of man's slow advancement from the ox-cart to streamlined trains, from smoke signals to television, from Watt's clanking steam engine to the smooth multi-thousand horsepower dynamos of today. Our National Anthem has new and deeper meaning after one has seen the original Star Spangled Banner that flew over Fort McHenry.

The National Museum's exhibits in these three buildings grouped together on the Mall cover many acres of floor space and present a picture of somewhat appalling magnitude and variety to a visitor. It is natural that they should, for they number between two and three hundred thousand objects spanning the entire scope of man's experience. Many a tired visitor is heard to exclaim, "Why, it would take a week to see everything here!" But if he should be required to see the entire collections—the specimens that are behind the scenes—and looked at one specimen every minute, eight hours every day, it would take him 170 years to finish the job. For there are well over 30,000,000 objects listed in the Museum's catalogues. It would be entirely reasonable to suppose that with this immense collection of articles on exhibit and on file, the guards would be able to produce almost anything asked for by a visitor. Occasionally they are stumped, however, as for instance, when an elderly man asked a guard in the Arts and Industries Building to show him "the hill on which Custer made his last stand."

The great National Museum is only one of the ten bureaus that have grown up around the Smithsonian during its more

than a century of existence. Their varied activities actually present a cross-section of the universe. Besides the National Museum, the other bureaus that offer exhibits to the public are the National Air Museum, the National Gallery of Art, the National Collection of Fine Arts, the Freer Gallery of Art, and the National Zoological Park. Others that operate more or less behind the scenes are the Bureau of American Ethnology, the Astrophysical Observatory, the International Exchange Service, and the Canal Zone Biological Area.

Through the world-wide activities of its ten bureaus the Smithsonian justifies the trust reposed by James Smithson in the United States of America. It is completely catholic in its endeavor to increase and diffuse knowledge. It collects butterflies across the Potomac in Virginia, and it studies the sun in dark tunnels on mountain tops on two continents. Simultaneously it unearthed ancient Eskimo ruins in the Canadian Arctic and collected the unique plants of the down-under island of New Zealand. Its scientists analyze meteorites from interplanetary space and mud from the bottom of the ocean. It advises Government officials of the highest echelons and answers schoolboys' questions. It belongs to the people of America. Through the generosity and far-sightedness of the English scientist James Smithson, anyone who is an American citizen is part owner of several complete dinosaurs, the world's largest mineral and gem collections, 17,000 human skulls, and millions of other diversified objects in every field of natural science and human endeavor.

The Smithsonian is an American institution, though of international scope. It is essentially a private foundation, although

the ward of the United States Government. Of its ten branches, some are Government bureaus, some are part Government and part private. Part of its money is in the United States Treasury, another portion is invested in stocks and bonds, and some is on deposit in Washington banks. There is nothing quite like this institution in the entire world. It is an American heritage and has become an American tradition.

II. *Our Planet Earth*

By far the largest Smithsonian bureau, and the one best known to the public, is the great United States National Museum, often called "The Nation's Treasure House." Here may be seen almost literally "everything under the sun." Starting with the Institution itself more than a century ago, it grew slowly at first around the nucleus of James Smithson's own mineral collection. Gathering momentum, as it acquired Secretary Baird's large private museum and the valuable loot from Lt. Charles Wilkes' United States Exploring Expedition of 1838 to 1842, it snowballed rapidly with the addition of the Patent Office models, the exhibits of all nations at the Philadelphia Centennial in 1876, and the specimens brought in by its own staff and sent in by innumerable collaborators, professional and amateur.

Today the National Museum is a great storehouse of fabulous riches both in natural history and in every phase of human endeavor. It operates through six departments: geology, zoology, botany, anthropology, engineering and industries, and his-

29

tory. Behind the scenes, in the vast study collections, is conducted a large part of the Smithsonian's basic research. New knowledge arises from these studies like steam from a bubbling cauldron, stirred by the men of science. To diffuse knowledge, the Museum places on exhibition many thousands of specimens, carefully arranged and labeled and chosen for their interest and educational value.

In presenting these treasures, in which every American may feel pride of ownership, it seems logical to take up first the stage on which the drama of life is played—our planet earth. It is the abode to which we are all restricted by the prison bars of gravity, at least until man-made rockets attain a speed of seven miles per second—the velocity of escape to outer space.

The earth story is the business of the Department of Geology, which contains some of the most popular of all the Museum exhibits. For here we may see not only the story of our planet itself and the slow evolution of life on it, but also the fossil monsters that once dominated the earth and suddenly disappeared, the beautiful minerals in endless variety, gems worth a king's ransom, and meteorites—those chunks of matter from outer space which may be the debris of an exploded planet like our own.

The origin of the earth is one of the most difficult problems to be encountered by geologist and astronomer alike. A vast amount of speculation and study has gone into the problem, but in the words of Thornton Page, of Yerkes Observatory, "With all the spectacular success of recent scientific research, it is perhaps refreshing to examine a field so characterized by failure as this one."

Our Planet Earth

The two best-known theories are those of Kant—later modified by Laplace—and of Chamberlin and Moulton. According to the first, the sun and all its planets were formed from a single large rotating cloud of gas which condensed into several parts, each part condensing further into a planet or satellite. The Chamberlin-Moulton theory supposed that the close approach of another star to our sun drew out a streamer of gas which condensed into small solid particles; from this great mass of cold particles the earth and other planets grew by accretion. Later theories for the most part have been modifications or amplifications of these two. The very latest theory, and the most fantastic yet proposed, is radically different. Put forward by the British biologist Haldane and based on Milne's theory of relativity, it postulates that the entire universe, including time and space, started at one point and one instant three billion atomic years ago and expanded in every direction. The giant quanta of radiation under such conditions would have had ample energy to knock planets out of the sun and other stars as they formed. This theory, though far from proved, does agree with the apparent evidence that all the galaxies are rushing away from us in every direction.

It may be a long time before there is anything like general scientific agreement on how our earth originated, but geologists have not waited for that point to be settled. They have taken the earth as they found it and, through patient study of vertical miles of rock layers, have built up a fascinating panorama of earth history. The pictures making up this planetary panorama take us back an incredibly long time—a sweep of time so vast that it must be reckoned not in years or in centuries, but in mil-

lions of years. Starting with the present earth as we see it now--
the age of man, which has lasted not more than a brief one mil-
lion years—we drop back down the well of time through the
Cenozoic Era. the age of mammals and modern plants (which
lasted for 50 million years), down through the Mesozoic Era,
the age of reptiles including the fantastic dinosaurs (150 mil-
lion years), and through the long Paleozoic Era, the age of in-
vertebrate creatures (which persisted for 300 million years).

Even with these enormous periods of time, we are only start-
ing our long downward plunge, for at this point we start down
through the long hazy dawn period of earth history. We next go
back nearly half a billion years through the age when the only
life on earth was in the form of primitive plants, the Proterozoic
Era; then down through the long Archeozoic Era during which
for another half billion years primal life in the form of single-
celled things fought to establish itself. Back of all this incredi-
ble stretch of time lies the original earth crust which is seldom if
ever seen by geologists because this crust has through the ages
been so crumpled and otherwise transformed as to be unrecog-
nizable.

In the carefully planned geology exhibits in the National Mu-
seum, the dramatic story of the earth's long existence can read-
ily be followed. The story begins in the Hall of Fossil Inverte-
brates, the little creatures without backbones whose fossilized
remains are found in rock formations going far back into the
mists of primeval time. A large stone slab at the entrance to this
hall makes the visitor feel that weird crawling things did actu-
ally live in those times of remote antiquity. For this stone slab
is the solidified sand of an incredibly ancient tidal flat, and not

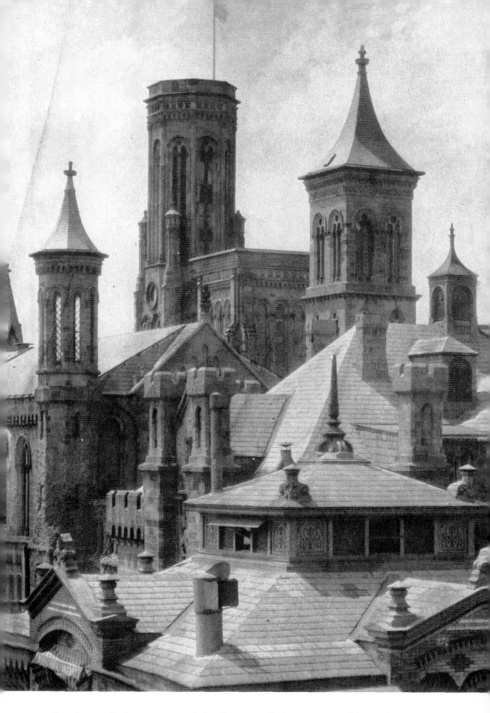

1. Some of the towers and battlements of the 100-year-old Smithsonian Building. It was designed by James Renwick after a twelfth century Norman castle. The flag tower in the center is 140 feet high.

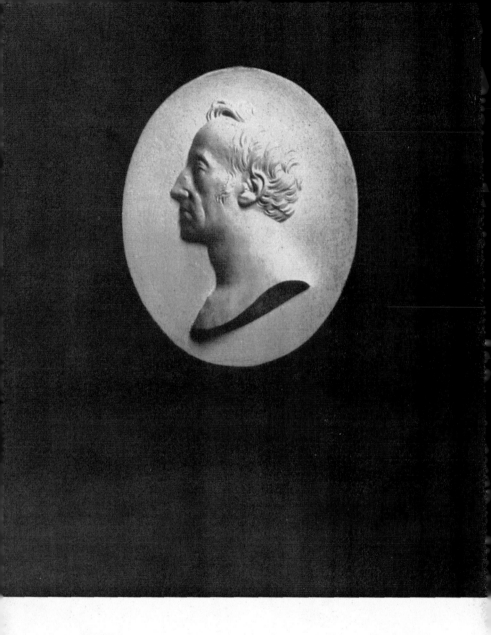

2. Medallion of James Smithson, the lonely English scientist who founded the Smithsonian Institution.

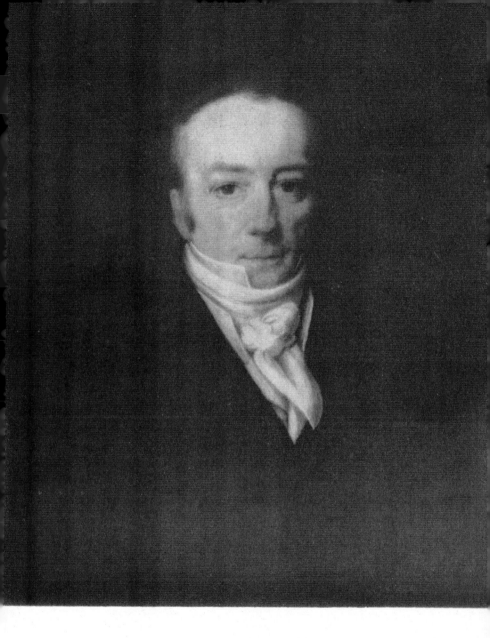

3. Portrait of James Smithson painted in 1816 by Johns.

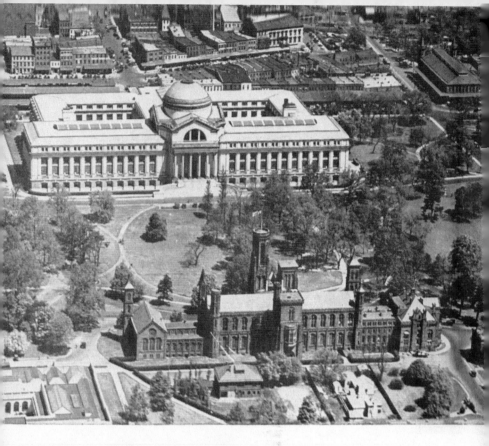

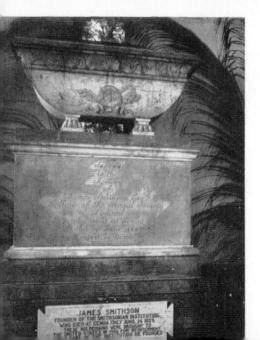

4. *Above:* Air view of a part of the Smithsonian group of buildings taken around 1930. Smithsonian Building in center foreground, with Freer Gallery at left and corner of Arts and Industries Building at right. Natural History Building in center background.

Left: James Smithson's final resting place. Brought over from Italy in 1904, his remains repose in a beautiful crypt at the entrance of the Institution he founded for the benefit of all mankind.

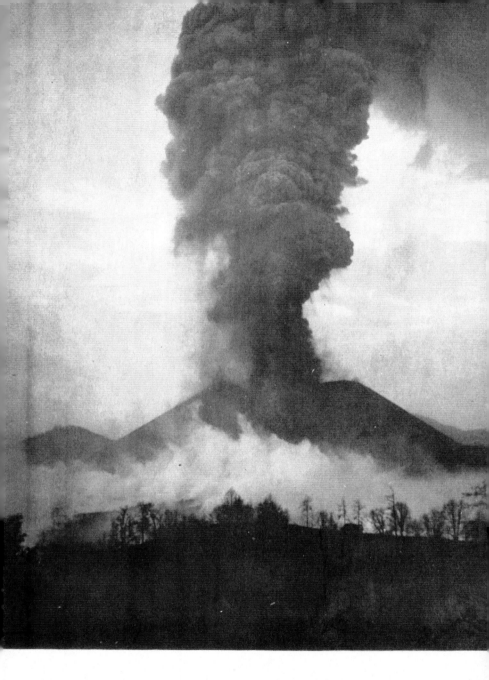

5. The new volcano, Parícutin, in Mexico only a few months after its birth. The eruptive column rises 20,000 feet in the air.

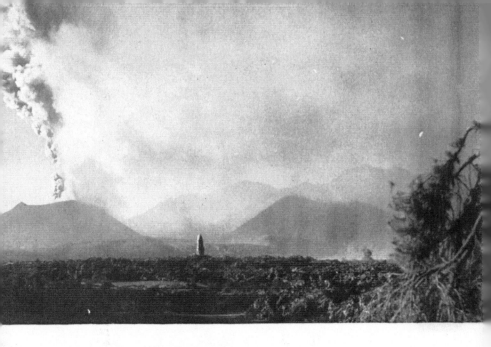

6. *Above:* Lava flow from Parícutin has engulfed the village of Parangaricutiro, leaving only the church steeple showing.

Below: The tremendous explosions of fiery lava from Parícutin made an awe-inspiring fireworks display at night.

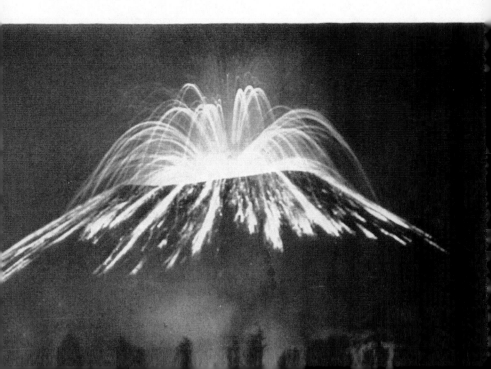

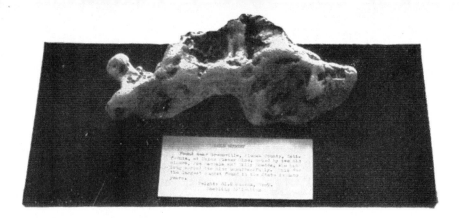

7. *Above:* One of the largest gold
nuggets ever found in California.
Weight, 61.9 ounces Troy.

Below: The actual first flake of gold
found by James Marshall at Sutter's
Mill. It started the California gold rush
of 1849.

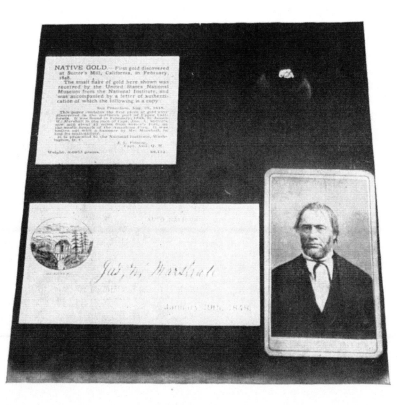

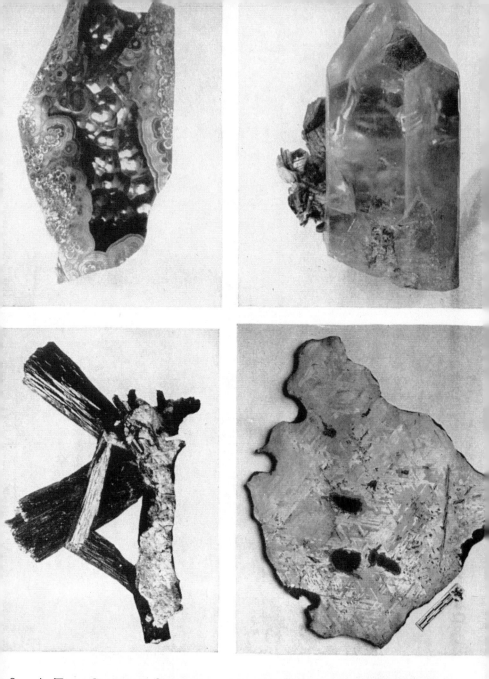

8. A FEW STRIKING SPECIMENS IN THE DIVISION OF MINERALOGY.

Above: Malachite from Siberia.
Below: Azurite from South West Africa.

Above: Beryl 6 inches long from Brazil.
Below: Section cut from a meteorite.

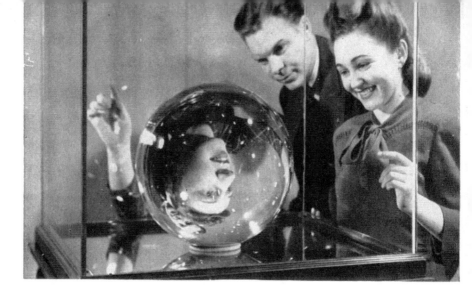

9. *Above:* The world's largest flawless crystal ball, 12⅞ inches in diameter. It weighs 106¾ pounds, but the block of Burmese rock crystal from which it was cut weighed over 1,000 pounds. To cut and polish it required 18 months of hand labor. All reflections appear upside down in it. *Courtesy National Geographic Magazine.*

Below: Natural and cut specimens of aquamarine in the National Museum. In the lower left and upper right corners are shown unusually fine uncut examples of this beautiful gemstone. *Courtesy National Geographic Magazine.*

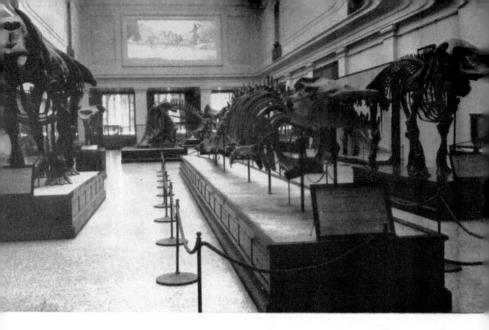

10. *Above:* Fossil skeletons of long-extinct mammals. At left and right, the great elephant-like mastodon; in the center, the weird sea-living mammal *Basilosaurus* which would have made a good "sea-serpent" story for the newspapers of 4,000,000 years ago, for it is 55 feet long.

Below: "Gertie," the *Diplodocus,* a representative of the world's largest land animals. It took five men seven years to chip this dinosaur out of its hard rock matrix and assemble the bones properly.

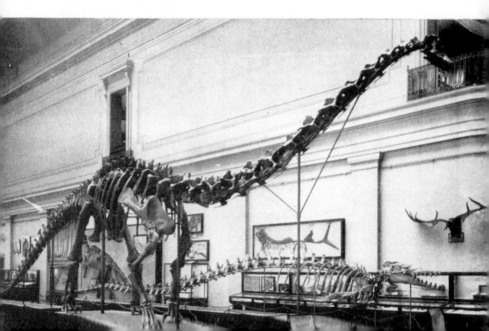

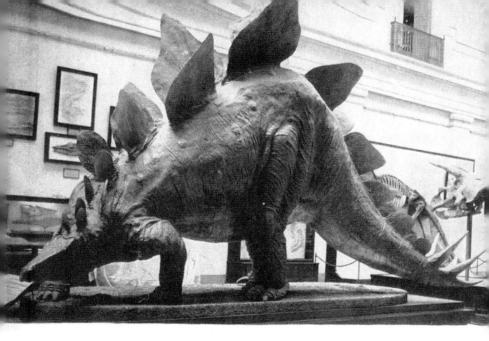

11. *Above:* This dinosaur is the *Stegosaurus,* or plated lizard. A well-armored plant-eater, this monster was about 15 feet long but had a brain weighing only 2½ ounces, about one-fifteenth the size of a man's brain.

Below: The horned dinosaur, *Triceratops,* the largest-headed animal the world has ever known—his skull was 6 feet long. Dinosaurs inhabited America a few million years before the Rocky Mountains were born.

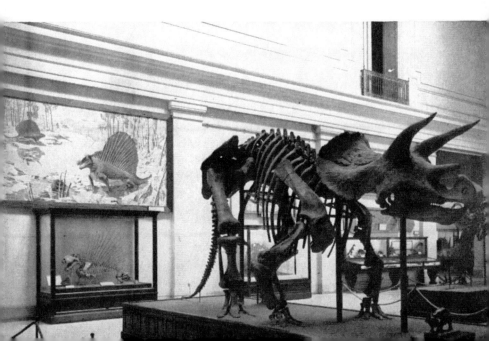

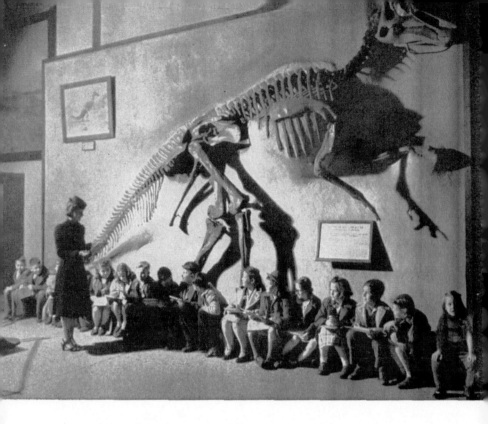

12. *Above:* School children in the menacing shadow of a duck-billed dinosaur that roamed over Wyoming swamps some 80,000,000 years ago. Although equipped with more than a thousand teeth, it ate mostly water plants. *Copyright National Geographic Magazine.*

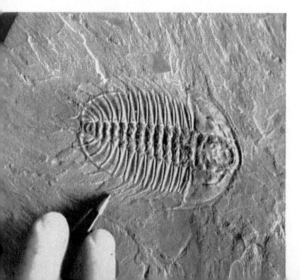

Left: A well preserved fossil trilobite found in rocks of the ancient Cambrian era dating some half billion years ago. This very early form of life resembles vaguely some of our modern crustaceans. *Copyright National Geographic Magazine.*

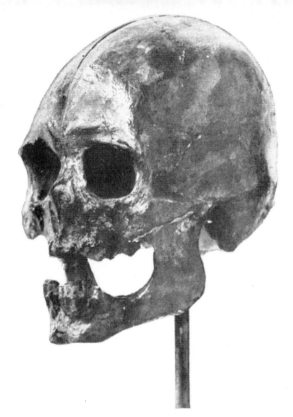

13. Cast of the skull of Tepexpan man, an individual who may turn out to be the oldest known inhabitant of the Americas.

The skull and skeleton were found in 1947 on the shore of a lake in the Valley of Mexico in strata of Pleistocene age, dating probably from ten to fifteen thousand years ago.

The bones were in direct association with skeletal remains of a mammoth, an extinct elephant-like animal of the Pleistocene era. Tepexpan man was brought to the Smithsonian for reconstruction and study, after which the original bones went back to their Mexican homeland.

14. On this page and the opposite page are shown a sculptor's conception of various stages in the evolution of man based on casts of skulls of ancient man in the National Museum.

Such reconstructions, as well as the dating of the ancient skulls themselves, are always controversial, and the ideas of anthropologists change as new studies are made. But at least these fanciful portraits will serve to give an idea of the tremendous change in man's physical appearance since the days of our most primitive ancestor *Pithecanthropus erectus,* or Java Man.

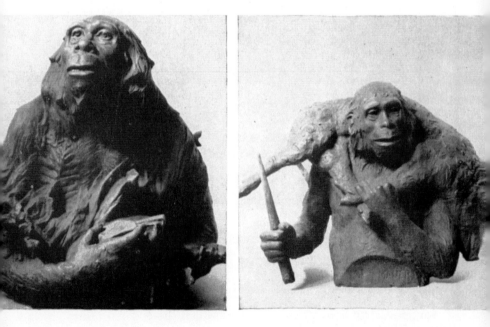

A. Java Man of approximately 1,000,000 years ago.

B. Heidelberg Man, Germany, around 500,0C years ago.

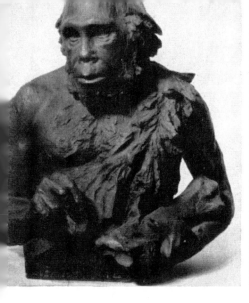

C. Neanderthal Man, Central Europe, the ear East, and Siberia.

D. Galley Hill Man, England, Late Paleolithi

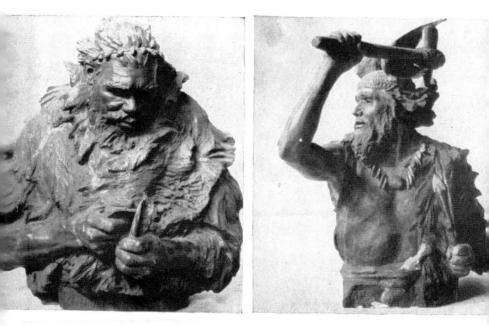

. Cro-Magnon Man, France, variously placed t from 50,000 to only 14,000 years ago.

F. Man of Spiennes, France, a contempora of Cro-Magnon Man.

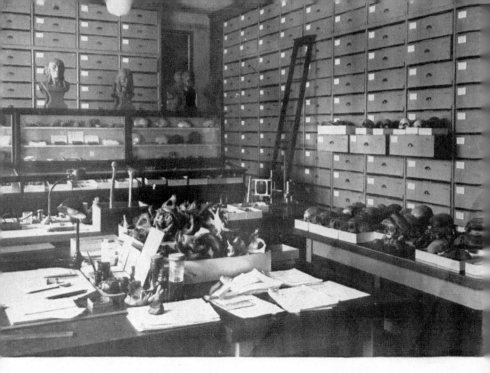

16. *Above:* A great file of the world's human types as represented by their skulls. In this laboratory of the Division of Physical Anthropology are some 17,000 human skulls and facilities for their study.

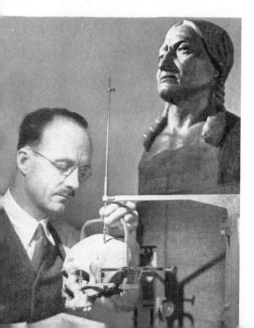

Left: Smithsonian anthropologist, Dr. T. Dale Stewart, tracing the coronal suture of a Sioux Indian skull, using a Schwarz stereograph. Through many years of such painstaking studies at the Smithsonian, there is available a vast body of exact data on the physical characteristics of the races of man.

In the background is a bust of Sitting Bull, the famous Sioux Chief. *Courtesy National Geographic Magazine.*

only does it show ripple marks as clearly as on sandy shores of today, but it is crisscrossed by the unmistakable tracks of a large lobster-like animal, which strangely resemble the tracks of automobile tires.

Along one wall of this hall is a long row of exhibition cases showing in order the characteristic fossil creatures of each of the geological formations, along with actual samples of the typical rocks. The formations range from the basal rock layers such as those at the very bottom of the Grand Canyon right up to the sands of modern beaches.

Of great popular interest is the painted geological section 90 feet long showing the rock formations across the entire United States. This section shows clearly the relation between geology and geography. For instance, the low-lying Atlantic Coastal Plain is seen to be formed of sands and clays of quite recent origin, whereas the higher Piedmont Plateau is underlain chiefly by contorted and deeply eroded igneous or metamorphic rocks. It can be seen that the Appalachian Valley is in considerable part a great limestone area, and that the Cumberland Plateau is composed of sandstones, shales, and coal beds, forming the great coal fields of the East. The strong contrast can be observed between the old mountain ranges of the Appalachian area, which are worn down by erosion almost to their roots, and the more recently uplifted and less eroded Rocky Mountains. Dislocation of rock strata can be clearly seen in the western mountains and also along the Pacific Coast Range, where occurred the renewal of faulting to produce the disastrous 1906 San Francisco earthquake.

A third series running the length of this hall visualizes the ev-

olution and classification of invertebrate life forms beginning
with the simplest of all—the single-celled protozoa—and go-
ing upward in the scale through the sponges and corals, the
queer but ubiquitous trilobites that look something like our
horseshoe crabs, the sea lilies, brachiopods, and many other
forms that dominated the scene in the successive geological
periods.

Some of these invertebrate fossils—microscopic ones at that
—surprisingly enough turned out to have a practical value that
must be reckoned in terms of many millions of dollars. The ones
in question bear the rather uninviting names of foraminifera, os-
tracodes, conodonts, bryozoans, and diatoms. Of all these the
foraminifera have been chosen as the best guide fossils in oil
geology. Rock strata of certain geological periods are known by
oil geologists to indicate the probable presence or absence of oil
deposits below. The types of fossils encountered in drilling be-
tray the age and structure of the rocks passed through, but the
churning bit grinds the larger fossil species to unrecognizable
fragments. The microscopic foraminifera, on the other hand,
come through the ordeal unscathed, and are ready to tell their
story to anyone who knows them well enough to interpret it.

Joseph A. Cushman, a Smithsonian collaborator since he first
started his pioneering classification of the fossil "forams," was
the first to demonstrate their usefulness to the oil geologist.
Cushman for years worked at classifying the forams, and as
their value became more and more apparent, others entered the
field. Many of Cushman's papers, so valuable to oil geologists,
were published by the Smithsonian. When Cushman died only
a few years ago, he bequeathed to the Smithsonian his private

collection of foraminifera comprising literally millions of speci-
mens. It will serve as a great "library" of these economically im-
portant forms.

To go back for a moment to the trilobites and other strange
creatures of the ancient Cambrian seas, it was the Smithsonian's
fourth Secretary, Dr. Charles D. Walcott, who contributed so
much through a lifetime of research to man's knowledge of that
ancient life ferment. Dr. Walcott was one of those rare people
who know from childhood what they want to do and then do it.
He began his geological studies at the age of thirteen, and was
still pursuing them with unabated vigor when he died at the
age of seventy-seven. A leading geologist credited Dr. Walcott
with contributing 70 percent of all our knowledge of Cambrian
geology.

Some people object to scientific findings of the slow evolution
of life forms through hundreds of millions of years because they
feel that such a process does not agree with religious teachings
as revealed in the Bible. Dr. R. S. Bassler, retired Smithsonian
head curator of geology, and a world authority on certain in-
vertebrate fossils, particularly the bryozoans, has shown that in
a proper interpretation of Genesis, the seven days of creation
parallel so closely the great divisions of earth history as re-
vealed through the fossil evidence in the rocks that there need
be no conflict. Many scientists, who have spent a lifetime in
delving into the innermost secrets of nature, are among the
most truly religious of all people. This applies especially, per-
haps, to the astronomer who sees the silent majesty of the
universe sweeping out unimaginable distances to infinity; the
biologist who glimpses through his microscope the teeming

miracle of life in a drop of water, who sees "the world in a grain of sand"; and the paleontologist who scans the infinite variety of life forms traced on the rocks back to the very beginning of life itself. They realize most deeply the beauty and harmony of the stupendous plan of the Creator, and for them there is no discordance between science and religion. Man was endowed by the Creator with an insatiable curiosity about himself and his world. The scientist seeks only truth, and he must accept the evidence he sees whether as fossil creatures in ancient rock formations or in any other form. Dr. Bassler likes to sum up this feeling in the opening stanzas of a poem by Carruth, "Each in His Own Tongue":

> "A Fire-mist and a planet—
> A crystal and a cell—
> A jelly-fish and a saurian,
> And caves where the cave-men dwell;
>
> Then a sense of law and beauty,
> And a face turned from the clod—
> Some call it evolution,
> And others call it God."

In the few steps from the Invertebrate Hall to the adjoining range we span a tremendous advance in the evolutionary process, for here we come abruptly among the reptiles and mammals—the vertebrate line that finally culminated in man. The most appealing because of their very grotesqueness are the dinosaurs or terrible lizards. These were the monsters of the Mesozoic era, that age of reptiles when the cold-blooded tribe

ruled on the land, in the sea, and in the air. The Museum favorite with visitors is "Gertie," the *Diplodocus,* so nicknamed by the staff for an undisclosed reason. "Gertie," covering the amazing span of 90 feet lengthwise and 12 feet up and down, represents the largest creatures ever to live on the land. To release her from her stony grave in Dinosaur National Monument on the flanks of the Rockies in northeastern Utah and put her together again in Washington required the time and effort of five men for seven years. Since her rejuvenation she has taken a leading role in several motion-picture productions. Despite the great size of *Diplodocus,* its brain was so small that it would seem to be grossly inadequate to coordinate such a huge bulk. Oddly enough, the food of this grotesque monster was entirely vegetable.

Other strange creatures from the age of reptiles are the duck-billed *Trachodon annectans,* a 30-foot plant eater which walked around mostly on its strong hind legs. One of the scourges of this era must have been *Ceratosaurus nasicornis,* a powerfully built meat-eating animal 17 feet long and equipped with strong, sharp teeth for grasping its prey and for tearing and rending flesh. Like the mythical unicorn it had on its nose a single large horn. Another conspicuous dinosaur skeleton is that of *Triceratops,* whose claim to fame lies in the size of its skull. The skeleton is only 20 feet long, but the skull measures almost one-third of that length, giving it the largest head ever known on a land animal. Its name derives from its three formidable horns, two large sharp ones on the forehead and a smaller one on the nose.

Even more fantastic is the *Stegosaurus* or armored dinosaur.

Its tiny head hardly seems to belong to the great bulk of body, and its back is adorned for its entire length with great bony vertical plates almost like wings. The Smithsonian's *Stegosaurus* exhibit is the most comprehensive known. It includes a complete skeleton lying flat in its rock bed just as it was found to illustrate the arrangement of the bony plates, a mounted skeleton showing how the armor plates were attached, and a full-sized lifelike restoration.

Before leaving the Fossil Vertebrate Hall, visitors pause before the great flying reptile, *Pteranodon,* which died a hundred million years ago and left its skeleton intact in what became the Kansas chalk beds. When Smithsonian Secretary Langley was searching for the basic requirements of a heavier-than-air flying machine, he is said to have found his answer in this very specimen. The *Pteranodon's* muscular energy corresponded to an engine for motive power, its membrane-supporting greatly elongated fourth fingers to a flying machine's wings. The shape of this giant flying creature is strongly suggestive of some modern planes. Nor can visitors resist the giant fossil fish *Portheus,* 12 feet long, which at least had a good meal before he died as proved by the presence of a 6-foot fish skeleton in its body cavity. *Portheus* looks down upon a fossil "sea serpent" in the form of the 55-foot-long swimming mammal *Basilosaurus,* a relatively recent creature that lived only four million years ago.

Of equal interest are the chronological series of fossil plants from the primitive sea-weeds of the ancient Paleozoic era to the immediate ancestors of our flowering plants of today. The visitor can examine and feel the trunk of a fossilized carbonifer-

ous coal-producing tree, in life exceeding 100 feet in length, as well as fossilized or "petrified" logs from Arizona and other regions. In the Hall of Fossil Mammals the visitor feels that he is emerging from the dark nightmare past and coming back to shapes more familiar to him as exemplified by the fossil skeletons of elephants, deer, and horses, some of them not so different from those of our own time.

Returning to the present, visitors next find themselves in an exposition of geological processes, some of which we can see in action in the world about us. Separate exhibits illustrate the different kinds of rocks, cave formation, glacial action, earthquake phenomena, volcanic activity, and other subjects incidental to the formation and reshaping of the earth as we know it.

The one that perhaps appeals most to the imagination is the exhibit relating to volcanoes. Here is a subject full of the drama of human lives and of the titanic primal forces of nature. The cases filled with the varying forms and kinds of lava, ancient and recent, from volcanoes in many parts of the world recall to mind the engulfing of Pompeii in probably the best-known of all volcanic cataclysms.

Pompeii was a prosperous city and seaside resort in the heyday of the Roman Empire. Here came pleasure-bent emperors and other great personages of Rome to vacation in the shadow of peaceful Mt. Vesuvius. In A.D. 63 a great earthquake almost leveled the city, but the undaunted inhabitants started almost at once to rebuild it. A new Pompeii was slowly rising from the ruins when suddenly, in the year 79, the sleeping monster Vesuvius awoke with a roar and literally blew itself to pieces. The

entire city was enveloped in inky blackness and buried under a thick shroud of rock fragments and gray ash. The terrified people of the city were trapped, whether they barricaded themselves in their homes or ran about the streets. Thousands died in a matter of hours, and Pompeii was so completely buried as to be lost to history for seventeen hundred years. About two hundred years ago the ruins were rediscovered by accident, and sporadic excavations were conducted on the site. Gradually this ancient city, buried by a volcano, is coming out into the light again, some of it almost perfectly preserved after the passage of nearly 2,000 years.

Another terribly convincing bit of evidence of the repressed forces within our globe was the eruption of Mt. Pélee on the island of Martinique in the West Indies on May 8, 1902. This great volcanic cone hung almost over the city of St. Pierre with its population of more than 25,000 people. When Pélee burst its bonds, belching forth noxious gases and dust in a great cloud, the city and practically its entire population were wiped out in three minutes. One of the very few to survive the catastrophe was a condemned criminal incarcerated in a round thick-walled stone dungeon in the old St. Pierre prison.

Nor is volcanic activity wholly a thing of times past. Only a few years ago, in the middle of a peaceful cornfield in Mexico, there suddenly appeared a crack in the earth from which emerged a boiling, seething inferno to take its place among the earth's famous volcanoes. Starting from a level field, the earth vomited forth such vast quantities of molten lava and ash that within a matter of months a gray cone 1,500 feet high dominated the entire area.

Our Planet Earth

One of the first scientists to see the new Parícutin volcano was Dr. William F. Foshag, present head curator of the National Museum's Department of Geology. He and a Mexican colleague, Jenaro Gonzales R., thereafter kept the new volcano under observation for nearly three years. Dr. Foshag has summed up the birth and development of Parícutin thus:

"After two weeks of local earth tremors and subterranean noises, which increased day by day in strength and frequency, on February 20, 1943, about 4 P.M., a small fissure about 25 meters long opened on the farm Cuiyutziro, near Parícutin village. About 4:20 P.M., a sudden explosion opened a small vent about half a meter across at a spot near the west end of this fissure, and a small eruptive column of fine gray ash and small bombs arose from the orifice. This orifice increased in size by the collapse of its walls, reaching 2 meters in diameter at 6 P.M., and the eruption increased in volume. Within the throat of the vent the ash bubbled like the sand in a spring, with a noise like a cauldron of water boiling vigorously. An odor of sulfur pervaded the vicinity of the vent. Small mounds of fine hot ash half a meter high began to collect about the orifice. Between 10 P.M. and midnight heavy eruptions began, with thunderous noises and the ejection of large incandescent bombs.

"During the night the cone grew slowly, reaching a height of 10 meters by 10 A.M. During the day of the 21st, activity greatly increased, and the cone grew very rapidly, reaching 30 meters by midday. Probably the first lava flow appeared during this day.

"Heavy activity, with thunderous noises, continued, with increased quantities of ejected bombs, and the cone rose to a

41

height of over 160 meters on February 26. In late March the first lava flow ceased, and the eruptive activity changed to the heavy emission of ash, the eruptive column rising to more than 20,000 feet. Later flows spread over the area, eventually engulfing the villages of Parícutin and Parangaricutiro."

Back at the Smithsonian, Dr. Foshag put in motion exhaustive studies and analyses of the lava and other materials associated with the outbreak of this new volcano. It is possible that the knowledge accumulated as a result of this unique study may eventually aid in predicting future disastrous eruptions of apparently inactive or sleeping volcanoes.

Leaving the rather awesome story of the earth's strange past history and of its overwhelming inner forces, the National Museum visitor enters suddenly a fairyland of beauty in form and color—the Hall of Minerals and Gems. Here is an almost indescribable fantasy of nature's whims—crystals of the strangest shapes and tints, large and small mineral specimens of every rainbow hue, gems and precious stones of incredible size and beauty—in row upon row of cases almost as far as the eye can reach.

The Smithsonian mineral collection is probably the largest and most complete in the world. It has reached its present magnitude through the addition of the great Roebling, Canfield, and Isaac Lea collections, plus many lesser ones. The assemblage of gems, likewise, is unquestionably one of the finest. At the entrance to the hall, a carefully chosen group of specimens illustrates the characters by which minerals are distinguished— their crystalline form, hardness, color, composition, and origin. Down one whole side of the hall is a showing of some 4,000 min-

erals arranged according to their scientific classification in increasing complexity of chemical composition. Although designed especially for the student of mineralogy, nevertheless this very complete series is often used by visitors to identify their own mineral specimens.

Down the other side of the hall are the especially showy minerals such as large clusters of beautifully colored copper compounds, a 1,022-pound beryl from New Hampshire, a 95-pound section of a huge piece of topaz, quartz in many odd forms, calcite, fluorite, semi-precious stones, and countless others of amazing beauty and interest in color and form. At the end of this row is one of the few unprotected exhibits—a large chunk of lodestone so heavy no one could carry it away. With it is a supply of nails with which the visitor can amuse himself by demonstrating its strong magnetic pull.

In a separate case appears a tiny piece of metal that played an important part in American history a hundred years ago—the very flake of gold found by John Marshall in the mill race at Sutter's Fort in 1848, which started the California gold rush. This famous stampede, in which some made millions and others went "broke," greatly speeded up the development of the West.

In another special case is the comprehensive exhibit of uranium ores and minerals from various parts of the world. Just a rare metal a few short years ago, uranium has almost overnight skyrocketed into the No. 1 spot among all minerals in importance to the world. The only known source of fissionable materials for the production of atomic energy—and atomic bombs—uranium deposits are being eagerly sought throughout the world. So much interested is the United States Government

that it has printed a booklet entitled "Prospecting for Uranium," which can be bought by anyone from the Government Printing Office for 30 cents. This booklet tells what to look for, where to look, and how to know uranium ore if you find it. It also outlines the Government's bonus offer of $10,000 for the first 20 tons of uranium ore from a new locality, in addition to a minimum price of $3.50 per pound of uranium oxide determined to be recoverable. In the Museum exhibit you can see exactly what any kind of uranium ore should look like. A gadget on the wall nearby demonstrates the radioactivity of uranium. In a long wooden tube with a glass front, like a mail chute seen in office buildings, is suspended a chunk of uranium mineral. The visitor by pulling down on a knob can bring the uranium closer and closer to a Geiger counter which thereupon clicks faster and faster in response to the increased strength of the radioactivity as the uranium approaches the instrument.

Down the middle of the hall in a long row of flat-topped cases is the crowning glory of this phantasmagoria of nature's creations—the gems. Here is form and color and sparkle enough to satisfy connoisseur and layman alike. Here are diamonds, rubies, sapphires, emeralds, amethysts, opals, aquamarines, topazes—in fact, practically every gem and precious stone known to man. Among them we might mention the 155-carat blue topaz from the Ural Mountains, a 93-carat red topaz, deep red rubies from Ceylon, large and beautiful tourmalines—green ones from Maine and pink ones from California, a 40-carat aquamarine from Connecticut, blue zircons from Australia, a 50-carat white topaz from Japan, and thousands of others large and small of every conceivable color and from all parts of the

world. In a special wall case is a large assortment of opals on a black velvet background—small cut stones and large chunks of opal as it was found. These are beautiful in ordinary light, but when a visitor pushes a switch on the front of the case and floods the exhibit with bright light, it is hard for him to restrain an exclamation at the flashing fire of the opals—red, green, blue, violet, and orange.

As far back as history goes, mankind has known and cherished gemstones for various reasons. As expressed by Dr. George P. Merrill, a former head curator of geology at the National Museum, "Man has endowed gems with talismanic, curative, and supernatural powers. Certain gems preserved him from incubi, vampires, and kindred terrors; others preserved him from the powers of sorcery or conferred the powers of witchcraft; by their aid he controlled the spirits of evil or was protected from their malign influence. With a suitable gem he could foretell the future, review the past, or conjure up pictures of events taking place at a distance. Protected by their mystic influences he feared neither plague nor poison, while his belief in the marvelous efficacy of their curative powers gave them a place among his most potent remedies."

For example, the turquoise was highly valued by all orientals, and was worn by them to insure health and success. It was supposed to preserve the wearer from injury through accidents. In the presence of poisons a turquoise would sweat profusely. If the owner did become sick, the stone's color would pale, and if he died, would be lost entirely, only to be restored when the stone became the property of a healthy person.

A special case that attracts many visitors is one displaying

exact replicas of some of the world's largest diamonds, including the "Cullinan" from South Africa, the largest ever found, weighing over 3,100 carats. One of the oldest known diamonds is the 186-carat Indian "Koh-i-noor," or "mountain of light." Its exact history is lost in the mists of antiquity, but it is reported to have belonged to the ruler of an ancient oriental kingdom as far back as 3000 B.C. All the great diamonds of history have left behind them a trail of intrigue, murder, tragedy, and disaster—yet men continue to strive for them, and eager buyers always appear for the famous stones that occasionally come on the market.

Square in the middle of the gem exhibit is one of the most spectacular and perhaps the most valuable single exhibit in the entire National Museum. In a specially built square glass case and resting on a black velvet square is the world's largest flawless crystal ball. It was presented to the Institution by Mrs. Worcester R. Warner in memory of her husband. The block of rock crystal from which it was carved was mined in the interior of Burma and weighed in the rough about 1,000 pounds. For carving into spherical form it went to patient experts in China, and for the tedious final polishing to Japan. The entire process required eighteen months of hard labor. The finished product is a thing of sheer beauty for its perfection of form and flawless clarity. It is valued at well over a hundred thousand dollars.

The last exhibit in the Geology Department to be considered is one that appeals not so much to the senses as to the imagination—the "messengers from outer space," or meteorites. The specimens shown to the public are but a very small part of

the National Museum's collection—one of the most important in the world. The Museum has for many years been a leader in the study and classification of meteorites. A large body of classified scientific data is available to all students of the subject.

The shooting stars that streak across the night sky are known to scientists as meteors. The very few that escape burning up high in the atmosphere and actually fall on the earth are called meteorites. They form a real bridge between geology and astronomy, because they are similar in some respects to our ordinary rocks and at the same time provide the only objects from outer space that we can handle and study. Measurements of the speed of meteors have shown that at least they belong to our solar system and did not stray in from interstellar space. Other studies of the chemical compounds in meteorites indicate that they were once under conditions of high temperatures and pressures such as would be found in the interior of a planet. This finding has given rise to the plausible speculation that meteors are shattered fragments of an earth-like planet that crashed in the remote past into some other cosmic body.

Although millions of meteors enter the earth's atmosphere every day, only a few get through to us. In the Museum exhibit, these newcomers to earth are arranged so that the visitor can distinguish their unusual features and see how the atmosphere has sculptured their surfaces during their brief, swift flight through it. A wall map shows the location of all the places in the United States where meteorites are known to have fallen, so that a visitor can see for himself if one has dropped in near his home.

Most meteorites are small, many weighing less than a

47

pound. The largest known is the Hoba iron meteorite in South West Africa, with an estimated weight of 60 metric tons. There is a record, however, of an immensely large fall—Meteor Crater in Arizona, a hole in the ground 570 feet deep and three-quarters of a mile in diameter. This great crater stands as a monument to the greatest explosion ever to take place on earth. There is no assurance that another equally large piece of matter may not some day crash in a densely populated area, but this should not be a cause for alarm since the evidence indicates that such large falls are extremely infrequent.

The National Museum has samples of nearly one-half of all the known falls of meteorites. It is anxious to continue building up its collection, however, in order to further its exhaustive researches in this field. The Museum is always glad to examine possible meteorite finds sent to it by the public, and will make an offer to purchase any that are considered to be useful in its researches.

Museum exhibits have been compared to the part of an iceberg that shows above the water. The far greater part that is unseen serves in a sense as the foundation of the exposed portion and corresponds to the Museum's great study collections which are not seen by the public. In the geology study series are millions of specimens of rocks, ores, minerals, fossils, and meteorites on which research continually goes forward and which are available to all qualified students. The Smithsonian has pioneered in many branches of geological research, notably paleogeography—the science of mapping the ever-changing lands and seas of geologic times, the geology of glaciers, chemical geology, micro-paleontology—the science of fossil micro-

scopic organisms, and taxonomy—the science of systematic classification.

At the present time many lines of research in the field of geology are going forward vigorously. For some years attention has been devoted to the small animals of the Tertiary, the period famous for producing the dinosaurs. These little creatures are the root stocks of many mammal lines and have the possibility of telling a great deal about evolution. Another blank in the canvas of life which one of the Museum scientists is trying to fill is that of the ancient fish. This scientist is an authority on the study of fossil fishes, and his primary interest is the fish of the Middle Paleozoic. At that time fishes of bizarre forms, often heavily armored and of huge size, existed.

The major program of the Division of Invertebrate Paleontology and Paleobotany is devoted to dissolving fossils from limestone with acid. In certain localities in this country and elsewhere in the world limy fossil shells are selected by percolating waters and altered to silica, which is the basic substance of sand and which is the primary stuff of which glass is made. Why the waters select the fossil shells for alteration, and not the matrix in which they are enclosed, is one of the mysteries that geology has not yet solved. But the fact that this does happen permits the paleontologist to dissolve silicified fossils from rock from which the specimens could be taken by no other means. The chief advantage of that method over fracturing the rock is the fact that the fossil shells can be obtained in their pre-fossil state of perfection. Clams, snails, and brachiopods have been discovered that are covered with minute spines, or have spines up to several inches in length on a shell only

an inch long. A completely new concept of what some animals were is derived by this process.

Another group of animals that will be better known as a result of these studies are the sponges. These evidently occurred in an infinite variety in the ancient Paleozoic, but hitherto had not been well known. The etching method permits the recovery of specimens showing the external form as well as interior details. Although these animals do not strike the public fancy, yet locked within the history of their development are basic laws of evolution yet undetected, which eventually should help man understand what has happened to life over the ages.

In the field of mineralogy, much time is devoted to the acquisition and study of meteorites, and a great deal of our knowledge of the composition of celestial bodies has come through such efforts. The most up-to-date methods are being used in the identification of minerals—the study of powder minerals by X-ray in order to learn the molecular structure. Smithsonian knowledge of gems and minerals is frequently called upon by Federal agencies in examining fraudulent claims. Smithsonian mineralogists also study the occurrence of minerals in the field with the idea of discovering new sources or reviewing old ones. In this day of dwindling mineral resources, these activities of the Mineralogy Division are of vital practical significance. In fact, this is true of all the work of the Geology Department.

Although efforts of the paleontologists do not on first thought seem practical, yet accurate geological mapping is based on detailed study of fossils. The only way that complicated distribution of the bed rock can be unraveled is by determining the position of the strata by the use of fossils. The oldest fossils

are always at the bottom. Consequently, if a sequence of fossils is discovered in reverse order, some cataclysmic event is clearly responsible for it. Major faults in the earth's crust can be detected by the use of fossil sequences. In short, the work of the Department, like that of its sister organizations in the same field, is devoted to putting geology at the service of mankind. James Smithson, himself a leading mineralogist of his time, could not but be gratified at the contribution the Smithsonian has made and is making to the existing knowledge of our planet Earth.

III. *The Myriad Forms of Life*

In far distant eons of forgotten time when our earth was still young and carefree, it began to be afflicted with an uneasy ferment that we call life. Starting out insignificantly as the lowliest plants such as bacteria and simple algae, it progressed with great deliberateness at first and more rapidly later to higher and more complex forms of plants and animals. Today, after a thousand million years, the earth literally swarms with life in myriad forms—in the air, on the earth's surface, underground, and in all the waters of the globe. Hundreds of fathoms down in the sea, weird fishes prey upon each other in eternal silence and utter darkness. Tiny red plants grow on lofty Arctic glaciers in such vast numbers as to produce what is called "red snow." At the apex of the pyramid of life is man, who very naturally is keenly interested in all the other living things that share the earth with him.

The keynote of living forms is diversification. It is almost as though nature cherished an obsession against monotony and

set out deliberately to try every conceivable combination of elements in her creations. In the biological exhibits of the National Museum are assembled many thousands of the varied forms of the present day from tiny insects and fantasies in shells to whales, the largest animals that ever lived. To our eyes, animals, birds, fishes, and reptiles vary in appearance from beautiful to ugly, plain to bizarre, and from magnificent to comical. To each animal, however, others of his kind doubtless look about right, as most other humans do to us.

In the Museum the carefully selected exhibition specimens well illustrate the amazing differentiation of life now existing. And for each form that lives today there have been ancestral lines that outnumber the existing forms hundreds or perhaps thousands to one. Adding to the exhibited animals the vastly greater study collections, the National Museum has listed in its catalogues more than 27,000,000 individual biological specimens. Most numerous are the insects with 11,600,000 specimens, followed by mollusks (shelled creatures) with 9,250,-000, plants with 2,400,000, fishes with 1,500,000, marine invertebrates with 1,200,000, birds with 450,000, mammals with 255,000, reptiles with 137,000, and other forms with some 200,000.

Among the most striking animals to meet the eye upon entering the Mammal Halls of the Museum are the spectacular Roosevelt African groups, including lions, giraffes, rhinos, zebras, and the vicious African buffalo. The creatures were collected by ex-President Theodore Roosevelt in 1909, and the groups represent the finest taxidermy of the time. President Roosevelt, exponent of the strenuous life, was not content to

sit back and relax after his presidential term. He proposed and organized a very large-scale African expedition with the aid of financial support and trained personnel from the Smithsonian. The expedition brought back thousands of animals and birds from many of the big-game areas of the continent, not only for the National Museum's exhibition groups, but for the study series as well. The wildlife of Africa must have breathed a collective sigh of relief when the energetic Colonel set sail for home.

In striking contrast to the Roosevelt and other older groups, which still have a very strong appeal for visitors, are the four recently installed North American habitat groups of moose, caribou, bighorn sheep, and mountain goats, done in the most modern manner. Here is realism at its best. In the foreground stand the animals themselves in characteristic poses, and the soil, rocks, vegetation, topography, and incidental features represent actual conditions at the localities where the animals were collected. The foreground merges into a painted background of mountains, forests, and sky, so carefully done as to make it almost impossible to tell exactly where the actual scenery stops and the painted scenery begins. The whole effect is that of looking at an outdoor scene rather than a museum exhibit.

The animals and background material for the Stone's caribou and Alaskan moose groups were collected in the Mount McKinley region of Alaska and presented to the Museum by William N. Beach and J. Watson Webb. W. L. Brown, the Museum's chief taxidermist who directed the preparation of all the groups, accompanied the expedition to get materials, notes,

and photographs at first hand so as to insure the absolute accuracy of the finished groups. A family of caribou is shown in one of their regular migrations passing over a boulder-strewn bar on the bank of the Tonzana River. In the moose group, an enormous bull with wide-spreading antlers and a younger bull eye each other aggressively in the presence of a cow with her yearling calf. In each group the deep green of the northern spruce forest is brightened by the vivid autumn colors of deciduous shrubs, and the snow-covered peaks of the Mount McKinley Range rise in the background.

The bighorn sheep and mountain goats in the other two groups were collected by former Smithsonian Secretary Charles D. Walcott in the Canadian Rockies. The painted backgrounds show the massive escarpments and sheer cliffs of the President Range. The sure-footed mountain goats stand near timber line on a shale-covered windswept crest, looking down into a lake-filled glacial basin.

To illustrate the lengths to which the Museum went to insure the fidelity to nature of the habitat groups, we will quote a brief passage from the report of chief taxidermist Brown, who was sent to Field, British Columbia, to select a setting for the mountain-goat group. He wrote from there:

"I was told that at certain times of the year goats could be seen on the ledges of Mount Burgess, and arrangements were made for a trip up that mountain from the Emerald Lake side. A guide was employed, and horses were obtained to bring back the material to be collected. At a point 7,020 feet up as indicated by the altimeter, we reached an angular shale cliff which I decided would make an exceptionally fine natural set-

ting for the goat group, having seen four goats, many tracks, and much goat hair lodged in larch trees here. Rock rabbits running in and out of the ledges and the whistling of the marmots added to the interest of the spot. The President Range, rising high into the clouds, made a perfect background picture.

"Wildflowers bloomed profusely here, and it was interesting to note how the flora changed as we ascended the mountain. Photographs were taken, measurements of the rock formation were made, and a complete collection of the flora was obtained, along with soil and shale. Among the plants collected were the heather, windflower, mountain sorrel, Indian paintbrush, flowering wintergreen, and sedge. Several alpine larch trees and juniper bushes were also taken to complete the natural setting for the group. The abundance of fireweed and Indian paintbrush added much color to the hills."

Back at the Museum, Brown directed the setting up of the goat group as an exact replica of the spot where he had stood on the flank of Mount Burgess looking across the valley to the majestic President Range. No detail is overlooked to make the groups authentic to the last leaf and stone. Those who take time to study them at leisure are rewarded by the discovery of such details as the Parry ground squirrel crouching in the shelter of a boulder as the caribou pass, the red squirrel and the ptarmigan half hidden in the shrubbery of the moose group, a hoary marmot beside the rocky ledge where the bighorn sheep stand, and the black eyes and rounded ears of a pika in the shale almost beneath the feet of the mountain goats.

In the crowded Mammal Halls, the visitor must feel that he is looking at every kind of animal that ever walked the earth.

Yet actually only a few hundred different kinds are shown of the some fifteen thousand known to exist. Of particular interest are the American mammal groups, such as bison, elk, and musk-ox. Africa and Asia are especially well represented, and the delegates from those continents that draw most popular attention are the primates—monkeys of all shapes and sizes, as well as the fierce-looking gorillas and orang-utans. Most comical-looking is the little proboscis monkey who unlike most monkeys has a definite human-like "nose."

The whales—sea-living mammals—require an entire hall of their own. Eclipsing all the smaller fry are the entire skeleton and a molded replica of a 78-foot sulfur-bottom whale, a creature which most visitors have read about but have never seen. Even while they are looking at it, many visitors refuse to believe that such a monstrous creature exists in nature. Although dwarfed by the huge sulfur-bottom, the other smaller whales and porpoises have great popular appeal. One is the curious narwhal, a 20-foot Arctic whale. An Army man recently back from Japan brought in for identification a photograph of a mysterious "horn" that was the prized possession of a Japanese family. He refused to believe the Museum expert's assurance that the "horn" was a narwhal tusk until he was taken to the whale hall and shown a narwhal skeleton with a huge tusk projecting straight forward from its head like a horn.

Next door to the mammals we come suddenly among the birds of the world—a symphony of beauty in form and color that cannot be surpassed anywhere in the Museum. The dainty little hummingbirds vie for attention with the gorgeous coloring of the parrot tribe and the exotic beauty of birds-of-paradise,

lyrebirds, and egrets. Yet there is a sinister side even to such an aggregation of charm. The kea, a large New Zealand parrot, has been accused of stabbing live sheep with its sharp beak, pulling out the kidney and leaving the poor animal to die. A bounty was placed upon the birds, but actually there has been no definite evidence that keas ever attack live sheep—they simply tear at dead animals and eat the fat. Being caught at such a feast, they would naturally appear to be guilty of killing the sheep. Fortunately, criminal characters are rare among birds, and the vast majority of them are beneficial to man, both esthetically and from the practical angle of serving to check an overabundance of insects.

Birds far outstrip all other forms of life in completeness of representation in the National Museum. Of some 30,000 known forms of bird life in the entire world, the Museum has examples of 65 percent, or more than 19,000 different kinds. The Museum collection is one of the largest in the world, and for the birds of North America it is by far the most complete in existence. It is also rich in birds from southern Asia, East Africa, the Philippines, and large parts of South and Central America, with good representation from Europe and Australia. The collection of bird skeletons, important scientifically, is one of the two largest in the world, its only rival being that of the British Museum.

The outstanding position of the birds among the Museum's zoological kaleidoscope is due in considerable part to the interest of the Smithsonian's present Secretary, Dr. Alexander Wetmore. An ornithologist of world-wide renown, Dr. Wetmore has done much to promote the growth of the bird division, both through his own extensive collecting activities in many parts

of the world, and through stimulating the interest of others in the national collection. Coming to the Institution from the Biological Survey in 1924, he has served successively as head of the National Zoological Park, as Assistant Secretary in charge of the U. S. National Museum, and since 1945 as Secretary of the entire Smithsonian Institution.

Dr. Wetmore is the author of more than 500 books and articles, chiefly in the field of bird science. They deal with nearly every phase of avian study, including the geographical distribution, evolution, and classification of birds. As stated elsewhere, his scientific classification of the birds of the world is now standard.

Besides the enormous number of individual birds from all the world, among which visitors can be sure of finding any particular kind they wish to see, a number of fascinating group cases show especially interesting features of bird life. One case might well be labeled "Memorial to Man's Destructiveness," for here congregate pathetic remnants of bird species that have been completely exterminated in recent times. No one will ever see one of these birds in flight again. The roster includes the great auk, Labrador duck, heath hen, passenger pigeon, Cuban macaw, Guadalupe caracara, Guadalupe flicker, Guadalupe towhee, and Carolina paroquet. The story of the passenger pigeon is particularly shocking. Before the middle of the last century these birds were so incredibly numerous that flocks passing overhead sometimes obscured the sun for hours. A single flock was carefully estimated to contain more than two billion birds. In September 1914 the very last passenger pigeon on earth died a captive in the Cincinnati Zoo.

The Myriad Forms of Life

Another case might be labeled "Too Little and Too Late," for it shows examples of birds now protected by law but it is feared too late to save them from extinction. These are the trumpeter swan, whooping crane, ivory-billed woodpecker, California condor, and Eskimo curlew.

The courtship displays and posturings of birds are the most varied and spectacular of any form of animal life. A special exhibit shows a number of these—the spread-tail, ruffled strutting of the turkey, the orange neck pouches of the prairie chicken, the upside-down display of the blue bird-of-paradise, the dainty nuptial dorsal plumes of the egret, and the rival posturing of the blackcock.

The nests of birds rival the homes of humans in variety of shapes and materials. Some of the more interesting shown in a separate case are the large mud "ovens" with a spiral opening in the side built by the Argentine ovenbird, the nests of the Australian riflebird which are decorated with discarded snake skins, the very dense felt-like, closed, purse-shaped nests of the African and European penduline wren-tits, the hole-nests of woodpeckers, and the very curious nests of the oriental swift. These last are used by the Chinese for making their famous bird's-nest soup. It may not add to the appeal of this Chinese delicacy for Americans to mention that the nests are composed chiefly of the birds' saliva, hardened on exposure to the air. The exhibit shows a nest decorated with twigs as it occurs in nature and another prepared for use by stripping it of its ornaments, exposing the basic edible structure.

A very different group of creatures shown in the National Museum which arouse conflicting feelings in the public are

the reptiles and amphibians. Some people find them repulsive, others seem to be fascinated by them. At any rate, they are interesting, and it is well to know something about them, as some are deadly poisonous, others entirely harmless. Among the snakes, the venomous rattlesnakes, copperhead, and cottonmouth are well represented, as well as the coral snake and its distant relative, the cobra. In a case by itself is the famous king cobra, the world's largest poisonous snake. It is known to reach a length of 18½ feet. This great reptile lives in the woods of southeast Asia and fortunately is secretive by nature—otherwise there would surely be a heavier annual death toll of the native population through snake-bite. Many of the harmless American snakes are also shown for comparison, including the widespread hognose snake that mimics the copperhead by inflating its body.

It is rather surprising that there are only two kinds of poisonous lizards in the world, both species of the genus *Heloderma*. One inhabits Mexico, the other the western United States-Mexican border. Both are shown in the Museum, as are also casts of the monitor, the iguana, and other leather-producing lizards. The recent craze for articles made of lizard skin creates much visitor interest in these creatures. Among the monitor group is the fantastic Komodo dragon of the East Indies. This fearsome animal reaches a length of ten feet and is strangely reminiscent of the dinosaurs that have been extinct these many millions of years.

The parade of turtles is led by the giant Galápagos tortoise that attains a weight of more than 400 pounds. It will surprise

many to know that we have in this country a fresh-water turtle that weighs up to 220 pounds. It is the alligator-snapper, a realistic model of which can be seen in the Museum. This creature has an unusually large head for a turtle, skulls nearly eight inches wide having been recorded. Through experimentation it has been learned that a large alligator-snapper can carry a 165-pound man on his back without apparent effort.

The alligator and crocodile are displayed side by side because the question uppermost in most people's minds about these weird-looking creatures is how to tell them apart. There are actually numerous differences, but one that readily presents itself even to the casual observer is the difference in shape of snout. The alligator has a broad, almost semi-circular snout, the crocodile a long, tapering one.

The realm of fishes is a fantasy of weird forms, exquisite coloring, and queer ways of life. The showing of fishes in a museum is one of the most popular as well as the most difficult of all life forms. For the brilliant colors of the tropical forms are evanescent—a few hours after the fish dies they fade out and disappear. The only way they can be shown to the public is to record the colors photographically or as descriptive notes and then paint them by hand on casts of the fishes. Nothing in nature—not even birds or butterflies—can outshine the coral fishes of the Tropics with their dazzling contrasting color patterns of crimson reds, bright yellows, rich browns, emerald greens, royal purples, blues, and whites. Of special interest for both color and form is the five-foot ribbonfish shown in the Museum. Long and narrow in the extreme, it is delicately tinted in silver

and pastel pink. A related species reaches a length of over thirty-five feet, giving it occasional newspaper publicity as a "sea serpent."

The best known of the big game fishes—marlin, tuna, sail-fishes, and sharks—are exhibited as a result of the generosity of Michael Lerner. Another game fish whose story is so full of interest as to deserve telling is the Pacific salmon. On a Smithsonian radio broadcast, in which the story of this fish was dramatized, a salmon fisherman from Alaska painted a vivid word picture of the king salmon's spawning migration:

"Just picture it, Oldtimer—just picture the sight of a twenty-pound king salmon as it starts out on its long grueling battle upstream to spawn—yes, and to die! Odd, isn't it—to travel 2,000 miles or more just to die! The salmon starts on its long journey looking as fresh and plump and shiny as a white pebble in a stream. For about three years it's been in the ocean—feeding, storing up strength and energy, its flesh a bright, healthy red. And then it gets the urge to spawn—the urge to return to the stream where it was born. How does it find its way to the same stream? How can it tell one river from another? I don't know—nobody knows. It's one of the great mysteries of nature. They call it instinct. Well, maybe so; but it's a marvelous thing to think about. It sort of makes one think a little more of this thing called nature.

"Into the mouth of the river they come, each salmon knowing exactly where he's headed for. They rest at the mouth of the river for a little while—then they start mushing for home! Upstream they head, and upstream they go, nothing stopping

them—rapids, waterfalls, streams that rush by so fast a man would be swept off his feet. But the salmon can take it! Why, I've seen 'em leap ten feet high! A flex of their bodies, a sudden straightening out, and like a flash they are above the falls! Up the river they go—up—up—up, where the streams are fast and clear and the bed of the stream is gravel instead of sand. Think of it! All this time they've been without food—weeks and weeks of fighting the strength of a river, and all without food. Why? Because as the spawning season approaches, the throat and the stomach of the salmon begin to atrophy—to waste away. The salmon shrinks and hardens and can't take nourishment. Picture it—swimming all those miles on nothing but a reserve of flesh and blood and a heart that's as big as a grizzly's!

"When the salmon reaches the spawning ground it's a different looking fish. From a shiny silver its body has become red, spotted with black and gray. The mouth of the male starts to hook. Its back arches. It looks gaunt and feverish. The female is nearly exhausted, but her work is not yet done. She scoops nests, or redds, out of the gravel, lays thousands of eggs in them —which are immediately fertilized by the male—and covers them with gravel.

"By this time Mr. and Mrs. Salmon are just about finished. It's not the spawning that kills 'em, mind you; it's the exhaustion of the trip upstream, plus the fact that their digestive systems are useless. In a day or two after the spawning they're on their sides floating downstream. Dead! Yes, dead. And that's the only time an adult salmon will go downstream, Oldtimer, because while there's a spark of life left in their bodies they'll

point their noses upstream and swim! There's a fish for you, Old-timer—a real fish, with power, with courage—with just plain guts!"

We think of fishes as purely aquatic creatures, but a few of those shown in the Museum exhibits can burrow, walk, and skip on dry land for considerable periods of time. The walking perch of southeastern Asia is renowned for its extended jaunts overland from one pond to another. It can do this because it has evolved an accessory air-breathing chamber located above its gills which enables it to travel even over dusty roads and dry grass for several hours at a time. The goby, genus *Periophthalmus,* which lives in burrows on mud flats, comes out on the surface of the mud to forage for food. There it rests on its elbow-like fins until disturbed, when by successive flips of its fins it goes skipping over the mud flats faster than a man can run.

Among the strangest of all living creatures are the fishes that can generate electricity—the electric catfishes of Africa, electric rays of tropical seas, and, most powerful of all, the electric eel of South America. This last fish, with the suggestive name of *Electrophorus electricus,* lives in the rivers of the great Amazon-Orinoco systems. On each side of its body from back of the head almost to the tail are electric glands that can generate more than 500 volts of electricity. At will the electric eel can produce a shock every few seconds with enough kick to it to fell a mule. The eel uses this strange power to knock out other fishes that it desires for food, or in some instances for its own defense.

Exhibits of smaller scope but of no less interest are main-

tained by the Divisions of Marine Invertebrates, Mollusks, and Insects. The most striking creature in the first-named category is the incredible giant crab of Japan with a span of something over twelve feet. Nearby is a large Florida spiny lobster widely used for food, although spurned by New Englanders as inferior to the clawed lobster of their colder waters.

Of the mollusks on exhibit the most conspicuous are two kinds that from their appearance one would not suspect of being related. One is the giant clam, known in scientific circles as *Tridacna gigas,* the other the giant squid. The giant clam is an innocuous seaweed-eater unless you happen to be a diver and get a foot or leg between his shells, when he may close up and hold you helpless until you drown, as has been reported to happen to native divers. The giant clam lives in the tropical waters of the Indo-Pacific region, and the one shown was brought up from forty-five feet of water in the lagoon of Bikini Atoll. Its shell is nearly 3½ feet long and weighs just short of 250 pounds. The largest specimen on record was 4½ feet long and weighed 450 pounds.

The giant squid and his cousin the giant octopus are shown as models made from living animals. They are so large they had to be suspended from the ceiling, the squid measuring forty feet in length and the octopus something over twenty feet in over-all diameter. The giant squid roams the open waters of the stormy North Atlantic, but is sometimes encountered by fishermen off the northeast coast of North America. It too is guilty of posing at times as the sea serpent of newspaper yarns. It makes a good one, for individuals have been taped—not guessed—at fifty-five feet long. The giant octopus, living

along rocky Pacific shores from California to Alaska, reaches only twenty-eight feet in maximum dimensions but is perhaps even more fearsome to behold because of his eight long writhing tentacles spotted with saucer-like suckers.

The insect exhibit, though small, is of great popular interest. In fact, when the beautiful and instructive butterfly exhibit had to be taken down recently for repairs and overhauling, it was soon made evident that butterflies had been one of the most popular of all the Museum's exhibits. As remodeled, the butterfly material illustrates the classification of these insects, their anatomy and metamorphosis, and the camouflage and mimicry by which they hope to escape their enemies. Another insect exhibit of very practical interest is that of termites. Termite nests over two feet high are shown, and more pointedly, samples of timbers that have been practically eaten away inside by termites and almost completely destroyed, all within a few hours.

Thus far we have been speaking solely of animal life. The other great division of life on this planet—that of plants—is handled under a separate department of the National Museum, the Department of Botany, also known as the United States National Herbarium. It has no public exhibits, all its specimens being in the form of pressed and dried plants attached to stiff paper, carefully labeled, and filed in herbarium cases according to the natural sequence in the great plant kingdom. It is one of the two or three largest herbaria in the world. Its plant specimens are all contained in one room—but the room is 200 feet long and 50 feet wide. This vast concourse is almost

completely filled with cases for the dried plants, only enough space being left to walk between the rows. And the cases are for the most part three tiers deep, necessitating the use of a stepladder to get to the top tier. Here you may examine almost 2,500,000 labeled specimens, but if you intend to do a thorough job by looking at one specimen every minute for eight hours every day, it will be necessary to allow fourteen years for the job.

Fortunately, the botanists who use the collections always restrict their studies to a particular group of plants, so that less time is required for their work. A very large amount of research is continually under way in the National Herbarium, both by members of its own staff and by outside investigators. The entire science of botany is based on such great collections, because every research connected in any way with plants must start with absolutely correct identification. In a recent year, in addition to the usual large number of staff members of United States Government agencies using the collections, seventy-eight out-of-town botanists carried on research studies in the herbarium.

The value of the National Herbarium is far from being purely academic. In line with the pattern of Smithsonian work, its own researches are in the nature of basic investigations, it is true, but its identifications and other botanical assistance to other agencies and individuals are practical in the extreme. During the late war and after, the Herbarium was the chief source of reliable information on the kinds and geographic occurrence of plants of great economic importance. These in-

clude plants that produce substances of obvious usefulness to all of us, such as quinine and other drugs, insecticides, rubber, cordage, essential oils, food, and clothing materials.

The Herbarium assists the F. B. I. on occasion in crime detection. Seeds or fragments of leaves or twigs are sometimes found on the clothing of crime suspects. These are brought in for identification and comparison with plants found growing at the scene of the crime. In this way, particularly if the plants are of rare occurrence or very local in their distribution, corroborative evidence may be found that indicates the presence of the suspect at a certain place. Assistance through plant identifications is frequently given to foreign governments, particularly in Latin America, where new means of transportation are throwing open the doors to previously unexplored regions. They wish to know exactly what the plants are that grow in these regions and which ones may be useful to their people.

As the value of a plant collection depends primarily on the correctness of the identifications, botanists on the National Herbarium's staff are continually revising or reclassifying genera and families of plants. In addition each staff scientist gives special attention to one or more plant families with the aim of publishing a monographic study of those particular groups. An essential adjunct of such studies is field exploration, and Smithsonian botanists have wandered far over little-explored parts of South and Central America, Mexico, and the West Indies.

The explorations take the scientists into all sorts of odd corners of the earth, as for example a weird valley in the high

Index

Ward, Herbert, African collection, 89-92

Warner, Mrs. Worcester R., 46

Washington, D.C., prediction of temperatures for, 170

Washington, George, 19, 126, 127, 128

Washington, Mrs. George, 128, 131

Washington relics, 128

Water craft, American, 110

Weather forecasting, long-range, 169-172

Webb, J. Watson, 55

Webb, William H., 107

Wells, H. G., 275

Wenley, Mr. A. G., 246

Wetmore, Secretary Alexander, 59, 60, 263, 264, 296

Whales, 58

Whistler, James McNeill, 247, 251

"White Indians" of Panama, 205

Widener collection, National Gallery of Art, 254

Wilkes, Lt. Charles, 29

Will, Smithson's, 17, 18, 19

Wimperis, H. E., 273, 274

Winnie Mae, Wiley Post's, 143

Winthrop, Governor Robert C., 129

Worch, Hugo, 96

"World Is Yours, The," Smithsonian radio program, 267-270

World Weather Records, Smithsonian, 263

Wright Brothers, 271, 288

Wright "Kitty Hawk" plane of 1903, 143, 144, 145-149, 152, 288

Yangtze Valley, China, expedition to, 207-209

Yukon, Alaska, expedition along the length of, 211

Zimmer, Louis, 111

Zoological Park, National, 221-238

Index

Smithson, James, 13, 14, 16, 17, 18, 19, 20, 21, 22, 23, 26, 29, 51, 255, 257, 258, 298
Smithsonian Building, 23
Smithsonian Park, the, 23, 99
Snake Society, African, 231, 232
Snakes, 62
Snodgrass, studies of insect anatomy by, 263
Social Anthropology, Institute of, 97
Solar constant of radiation, 163, 166
Solar cooker, 175, 176
Solar energy, use of, 175, 176
Solar flash boiler, 176
Somers, Captain Richard, 126
Spanish conquistadores, 181
Spad, General Billy Mitchell's, 143
Spirit of St. Louis, 143, 153-155, 288
Sponges, 50
Squid, giant, 67
Stamps, 138-140
Stanley Indian paintings, 239, 240
Star Spangled Banner, 121, 122
Statue of Freedom, 141
Statuettes, bronze, of American leaders during World War II, 134, 135
Steam engine, oldest American-built, 106
Steamboat, development of the, 108
Stevens, John, 106, 108
Steward, Dr. Julian H., 193
Stewart, Dr. T. Dale, 80, 81
Stirling, Dr. M. W., 97, 188, 218, 219, 220
Stone Age, 79, 86
Stone, Chief Justice Harlan F., 293
Stone figures, giant, Easter Island, 94, 95
Stradivarius violins, 96, 97
Stringfellow, Henson and, 151
Strong, Dr. Duncan, 217
Study collections, National Museum, 30
Study series, geology, 48
Sumatra, National Zoo expedition to, 229-231
Sun, our knowledge of, 165
Sun, study of the, 161-177
Sun-power plants, possibilities of, 176
Sunspots, 165, 166
Supplies, Smithsonian, 291, 292

Survival Manual prepared by Smithsonian, 286
Swanton, Dr. John R., 211
Swords, historical, 124
Szechwan Province, China, expedition to, 209, 210

Tables, Smithsonian volumes of, 263
Telephone, Bell, 104
Tepexpan Man, 82
Termite exhibit, 68
Tewa Indians, 179
Textiles, 112
Thayer, Abbott Handerson, 244
Thimonnier, Barthelemy, 113, 115
Tibet, expedition to, 205-207
Time-keeping devices, 111
Tomb of James Smithson, 23
Topa Inca, Inca emperor, 196
Trilobites, 35
Truman, President Harry S., 279, 293
Ts'aidam, Mongolia, description of, 206
Tule Indians of Panama, 205
Turtles, 62
Type specimens, 73

Ultraviolet rays, 174
United States National Museum, 23, 24, 25, 29
Uranium, 43, 44

Vandalism, minor, at the Smithsonian, 280
Vesuvius, Mt., 39
Violins, Stradivarius, 96, 97
Viruses, 174, 175
Visitors to the National Zoological Park, 224
Visitors to Smithsonian buildings, 287-289
Volcanoes, 39

Walcott, Secretary Charles D., 35, 56, 263, 297
Walker, Ernest P., 233, 236, 237
Walker, Mrs. Ernest P., 236
War Background Studies, Smithsonian, 284
War work, Smithsonian, 283-287
Ward, Herbert, 90, 91, 92

305

Index

Patent Office models, 29
Peacock Room, Whistler's, 247
Pélee, Mt., 40
Peopling of America, 182
Percy, Lord, 14
Pershing, General John J., 133
Persian manuscripts, Freer Gallery of Art, 249, 250
"Petrified" logs, 39
Philatelic Collection, National, 138-140
Photosynthesis, 172
Physical anthropology, curator of, 80
Piano collection, 96
Pickersgill, Mary Young, 122
Plant identifications, 70
Plants, 68-71
Plants, fossil, 38
Polar Star, Lincoln Ellsworth's, 143, 155-158
Polk, President James K., 22, 293, 296
Pompeii, 39, 40
Pope, John Russell, 252
Population of the National Zoological Park, 233
Post, Wiley, 143
Postal stationery, 140
Powell, Major John W., 184-186
Preble, Commodore Edward, 125
Prehistoric Indian sites, 199-201
Proceedings of the National Museum, 264
Procter, John Clagett, 294, 295
Publications, Smithsonian, 257-265
Puerto Rican deep, expedition to, 217, 218
Purchase of Alaska, Smithsonian part in, 213, 215

Questions on scientific subjects, 266

Racial groups, 82-85
Radar contact with moon, 105
Radiation and Organisms, Division of, 172, 174
Radio programs, Smithsonian, 267-270
Randall, Ben., 129
Rarities in the stamp collection, 139, 140

Religion, Inca, 197
Religion, science and, 35
Renwick, James, Jr., 23
Reptiles and amphibians, 62
Research, anthropological, 97, 98
Research, basic, value of, 177
Research, botanical, 69, 70
Research, geological, 48, 49, 50
Research, National Museum, 72-74
Rhinos, search for in Africa, 227-229
River Basin Surveys, 199-201
Roads, Inca, 196, 197
Roberts, Dr. Frank H. H., Jr., 199, 200, 201
Rocket research, Goddard's, 258-261
Rockhill, W. W., 205, 206, 207
Rocks, kinds of, 39
Romero, Dr. Xavier, 82
Roosevelt African groups, 54, 55
Roosevelt, President Franklin D., 251
Roosevelt, President Theodore, 54, 55, 226, 245
Rosenwald, Lessing J., collection, National Gallery of Art, 254
Rosetta Stone, 88
Royal Society of London, 15, 19
Rumsey, James, 108
Rush, Richard, 21, 22
Ryder, Albert Pinkham, 244

Safety pin, invention of, 114
St. Pierre, 40
Saint, Thomas, 113
St. Vincent, 71
Salmon, Pacific, spawning migration of, 64, 65, 66
San Blas Indians of Panama, 205
Science and religion, 35
Schmitt, Dr. Waldo L., 210, 215, 216, 217
Schultz, Dr. Leonard P., 217
"Sea serpent," 38
Secretary, the Smithsonian, 22
Setzler, Frank M., 97, 211
Sewing machine, the, 112-116
Sheep, bighorn, 56, 57
Ships, 106-110
Singer, Isaac M., 115
Skulls, human, 80
Smithson, Sir Hugh, 13, 14

304

Index

Maintenance and repair, Smithsonian, 289-291

Mammal groups, 58

Mammal Halls, 54-58, 282

Mammals, researches on, 73

Mankind, evolution of, 77-79

Mann, Dr. William M., 225, 227, 230, 231

Mann, Mrs. W. M., 231, 232

Manning, Mrs. Catherine L., 140

Marine Invertebrates, Division of, 67, 74

Marsh, Mr. R. O., 204, 205

Maya, 181

Mechanical elements, basic, 105, 106

Medicine and Public Health, Division of, 102, 110, 116

Medicine Creek Reservoir, Nebraska, prehistoric Indian sites in, 201

Mellon, Andrew W., art collection, 241, 251, 252, 253

Merrill, Dr. George P., 45

Meteor Crater, Arizona, 48

Meteorites, 46, 47, 48, 50

Meteors, 47

Métraux, Dr. Alfred, 93, 95

Michea, J. T., 66

Michel, A. Eugene, 140

Microphone, early, 104

Miller, Mr. Robert R., 11

Mineral collection, 42

Mineralogy, Division of, 50

Minerals and Gems, Hall of, 42

Minerals, identification of, 50

Miscellaneous Collections, Smithsonian, 263, 264

Mitchell, General Billy, 143

Mollusks, Division of, 67, 74

Mongolfier Brothers, 150

Moon, radar contact with, 105

Moore, John, 147

Moose group, 55, 56, 57

Morrow, Governor J. J., 71

Morse, Samuel, 103

Morse telegraph, 103

Mount Montzeuma, Chile, solar observing station on, 166, 167, 169

Mt. Vernon, 126, 127

Mummy, Egyptian, 86-88, 281

Musical instruments, 95, 96, 97

Mynah, Javanese, 225

Mystery stories, Museum setting for, 281

Narwhal, 58

National Air Museum, 144, 158

National Collection of Fine Arts, 241, 242-245, 279

National Gallery of Art, 240, 241, 242, 251-254

National Geographic Society, co-sponsor of Arnhem Land expedition, 211

National Geographic Society, sponsor of expedition to Sumatra, 229

National Herbarium, United States, 68-70

National Museum, United States, 23, 24, 25, 29

National Museum, departments of, 29

National Museum, researches, 72-74

National Museum, study collections, 30

National Zoological Park, 221-238

Natural History Building, 24

Neolithic, 86

Nests, birds', 61

News Releases, Smithsonian, 265, 266

Northwest Coast Indians, 179

Numismatic Collection, National, 135-138

Observing stations, solar, 169

Occasional Papers of the Freer Gallery of Art, 264

Octopus, giant, 67

Oil geology, 34

Oriental art, 246-251

Oriental Studies of the Freer Gallery of Art, 264

Orteig, Raymond, 153

Pachacuti, Inca emperor, 195, 196

Packet ships, 106, 107

Page, Thornton, 30

Paleogeography, 48

Paleolithic, 79, 86

Panama, Isthmus of Darien, expedition to, 204, 205

Paper money, 137, 138

Parícutin volcano, Mexico, 41, 42

Passenger pigeon, 60

Index

Henson and Stringfellow, 151
Hewitt, Dr. J. N. B., 190, 192
Historic American Merchant Marine Survey, 110
Historical collections, 123
History, Department of, 123
Hollick-Kenyon, 156
Holmes, Dr. W. H., 90
Homo sapiens, 79
Honduras, Beaches of the Dead, expedition to, 217
Hood, Thomas, poem by, 112, 113
Hopi snake dance, 82-84
Howe, Elias, Jr., 114, 115
Hoy, Charles M., 207, 208, 209
Hrdlička, Dr. Aleš, 211
Hungerford, Henry James, 17
Hunt, Walter, 114, 115
Hutcheson, Dr. John A., 177

Inca, 181, 195-198
Incorporation, Act of, 22
Index of American Design, 254
Indian groups, 82
Indian specimens, 85
Indians, American, 179-201
Indians, American, origin and history of, 182, 183
Indians, Handbook of South American, 262
Insect damage, protection against, 292
Insect exhibit, 68
Insects, Division of, 67, 73
Institute of Social Anthropology, 97
Instruments for measuring solar radiation, 167
International Exchange Service, 265
Inventions, American, 103
Invertebrate life forms, evolution of, 34
Invertebrate Paleontology and Paleobotany, Division of, 49
Iroquois Indians, 179, 187, 190-192
Island universes, 164

Jackson, H. Nelson, 101
Jackson, President, 20
Jefferson, Thomas, 96, 128, 129
Jeffries and Blanchard, 150
Jivaro Indians of Ecuador, 187-190, 219, 220

John Bull locomotive, oldest in America, 117
Johnson, Mr. David H., 211
Johnson, Mr. Eldridge R., 217
Johnson, Ralph Cross, art collection, 241, 243
Johnston, Mrs. Harriet Lane, 240, 242
Johnston, Henry Eliot, 132
Johnston, Captain John, 107
Joseph Conrad, ship used on West Indies expedition, 215
Jungle researches, 72

Kalish, Max, 134
Kea, 59
Kennicott, Robert, 214
Kensington Stone, 92, 93
Key, Francis Scott, 121, 122
Kiplinger, W. M., 134
"Kitty Hawk" plane, 143, 144, 145-149, 152, 288
Kress collection, National Gallery of Art, 253, 254
Kress, Samuel H., 253
Kuei-hua Ch'eng, Mongolia, description of, 205, 206

Lane, Harriet, 132
Langley, Secretary Samuel P., 38, 151, 152, 162, 166, 221, 222, 225, 297
Languages, American Indian, 186
Largest land creatures, 37
Last shot of World War I, 133
Lawrence, E. O., 274
League of nations, Iroquois, 190-192
Lewton, Dr. Frederick L., 113
Liberia, Zoo expedition to, 231, 232
Library, Smithsonian, 266
Life, 53
Life, nature of, 174
Lincoln, Abraham, 132
Lindbergh, Charles A., 143, 153-155, 288
Living Hall of Washington, 1944, The, 134, 135
Lizards, 62
Lodge, Mr. John E., 246
Lowe, Thaddeus, 150

Macie, Elizabeth Keate, 13

302

Index

Index

Board of Regents, the Smithsonian, 22
Boat Hall, 106-110
"Book of the Dead," Egyptian, 88
Botanical field exploration, 70, 71
Botanical research, 69, 70
Botany, Department of, 68
Bronze mirrors, Chinese, 249
Bronzes, Chinese, 247-249
Brown, Miss Margaret W., 131
Brown, W. L., 55, 56, 57
Buchanan, President James, 240, 242, 243, 289
Buffalo, 221, 222, 223
"Buffalo Bill" Cody, 223
Building, Smithsonian, 23
Bulletins of the Bureau of American Ethnology, 264
Bulletins of the National Museum, 264
Bureau of American Ethnology, 97, 186; publications of, 198
Bureaus, Smithsonian, 26
Butterfly exhibit, 68
Byrd, Admiral, 156, 158, 223

California gold rush, 43
Cambrian geology, 35
Canal Zone Biological Area, 71, 72
Care of captive animals, 237, 238
Caribou group, 55, 56, 57
Caroline, yacht used on Puerto Rican deep expedition, 217
Carruth, poem by, 36
Cayley, Sir George, 150
Cell growth, study of mechanics of, 174
Centennial, Smithsonian, 292-294
Chemistry, Smithson's views on, 16
Chinese paintings, Freer Gallery of Art, 250
Choco Indians of Panama, 204
Chrysler African Expedition, 227-229
Chrysler, Walter P., 227
Clam, giant, 67
Clermont, the, 108
Clipper ships, 107
Cody, "Buffalo Bill," 223
Coins, 135-138
Coins of Bible days, 89
Collections, National Museum, 25
Collins, Dr. Henry B., Jr., 266

Colorado River, first journey down, 184-186
Columbia River Basin, prehistoric Indian sites in, 200
Compton, Karl T., 172
Congo native life, specimens representing, 91
Contributions from the National Herbarium, 264
Coolidge, Joseph Jr., 129
Copán, Honduras, expedition to, 218
Cornerstone of Smithsonian Building, 294-296
Costume Hall, 130
Crafts and Industries, Division of, 102
Crawford, Thomas, 141
Crete, Smithsonian radio program on, 267-270
Crocodiles, alligators and, 63
Crystal ball, world's largest, 46, 281
Cunas Bravos of Panama, 204, 205
Cushman, Joseph A., 34

Dale, Chester, collection, National Gallery of Art, 254
da Vinci, Leonardo, 149
Decatur, Commodore Stephen, 124, 125, 126
Deganawida, Iroquois statesman, 191
Deignan, Mr. Herbert G., 211, 218
Design, Index of American, 254
Desk on which Jefferson wrote Declaration of Independence, 128, 129, 130
Desoto, expedition to trace route of, 211
Diamonds, world's largest, 46
Diffusion of knowledge, Smithsonian, 257
Dinosaurs, 36, 37, 38
Djigonsasen, Iroquois stateswoman, 191
Doy Chiengdao, Siam, expedition to, 218
Doyle, Conan, 71
Dresses of First Ladies of the White House, 130-132

Early Birds, 149
Earth, origin of, 30, 31; history of, 31, 32

Index

299

knowledge dropped from the hand of James Smithson, and have made of the institution he founded in very truth "an establishment for the increase and diffusion of knowledge among men."

which is named the henry in his honor, and magneto-electricity, the principle on which are based all modern electric motors."

At the Smithsonian Professor Henry inaugurated among other projects a pioneering weather program, receiving daily reports via the newly established telegraph system from widely scattered parts of the country. From these reports he constructed daily weather maps as early as 1850, and by 1857 he was furnishing advance weather indications to the Washington *Star*, which thereafter carried them every day. This meteorological service with its system of volunteer observers formed the basis for the present U. S. Weather Bureau.

Professor Henry in 1850 appointed as Assistant Secretary Spencer Fullerton Baird, a noted authority in the field of natural history. Between the two of them, many new lines of scientific work were started at the Smithsonian, and they saw to it that the great number of western exploring expeditions going out around the middle of that century were equipped with men and apparatus to make scientific observations and collections. Later Baird was responsible for the creation and direction of the U. S. Fish Commission, now incorporated into the Fish and Wildlife Service of the Department of the Interior.

The other four Secretaries of the Smithsonian—Langley, Walcott, Abbot, and Wetmore—have all been mentioned before at appropriate points in this book. These six men have for more than a century guided the increasingly complex activities of the Institution. All men of high integrity and international scientific reputation, they have carried forward the torch of

port of the United States official who received James Smithson's legacy, and a medal inscribed with a portrait of Smithson. The president who took part in this imposing ceremony was James K. Polk.

When the building was completed about 1855, Professor Joseph Henry, the first Secretary of the Institution, moved into living quarters in the east wing with his family and lived there until his death in 1878. He must have felt indeed like the lord of a manor, the sole occupant of this 500-foot-long stone castle rising in lonely grandeur on the otherwise unoccupied Mall area. The only family now living in the Smithsonian Building is a family of owls who occupy one of the towers. They are guaranteed sanctuary by the present Secretary, Dr. Alexander Wetmore, a world-renowned authority on birds.

When the first Board of Regents selected Joseph Henry as the first Secretary, they could not have made a wiser choice. His plan for carrying out Smithson's expressed purpose in bequeathing his fortune to the United States was so wise and far-seeing that it is still in operation today. Henry himself had been a brilliant research worker and was fully in sympathy with James Smithson's ideals. As stated in the Smithsonian's centennial publication:

"He improved the electromagnet from a useless toy to a powerful instrument capable of lifting 3,500 pounds. Through discovery of the intensity magnet, Henry in 1829 or 1830 succeeded in ringing bell signals at a distance of 8,000 feet; later this discovery facilitated the development of the telegraph. He also discovered the principles of self-induction, the unit of

sonian cornerstone—are placed in the northeast corner, but this cannot be taken as final because, as Mr. Proctor points out, the north wing of the Capitol Building has its cornerstone— laid under the same auspices—in the southeast corner. So it is likely that the location will never be known until the building is torn down, which it is hoped will be in the far distant future. The Smithsonian brownstone castle-like structure on the Mall is one of the few large edifices in Washington to diverge from the usual classic architecture of the Federal buildings. Although a few objections to this marked divergence have been heard, yet it is definitely refreshing to most people to glimpse across the Mall this authentic Norman castle with its lofty towers, small-paned, narrow windows, and its time-mellowed, creeper-covered stone walls.

The cornerstone-laying ceremony took on the dignity of a great national event through the eminence of those taking part in it. The gala affair was described thus by the National Intelligencer:

"The column (which included Masonic lodges of the District, Maryland, and Pennsylvania, accompanied by three bands) moved down Four-and-a-half Street to Pennsylvania Avenue . . . up Eleventh Street to F, and thence on F to the presidential mansion, where the President, heads of departments, diplomatic corps, etc., were received into the line. The entire column then moved to Pennsylvania Avenue and Twelfth Street to the site of the Smithsonian Institution."

Some of the items deposited in the cornerstone were gold and silver United States coins, the New Testament, copies of the Constitution and the Declaration of Independence, re-

zeal in the increase of the sum total of man's knowledge. The Smithsonian should continue to strive toward the end that man should not only know better his earthly abode, but should acquire the means of knowing himself better. Such studies are of vital significance in our present efforts to build a better world order, and to break the cycle of recurring wars of ever-increasing destructiveness.

"On this one-hundredth anniversary of the founding of the Smithsonian Institution, may we accord all honor to the founder, James Smithson, for his lofty and far-seeing ideals. May the next one hundred years bring even more glory to the name of the Institution and to that of its founder."

The event was also widely noted abroad. The extent of foreign coverage is not known, but actual clippings were received at the Institution from journals or newspapers published in Canada, Mexico, the Dominican Republic, Argentina, Belgium, Holland, England, France, Russia, and New Zealand. It is doubtful if many institutional birthdays have had more words written about them throughout the world than did the Smithsonian's one-hundredth.

At the time of the Centennial celebration, a further unsuccessful effort was made to locate the cornerstone of the original Smithsonian Building. A great ceremony marked its formal laying on May 1, 1847, but someone neglected to make a record of which corner of the building it occupied. According to the Washington historian John Clagett Proctor, the east end of the building was completed first and would therefore suggest itself as the proper end to search for the cornerstone. Today, cornerstones laid under Masonic auspices—as was the Smith-

ried feature articles on the Smithsonian Centennial, and radio commentators announced it on their news broadcasts. A convocation was held at the Institution attended by high Government officials and the country's leading scientists. A reception followed for a thousand distinguished guests, with music by the United States Navy Orchestra. At the suggestion of Chief Justice Harlan F. Stone and with the approval of President Truman a Smithsonian Centennial 3-cent United States postage stamp was issued. Later this was selected by a leading artist and stamp expert as one of the ten best commemorative stamps ever issued.

The public announcement by President Truman read in part as follows:

"On August 10, 1846, James K. Polk, eleventh President of the United States, put his signature on the Act of Congress establishing the Smithsonian Institution. Today, August 10, 1946, we celebrate the one-hundredth anniversary of this venerable organization that is an American tradition.

"As Presiding Officer of the Institution, it is fitting that I, as President of the United States, should publicly take cognizance of this occasion.

"For a full century the Smithsonian Institution has been a world center for the promotion of science, art, and other cultural activities. Congratulations are in order upon the Smithsonian's record in the advancement of science and culture during a most important century in the history of mankind, but this should not be merely a time for counting laurels. Rather it should be a time for further consideration of the ideals of the founder, James Smithson, and a renewal of the Institution's

butterfly and other nets, surgical and dental instruments, cameras and lenses, silver disks purchased from the U. S. Mint for use in building radiation-recording instruments, special cements and glues for model making and diorama building, heating oil and washing machines for mountain-top solar observing stations, and artist's colors and brushes. One of the most unusual recent requisitions was a wing jack for a B-29 Flying Fortress, needed by the National Air Museum.

An important feature of the proper safeguarding of valuable museum collections is protection against insect damage. Such vulnerable materials as animal skins, plant specimens, cloth of any kind, historical furniture, and similar things are quarantined in a fumigating room immediately upon receipt from collectors or donors. Here they are kept for 20 hours in contact with a gas formed by a mixture of ethylene dichloride and carbon tetrachloride, which penetrates even into sealed packages, killing any form of insect life that might be present.

Specimens on exhibition or in the study collections are periodically given the fumigation room treatment, and as an additional precaution, a mixture of paradichlorobenzine and naphthalene in crystal or flake form is kept in containers within the storage or exhibition cases.

In August 1946 the Smithsonian celebrated its one-hundredth birthday, and the event aroused great national interest. The President of the United States issued a public statement announcing the event and complimenting the Institution on its long and honorable record in achieving the increase and diffusion of knowledge for the benefit of all mankind. Newspapers throughout the country and all the leading magazines car-

estimated that about 50 percent of the sash and frames need replacing, posing a monumental job for the mechanical force, most of it hand work.

The purchasing, handling, and storing of supplies for an institution of such unusual and varied interests are no minor matters. The Smithsonian staff includes more than a hundred scientists in dozens of different research specialties, and many of them make frequent field trips in connection with their work. These trips usually lead to isolated localities where nothing can be purchased, so that the field kits carried must contain everything that might be needed. Some of the items that appear in field kits are whale harpoons, deep-sea dredges, nets of fine silk for collecting microscopic sea life, sonic equipment for ocean depth determination, containers of alcohol for preserving specimens, needles and thread, dissecting instruments, chemicals, portable stoves, cooking utensils, lanterns, tents, folding cots and chairs, machetes, guns and rifles, medicines and first-aid supplies, pencils, pens, ink, and labels.

The ammunition furnished for collectors' guns and rifles includes not only standard factory-loaded items, but also specially loaded shells for collecting hummingbirds and even some insect specimens. Dragonflies and certain tropical moths are obtained by shooting them with very fine dust shot.

Supplies purchased each year for the Smithsonian and all its bureaus average around 3,200 different items. Besides the usual office equipment, stationery, and supplies, this total includes pins and needles of all types for specimen work, chemicals both common and rare, special mounting cardboards and papers, modeling tools, microscopes, microtomes, harpoons,

dinary procedures used in homes or office buildings. To clean the other two-thirds, scaffolding or extension ladders must be used, which means, of course, that this large fraction is seldom cleaned, to the annoyance of the office staff and the embarrassment of the whole Institution.

Another unusual problem concerned with glass is the vast amount of it appearing in exhibition cases in the public halls which should be kept clean. The total amount of such glass in the three buildings adds up to 215,600 square feet, or just about five acres. With the relatively small cleaning force that can be provided, this is a staggering amount of surface to keep clean, especially in view of the fact that tanned or treated animal and bird specimens and painted figures and other accessories produce a chemical reaction that fogs or discolors the glass.

The original Smithsonian Building is constructed of Seneca sandstone, which has a marked tendency because of the softness of the stone to shale off or shed layers of stone. The exterior of the entire building must be inspected frequently so that any loose layers may be removed before they create a hazard to passers-by. Numerous ornaments of this same stone were placed on the towers and gables of the building; these were recently found to be badly weather-worn, constituting a distinct danger to people below, and had to be replaced by copper replicas. The very unusual wooden window sash and frames in the Smithsonian Building also create a major problem for the Superintendent. All the large windows, some of them 15 feet high, in keeping with the Norman architecture have diamond-shaped window panes about 6″ x 6″ in size. At the present time it is

lin's costumes" that he wore in making his famous comedies. As a matter of fact, great as are the collections on exhibition in the National Museum, just as many things have been refused as have been accepted.

Guards are often asked for "the perpetual motion machine" and for the "Betsy Ross flag," undoubtedly confusing this with the original Star Spangled Banner, which hangs in a glass case on a wall in the Arts and Industries Building. During the acute nylon shortage, guides on sightseeing buses had their little joke in the form of offering a pair of nylon stockings to the sightseer who came back from the Museum with the best description of President Buchanan's wife's dress. The catch, of course, was that Buchanan was a bachelor president, his niece Harriet Lane Johnston acting as White House hostess during his administration. Somewhat confused were two well-dressed college girls who asked the information desk one morning, "Where do we find the stuffed Indians?" They backed away sheepishly when it was explained that museums did not stuff and mount skins of human beings—that the realistic Indian groups were actually sculptured figures.

Problems of maintenance, repair, and cleaning are common to all large public buildings, but at the Smithsonian they take on serious proportions because of the age and unusual architecture of its buildings and the very large numbers of visitors. Architects of previous generations were inclined to give more weight to monumental and pleasing design than to practical aspects of maintenance and operation. For example, in the three main buildings of the Smithsonian group on the Mall, less than one-third of the windows can be cleaned by the or-

of the list of visitor attractions in Washington. License plates from every State can be checked among the cars parked near the Smithsonian buildings, and during spring vacations long lines of buses bringing school children to Washington from as far away as Maine, Texas, and California practically stop traffic around the Smithsonian. At such times the entrances to the various buildings have all the earmarks of a riot. The predominance of school buses emphasizes the educational importance of museum exhibits.

The number one question asked of the guards for a whole generation has been, "Where is the Lindbergh plane?" A related question that enters the minds of the majority of visitors looking at the plane is, "How did he see out?" And the answer is—he didn't, except through a periscope installed over the pilot's seat. This added difficulty of seeing where he was going makes Lindbergh's trans-ocean flight even more amazing. More recently, the Wright Brothers' "Kitty Hawk" plane since its installation in the National Museum shares public attention with the *Spirit of St. Louis.*

Some of the inquiries by visitors indicate that most people do not read newspaper articles very carefully. Many visitors ask to see the "plane that dropped the bomb on Hiroshima"; they have read that it was a gift to the Smithsonian but did not read far enough to learn that it is stored for the present in a warehouse at Park Ridge, near Chicago, along with other aircraft awaiting the erection of a building in Washington for the new National Air Museum. Movie-minded visitors want to be shown "Mary Pickford's curls," having read somewhere that they had been offered to the Smithsonian; also "Charlie Chap-

nian Building. On tours of duty during air-raid drills he had ample time to reflect on the extreme changes in methods of warfare since the days of the twelfth-century Norman castles after which the building is modeled. In those days armored henchmen of the lord of the castle poured molten lead on would-be invaders on the ground below. In our more civilized times, warplanes flying high overhead shower incendiary bombs on whatever buildings happen to get in the way—private homes, schools, and hospitals.

Besides assisting in the American offensive on two fronts, the Smithsonian staff is proud to feel that it most certainly saved the lives of many Americans through its continuous aid in the prevention of deadly diseases and through the furnishing of survival information for military personnel in completely strange localities.

The total number of visitors who have entered the doors of the Smithsonian buildings is almost incredible. The guards at the entrances punch a recording device for each visitor who comes in. Each day's totals are turned in to the captain of the guard, and the total for each year is published in the annual report of the Institution. An actual tabulation of these yearly counts from 1855, the year the original Smithsonian Building was completed, to 1950 shows a grand total of 66,711,817 visitors. This figure is almost half the entire population of the United States today.

Just as the Smithsonian shows a cross-section of the universe, so do its visitors represent a complete cross-section of America. They are all the people from all the States who come to see the Nation's capital. The Smithsonian stands very near the top

plants of the Pacific war area, on shipworm problems, on poisonous fishes and the distribution of sharks, and mollusks which serve as intermediate hosts for the deadly Oriental parasites that constituted a menace to our troops.

Some other requests were for methods of distinguishing physical features of Japanese and Chinese for use in a pamphlet to be used by American troops; for identification of Oriental rats; for a report on what should be a fishing kit for life rafts; for precise information on the poisonous snakes of New Guinea and other neighboring Pacific islands; and for a report on means of subsistence for downed aviators in China and Mongolia. A survival manual printed in millions of copies by the Navy was prepared almost entirely by Smithsonian scientists.

These are merely scattered examples to show the wide variety of subjects on which the Smithsonian was consulted many times daily. Some calls were of great urgency, and many staff members devoted their entire time to furnishing information and detailed reports to the military. Close to the nerve centers of war strategy and the high command in Washington, the Smithsonian proved to be a vital factor in producing essential and hard to find data relating to a theater of war previously little known to most Americans.

Like other organizations in strategic cities, the Smithsonian had to set up a plan of action in the event of bombing raids on Washington. Many tons of irreplaceable scientific and historical material were trucked to a distant locality in the Virginia mountains, and the staff was organized into air-raid wardens, patrols, and fire-watchers. The present author was for a time a fire-watcher in an upper story of the old Smithso-

the field of Oriental art and letters, was intrusted with the unique job of translating captured Japanese documents, which its experts did to the extent of hundreds of pages. They also transliterated into English the place names on Chinese maps used by the Army.

The Smithsonian recorded nearly 3,000 calls for special information from the military services and war agencies. Many of the localities asked about were ahead of the actual fighting in progress in the Pacific, and it was often apparent where future actions were to occur. The records of all requests were for this reason kept constantly under lock and key, for many of them could have furnished invaluable clues to foreign agents.

The requests came from the Army, the Navy, and the war agencies in about equal numbers. They covered every conceivable subject related in any way to science, engineering, and industry. Some were of a surprising nature, but the great majority were right in line with the Smithsonian's accumulation of specialized knowledge in many technical fields.

The Anthropology Laboratory was asked to make busts of an "average" youth around 19 years of age for use in designing aviator's equipment. One of the oddest requests was one addressed to the Institution's Astrophysical Observatory, asking for full data on the relative intensities of moonlight and twilight. The Curator of Physical Anthropology was asked for an exposition of the scientific concept of race with which to combat the fallacious Axis propaganda as to the superiority of certain "races."

On some important subjects numerous conferences were held at the Institution, as for example, on poisonous and edible

finally stopped altogether, except for investigations with a direct war bearing. Hundreds of requests had a direct connection with actual fighting on the front lines, and much vital information was given that could have been quickly obtained nowhere else.

Perhaps never before had the immediate practical usefulness of apparently academic studies been so clearly demonstrated. The Navy wanted to know the customs and religion of natives on obscure Pacific islands, what they ate for breakfast and what their taboos prohibited, so that they might not be offended by American sailors. The Army wanted the immediate identification of mosquitoes, so that the Medical Corps men could recognize disease carriers, for diseases can stop an army quicker than bullets can. Smithsonian mineralogists were south of the border looking for strategic minerals, the usual Smithsonian publications were abandoned in favor of a series of War Background studies that were used by the hundreds of thousands by Army and Navy for orientation courses. The Institution sponsored and took a leading part in an agency which carded the American experts on peoples and areas of the entire world, putting the country's knowledge at the Army's fingertips.

Another equally important activity, though less directly war-connected, was the improvement of cultural relations with our neighbors in the other American republics. Their help and good-will were of very real concern to our successful prosecution of the war, and the Smithsonian was peculiarly well-fitted to work with them because of the long years of friendly association with Latin-American scientists and cultural organizations.

The Freer Gallery of Art, because of its long years of study in

other like organizations, has been called upon to aid in the Nation's defense. America is a peace-loving nation; she has never waged a war of aggression. But the world has learned that this attitude is far from being a sign of weakness. In two world wars America has been forced to gird for battle by aggressor nations with a mad lust for conquest. Twice she has fooled these aggressors with miracles of production and a fighting spirit that has turned the tide of victory to the forces of democracy. The victory has been due in large part to the complete cooperation of every segment of the nation. In World War I, and even in the Civil War, the Smithsonian rendered noteworthy service, but in World War II, literally a war of science, the Institution assumed a really prominent part.

Most people interested in the Smithsonian took it for granted that during the second World War it would go on about as usual, perhaps on a reduced scale because of war restrictions. This is quite the reverse of what actually happened, however. It did keep open its museum and art gallery exhibits—in fact the number of hours they were accessible to the public was even increased, because it was recognized that such things are necessary outlets for both service personnel and civilians working under strain. But nearly all other Smithsonian operations were either suspended or reduced to an essential minimum in favor of war work.

Telephones started ringing insistently all over the Institution even before Pearl Harbor, and the calls for urgent information from Army, Navy, and civilian war agencies increased rapidly and steadily as the war progressed. Normal research work, field exploration, and publications gradually diminished and

—yet as we stare at the 3000-year-old mummy half in the shadows, was that a slight movement or a trick of the cross-reflections from the forest of glass cases?

We hasten on into the mammal hall, where the exhibits are surely dead, with no reservations. The giant gorilla, however, staring straight toward us with mouth open and teeth bared, recalls to memory a horror story read somewhere of the museum curator who had a caged gorilla, intended for the zoo, brought into his laboratory for a few days' study. Having brought his fiancée to see the great beast after museum hours, he steps into a nearby room to answer an insistent phone. The girl approaches the cage to get a better look at the gorilla. A lightning thrust of an incredibly long arm, and she is pulled helpless and screaming against the cage bars. But our hero, the curator, rushes into the room, quickly thrusts some of the gorilla's favorite food into the other corner of the cage, and just in time the beast drops the girl in favor of the nourishment.

Such yarns, in the realm of imaginative entertainment literature, are purely incidental by-products resulting from the nature of museum exhibits. The National Museum has, however, furnished the sound basis for many a serious feature story in magazines and newspapers. The very wide range of specimens exhibited and studied provides material for interesting and educational articles that fall into line with Smithsonian diffusion of knowledge.

An academic organization such as the Smithsonian, devoted to the advancement of science and the arts, cannot readily be associated in the mind with the ruthless destructiveness of war. Yet twice in this century the Institution, together with

forms on the walls and it is easy then to see why fiction writers like a museum as a setting for mystery stories. In the eerie silence, fantastic monsters of a hundred million years ago stare vacantly into space; hideous stone idols who have presided over countless human sacrifices are still grinning over what they have seen. In the limpid depths of the world's largest flawless crystal ball, shimmering shadows and reflections form pictures that might be of the past or of the future; imprisoned in that perfect sphere lie some of the secrets of our earth's creation through the reshuffling of atoms in the glowing cauldron of the sun's interior and in the tenuous vapor and infinite cold of outer space.

On an after-hours tour through the exhibition ranges, the gigantic shadows and the hollow echo of our footsteps in the deserted halls recall to memory bits of imaginative tales in museum settings that we have read at some time in the past. Pausing to peer in the dim light at the Egyptian mummy lying so still in his wooden case we are reminded of the story of a museum Egyptologist who, on a field expedition, uncovered an inscription so fantastic that none of his colleagues would concede its authenticity. In brief, the inscription related that an Egyptian prince of an early dynasty was murdered by his own brother. Just before he died he called for the royal embalmer and whispered in his ear the ages-old secret formula known only to the reigning family whereby a vital spark could be preserved even after death and might be fanned into life thousands of years later under certain very special circumstances. The prince hoped thereby to gain a remote chance of finally outliving his treacherous brother. Pure fiction, of course

hard to whittle or huge objects such as whales and dinosaurs, which cannot be entirely protected. A papier-mâché and plaster reproduction of a 78-foot sulfur-bottom whale is suspended from the ceiling of one hall, with the lowest surface nearly nine feet from the floor. In spite of this altitude, names and initials are frequently found inscribed on the whale's flippers. This art work could be accomplished only by someone holding the artist up—teen-agers are the most likely suspects.

No matter how many guards are provided, if the public can reach an exhibit, it is going to record its presence with initials and dates. The media employed for these inscriptions include pen, pencil, knife, and lipstick, with rare examples of diamonds used to etch initials in the plate glass of exhibition cases. Most of the effects of such minor vandalism can easily be removed, and real damage is negligible. In some instances, it is evidently not clear to visitors what are exhibits and what are not. An early type mail-box on exhibition in the Arts and Industries Building had to be sealed shut—visitors kept dropping letters in it.

The buildings and collections are very thoroughly guarded. A guard is stationed at every entrance, and others circulate regularly throughout the exhibition halls during visiting hours. No one carrying a package can leave without a special pass. All through the night guards make complete rounds of the buildings.

In the daytime a museum is a cheerful place, with sunlight streaming in the windows and crowds of people thronging the exhibition halls. At night things look very different. The weird half-light distorts familiar shapes, throwing grotesque shadow-

XIV. *Highlights and Sidelights*

Recently a Smithsonian guard burst into the Captain's office and reported in great agitation that a portrait in one of the buildings had been damaged. It had indeed—across the face of President Truman's portrait in the National Collection of Fine Arts was a scratch, and the story made headlines in papers throughout the country. Some visitor, perhaps of a different political persuasion, had apparently taken a swing at it with a blunt instrument of some sort. Fortunately the damage was so slight it could easily be restored by the artist who had painted the portrait. The incident served only to emphasize the fact that loss and damage at the Smithsonian have been so rare as to be practically nonexistent.

Americans are inveterate souvenir hunters, however, and nearly all exhibits must be shown in glass-covered cases or swung up out of reach of the minority element who would like to cut off just a little piece to take home. About the only things shown out in the open are large rock specimens that are pretty

and eventful people is, so to speak, on the brow of the hill, and we cannot see over, though some of us can imagine great uplands beyond and something—something that glitters elusively, taking first one form and then another, through the haze.

"We are in the beginning of the greatest change that humanity has ever undergone. If we care to look, we can foresee growing knowledge, growing order, and presently a deliberate improvement of the blood and character of the race. It is possible to believe that all the human mind has ever accomplished is but the dream before the awakening. All this world is heavy with the promise of greater things, and a day will come, one day in the unending succession of days, when beings—beings who are now latent in our thoughts and hidden in our loins—shall stand upon this earth as one stands upon a footstool, and shall laugh and reach out their hands amidst the stars."

"We perceive that man," he writes, "and all the world of men, is no more than the present phase of a development so great and splendid that beside this vision epics jingle like nursery rhymes, and all the exploits of humanity shrivel to the proportion of castles in the sand. We look back through countless millions of years and see the great will to live struggling out of the intertidal slime, struggling from shape to shape and from power to power, crawling and then walking confidently on the land, struggling generation after generation to master the air, creeping down into the darkness of the deep; we see it turn upon itself in rage and hunger and reshape itself anew; we watch it draw nearer and more akin to us, expanding, elaborating itself, pursuing its relentless, inconceivable purpose, until at last it reaches us and its being beats through our brains and arteries, throbs and thunders in our battleships, roars through our cities, sings in our music, and flowers in our art. And when, from that retrospect, we turn again toward the future, surely any thought of finality, any millennial settlement of cultured persons, has vanished from our minds.

"It is not difficult to collect reasons for supposing that in the near future humanity will be consciously organizing itself as a great world state—a world state that will purge from itself much that is mean and bestial, and much that makes for individual dullness and dreariness, grayness and wretchedness in the world of today; and although we know that there is nothing final in that world state, although we see it only as something to be reached and passed, yet few people can persuade themselves to see anything beyond that except in the vaguest terms. That world state of more efficient, more vivid, beautiful,

Spreading Knowledge

"But I should not want to indicate that the uranium matter is a disappointment, that after all we shall never find a way to bring about fission of the heavy elements for useful purposes. Quite the contrary!

"Perhaps the problem awaits a deeper understanding of the forces that hold nuclei together. That there are little-understood forces operative in the nucleus is more than evident; especially from observations of the cosmic rays, it has been established that particles of matter called mesotrons of intermediate mass between electrons and protons play a dominant role in nuclear structure. Theoretical considerations suggest that the mesotrons may be connected with the primary forces in the nucleus, and accordingly, an understanding of mesotron forces may ultimately yield the solution of the practical problem of atomic energy."

Less than four years later the chain reaction predicted by Lawrence appeared as a reality in the form of the atom bomb dropped on Hiroshima.

The great British thinker and writer H. G. Wells as far back as 1902 presented before the Royal Institution a novel discourse on the possibility of deriving scientifically a working knowledge of the future, and his fascinating paper was published in the Smithsonian Report for that year. His final conclusions after reviewing our knowledge of the past is that the story of man as we know him is most certainly not the last act in the drama of the evolution of life forms. A fitting close to this chapter on "Spreading Knowledge" will be a few quotations from Wells' Smithsonian Report article on this attempt to project knowledge into the future.

rier, but that hurdle has long since been cleared, and speeds far above his 600-mile figure have been unofficially reported. The reason for Mr. Wimperis' lack of optimism is that jet and rocket engines were not available when he wrote.

An article by E. O. Lawrence, inventor of the cyclotron, in the 1941 Smithsonian Report, is of great interest as appearing just before the coming of the event he foresees—although he apparently did not anticipate such quick success. He says:

"Now that it is an experimental fact that matter can be converted into energy, it becomes of great practical importance to inquire whether the vast store of energy in the atom will be tapped for useful purposes. This question has recently taken on added interest through the discovery of a new type of nuclear reaction involving the heavy element uranium . . .

"That neutrons are generated in the fission process is of the greatest interest because it opens up the possibility of a chain reaction, a series of nuclear reactions wherein the neutrons liberated in one fission process go to produce additional fissions in other atoms which in turn give rise to more neutrons which produce further fissions and so on. It is this possibility of a chain reaction that has excited the interest in uranium as a practical source of atomic energy.

"Without going into further detail, it is perhaps sufficient to say that there is some evidence now that, if U^{235} could be separated in quantity from the natural mixture of the isotopes, a chain reaction could, indeed, be produced. But herein lies the catch, for there is no practical large-scale way in sight of separating the isotopes of the heavy elements, *and certainly it is doubtful if a way will be found.* (Italics added.)

effect on him. Communication could be kept up with, and even, perhaps, a few stores introduced into a besieged place.

"But over and above these most important and far-reaching possibilities of aerial navigation, there is the likelihood of a revolution in our ordinary modes of travel by one infinitely more rapid, cheap, and convenient.

"What we see, then, looming in the future, more or less near according to the energies of, and the encouragement we give to, those pushing the matter forward, is the introduction of a new invention forming an invaluable and all-powerful weapon of war, an important aid to science and the practical knowledge of our globe, and a speedy, economical, and pleasant mode of getting from place to place, such as will probably completely revolutionize our present methods of travel."

Not so good a prophet was H. E. Wimperis, Past President of the British Royal Aeronautical Society, who said in an article on "The Future of Flying" published in the 1940 Smithsonian Report:

"Let us consider what lies ahead in the coming years in respect of speed, size, and range. No doubt military craft will go as fast as they can. *But since it seems that they cannot exceed 600 miles per hour much if at all* (italics added), there is little doubt that speeds between 500 and 600 will become usual. Not so, however, for the civilian air services, where quiet, comfort, and cost are all-important. Here there is good economic reason for speeds to settle down at the 200 to 300 range. In both these classes we seem therefore to be approaching some degree of finality."

He set his 600-mile limit, of course, because of the sonic bar-

we may reasonably suppose that 100 miles an hour will be no excessive speed for a flying machine.

"Those who think this estimate oversanguine may ponder over an extract I recently came across from an old newspaper published 78 years ago [1824], referring to the railway then about to be constructed from London to Woolwich. In this, reference is made to the possibility of the train being able to attain the terrific speed of 18 to 20 miles an hour; but it concludes, with sarcastic incredulity, 'We should as soon expect the people of Woolwich to be fired off on one of Congreve's rockets as to trust themselves to the mercy of such a machine going at such a rate.'

"Once a practical flying machine existed, the uses to which it might be applied are varied and important.

"Primarily, it would form an incalculably valuable engine of war. One can scarcely imagine any invention which could have a greater effect on the conduct of warfare. * * * I need not repeat the many instances that occur to me of the extreme value of such an apparatus for reconnoissance. If the dropping of explosives on the heads of an enemy is not now considered 'fair play' (though it is difficult to see why this should be less humane than throwing lyddite shells from a howitzer), yet there are many more uses to which the aerial fighter might be put.

"He could blow up the railroad lines and bridges, even if he had to descend to do so. He could cut all the telegraph wires in the country, and could set light to stores and do other damage. A machine soaring about over a town or camp occupied by the enemy would certainly have a very decided moral

272

Spreading Knowledge

It is a strange quirk of human nature that most people believe it is impossible to do something that has never been done before. So it was with flying before the Wright Brothers flew in December of 1903. The pioneering efforts of the early experimenters in aviation met with almost universal apathy or ridicule. There are fortunately, however, always a few far-sighted enthusiasts who can apparently see the handwriting on the wall and who encourage the struggling pioneers to go on with their efforts. For aviation, such a believer was the Englishman, Major B. F. S. Baden-Powell, who in December of 1902, a year before the Wrights' success, gave the presidential address before the Aeronautical Society of Great Britain, which was published in the 1902 *Smithsonian Report*. After reviewing the encouraging phases of the attempts to fly up to that time, he undertook to prophesy the possibilities of the future of aviation. Considering that man had never yet left the ground in free flight his vision is nothing short of amazing. He said:

"There has often been a lot of wild speculation about what might happen when flying machines are introduced into everyday life, but it may be worth while considering for one moment what is likely to result, so as to judge whether the matter is one really demanding an effort to accomplish; whether, in fact, 'the game is worth the candle.'

"Whatever the exact form the apparatus may take, we may assume that it will possess certain characteristics. The first of these is that it will travel very fast. Taking into consideration the speed at which birds travel, that at which models have been flown, and the theoretical calculations which have been made,

The Smithsonian

The young prince tightens his grasp on his sword and lunges at the monster that rears before him . . . He slashes out—again—again—

(*Roars—up*)

The monster howls at the sight of his own blood . . . The sword plunges in again and again—the walls almost crash as the tortured beast lashes out in fury. Theseus steps back —braces himself—and once more the sword finds its mark.

(*Final roar ending in hideous moan, followed by gurgle, as—music—in and out*)

Evans: The Minotaur was vanquished . . . Theseus, following the trail of thread, was soon out of the labyrinth . . . Ariadne was waiting—and the two soon clasped hands in the traditional Cretan ceremony of marriage.

The script goes on to show through dialogue how Sir Arthur's findings proved the historical basis for this time-honored legend and to review the fascinating story of the revelation of a lost city through archeological research.

To return to the Smithsonian Reports, these well-known volumes are unique in certain respects. One is that they endeavor to present developments in science in broad outline wherever possible, with even some philosophical discussion of implications and prophecies or speculations as to future trends. This has been thought to be a useful function in these days of ultra-specialization in most branches of science. With the great intricacy of modern science, such specialization is, of course, necessary, but it is well also to stand off occasionally and see how the minute bits of new knowledge fit into the whole picture. A few passages from *Report* articles will illustrate the fascination of looking back through some of the earlier volumes.

Good—it has the voice of the winds.

Ariadne: And here is something even better—a ball of woolen thread.

Theseus: (*Laughing*) What do I use that for?
To bind the hoofs of the Minotaur?

Ariadne: Listen to me, Theseus . . . The labyrinth is a greater foe than the Minotaur—yet this ball of thread is strong enough to conquer it.

Theseus: But how?

Ariadne: When you enter the labyrinth, bind one end to a stone near the entrance—then unwind it as you go through the maze . . . You understand—no matter how many turns you make—how many chambers you enter—this thread will always lead you to the entrance.

Theseus: By the Gods, it will.

Ariadne: You have a sword to pierce the Minotaur, and a ball of thread to conquer the labyrinth.

Theseus: And I have more . . .

Ariadne: Yes you have more, Theseus.

Theseus: And I will come back to claim it—believe me, I will, Ariadne.

(*Footsteps coming up off mike*)

Ariadne: The guard! Come back to me, Theseus—come back!

(*Door opens and closes as music—in and out*)

Evans: And so Theseus was led to the labyrinth. We can almost see him now—his great bronze sword at his side.

(*Footsteps steady with echo*)

Unwinding the ball of thread as he moves through the maze of corridors and chambers that Daedalus had built. Slowly—stealthily—carefully he makes his way deeper and deeper into the maze . . . Then—suddenly—almost at his elbow—a hideous roar—

(*Roar, reverberating on echo mike*)

269

presented the story of the spectacular findings of the famous British archeologist, Sir Arthur Evans. It introduced the well-known legend of Theseus and Ariadne and showed how Sir Arthur pieced together bits of knowledge found through his excavations at the site of Knossos, seat of Minos, great sea-king of Crete, to prove that there is some historical backing for the authenticity of the legend. Theseus, it will be recalled, was the son of Aegeus, King of Athens. He has just learned that Athens, ever since its defeat at the hands of Minos, King of Crete, has paid a gruesome tribute of seven youths and seven maidens every nine years to be thrown to the fabulous Minotaur in the great labyrinth under the castle of Minos. Theseus asks to be sent as one of the seven youths, with the avowed intention of slaying the Minotaur and ending the cursed tribute.

At Knossos he sees and falls in love with Ariadne, Minos' daughter, but still insists that he be the first to be thrown to the Minotaur. As he sits in a dungeon cell waiting for the soldiers to drag him to the labyrinth, the cell door swings open and Adriadne stands before him. She begs him to leave with her, but he refuses. "The World Is Yours" script carries the story on in this manner:

Theseus: Go, Ariadne, before the sweetness of your face blots out all recognition of duty . . . Go Ariadne, I beg you . . . go.

Ariadne: You will not come with me?

Theseus: No.

Ariadne: Then you must take these—perhaps they can help. Here—this great bronze sword—it will protect you.

Theseus: Let me feel its weight—

 (*Swishing*)

Spreading Knowledge

The great Smithsonian library serves both to increase and to diffuse knowledge. Boasting one of the largest assemblages in existence of the transactions and proceedings of the world's learned societies, its volumes are in constant use to further Smithsonian original researches. They also aid in the dissemination of new knowledge achieved by other organizations in every part of the earth. The number of volumes in the Smithsonian library lacks only a few thousand of reaching the one million mark.

Beginning as far back as 1923 the Institution has been on the air with several types of radio programs. Its most ambitious series was a weekly half-hour dramatized program known as "The World Is Yours," operated jointly with the Office of Education and the National Broadcasting Company. It went out over a nation-wide network every week for six years, and was terminated only because of the scarcity of air-time during World War II. Each program was prefaced by a specially written theme song, against the background of which the announcer opened the dramatization with the words, "Men have searched the earth, the air, even the sun and stars in their never-ending quest for knowledge." The dramatizations presented every phase of science, exploration, history, and art. The program was very popular, at one time rating at the top of all nation-wide sustaining programs. Nearly half a million letters were received from listeners during the six years, almost all of them being complimentary and many enthusiastic. The following brief extract from one of the scripts will show how the scientific subjects were highly popularized.

This particular program was entitled "Ancient Crete," and

relics of a long-vanished far northern culture of migrating Eskimo obtained by Dr. Henry B. Collins, Jr., of the Smithsonian Institution and his assistant, J. P. Michea, of the National Museum of Canada, in stone ruins on far northern Cornwallis Island in the Canadian Arctic Archipelago this summer.

"This site, lying near the 75th parallel, is one of four old villages with well-preserved remains of stone and whale-bone houses. Within historic times the region has been entirely uninhabited. Collins' excavation, the first to be made in the northern part of the Canadian Archipelago, showed that the villages were built, perhaps about 500 years ago, by whale and walrus hunters who were doubtless ancestral to some of the present-day Eskimo. They represent what is known to Eskimo ethnologists as the 'Thule culture,' which had its origin in northern Alaska.

"The general picture is that the Thule people made their way across Arctic Canada to Greenland, migrating slowly over the course of several centuries. There were both eastward and westward movements."

As another phase of diffusing knowledge, it was estimated a few years ago that the Smithsonian answered every year by mail some 8,000 questions on scientific subjects. In fact, the Institution seems to be looked upon as a court of last resort in obtaining hard-to-find bits of knowledge, for often the letters state that the writers have tried several other sources without success. And usually the answers can be given for the reason that the Smithsonian has on its staff experts on a very wide variety of subjects from aeronautics to zoology.

has been in operation nearly as long as the Institution has existed, is the International Exchange Service. It started out simply as a means of exchanging Smithsonian publications for those of similar institutions abroad. Having established these channels of exchange, the Institution was requested to include publications of other organizations. Official exchange agencies were set up in other countries, treaties stabilized the interchange, and a great impetus was given to the progress of research through world-wide exchange of intelligence.

Today the Smithsonian's International Exchange Service funnels some three-quarters of a million packages of publications a year—mainly scientific and governmental—to recipients in this country and abroad. Not only does this material go to all the great nations of the world, but packages also go regularly to such places as Ceylon, the Dominican Republic, Liberia, Newfoundland, El Salvador, and Thai. There is no way to tabulate the effects of this wide, free interchange of ideas, but there can be little doubt that had it not been in operation the pace of scientific advance would have been greatly retarded.

To reach a wider audience than is possible through its formal publications, the Smithsonian has for many years released to the press popularized accounts of its researches, explorations, and publications. They are widely used by newspapers, and through them the public can keep in touch with interesting scientific work which otherwise they would never hear of. A few paragraphs from a recent Smithsonian release will show the method of presentation:

"*Washington, D. C., September 25* —A pictograph on whale bone of an ancient Eskimo whale hunt was among the choice

The Smithsonian

more, the present Smithsonian Secretary, has published numerous bird papers in this series. Two of them are world standards for bird classification, *A Systematic Classification for the Birds of the World*, and *A Check-list of the Fossil Birds of North America*. Former Secretary C. G. Abbot has been writing for 30 years on the sun's radiation, and in more recent years on its connection with our weather, offering hope of long-range forecasting.

The *Bulletins* and *Proceedings* of the National Museum and the *Contributions* from the National Herbarium record the basic researches on the great national collections. By their nature they are for the most part technical works and are used primarily by other scientists and students in the fields of science covered. They have served to put on record a vast amount of new knowledge in zoology, botany, anthropology, and geology discovered by Smithsonian scientists, which, pooled with similar work by other scientific organizations, has created a great reservoir of fundamental data of sure value to economic workers.

Other Smithsonian series are the *Bulletins* of the Bureau of American Ethnology which record every facet of American Indian culture—customs, ceremonies, religion, myths, artifacts, language, and general way of life; the *Oriental Studies* and *Occasional Papers* of the Freer Gallery of Art, which contain chiefly results of researches in Far and Near Eastern art and archeology; and the *Annals* of the Astrophysical Observatory, a series of volumes issued at irregular intervals to record in great detail the unique research of the Observatory on the sun's radiation.

Another Smithsonian method of diffusing knowledge, which

spectacular progress in medicine, discovery of new methods of prospecting for oil, fascinating archeological finds in all parts of the world that take us back 7,000 years into the mists of antiquity—in fact, the whole story of man's groping but indomitable search for truth.

Some other widely known Smithsonian publications are its volumes of tables—Physical, Meteorological, Mathematical, and Geographic—which stand on the reference shelves of most research and industrial laboratories and so have played a not inconsiderable part in practical applications of science. These are revised at intervals in order to keep them abreast of the rapid progress of science. *The Smithsonian World Weather Records* volumes contain official figures on rainfall, temperature, and pressure at nearly 400 weather stations in all parts of the world from the beginning of weather recording down to 1940. This enormous and unique compilation is in constant use by meteorologists and other research workers everywhere. When the first volume appeared, the Institution within six months had requests for second copies from investigators who had actually worn out their first copies.

Outstanding series of papers have appeared in the Smithsonian Miscellaneous Collections, as for example, Walcott's numerous contributions to Cambrian geology. Here will be found descriptions and illustrations of some of the earliest forms of life on earth—creatures that lived in and near the oceans of perhaps half a billion years ago, near the dawn of life on our planet. Snodgrass' exhaustive studies of insect anatomy are sure to be of inestimable value to future economic entomologists charged with the control of destructive insect pests. Dr. Alexander Wet-

stock of each is exhausted within a few months after its appearance.

The Smithsonian recently published a two-page leaflet on a 6⅝-day cycle in Washington rainfall. At the same time there was in press a *Handbook of South American Indians* which will print in excess of 5,000 pages. These two examples will illustrate the range in size and the diversity of content of Smithsonian publications. Most of them are highly technical in character and are intended for an audience of scientists and students, as for example a Museum Proceedings paper entitled "*Machaeroides eothen* Matthew, the Sabertooth Creodont of the Bridger Eocene." Others are literally best-sellers, such as the Bent bird bulletins mentioned above, the *Aircraft Handbook* of which thousands of copies are sold each year at a nominal price, and the *Smithsonian Annual Reports*.

These Smithsonian Reports are probably the most widely known of all Smithsonian publications. Each year they contain, in addition to the report on the Institution's work, an appendix made up of non-technical illustrated articles on notable developments in all branches of science—in effect, a panorama of science for the year. Dozens of technical journals are screened by the Smithsonian Editorial Division to make sure no important scientific event is missed. A set of these Reports for more than a hundred years is a résumé of the fantastic advance in science for that fateful century from horse-and-buggy days to the atom bomb. In their pages will be found authentic stories of the discovery of radioactivity and X-rays, the steps leading up to the transmutation of elements and finally to atom-splitting, the beginnings of human flight, advances in engineering, the

ships. A book recently published by rocket enthusiasts shows color paintings of the weird scenery on Mars, Saturn, Jupiter, and other planets, of which the details were checked and commended by eminent astronomers. Professor Goddard's Smithsonian-sponsored pioneer experiments and publications are universally recognized as the starting point of this swift development which holds fascinating possibilities for the future.

A paper on the geological aspects of Niagara Falls was accepted for publication by the Institution. After it appeared, it was discovered that bits of clever propaganda for the private ownership of public utilities had been woven into the scientific aspects of the study. An informal Congressional investigation cleared the Smithsonian of blame, but thereafter manuscripts submitted by outside workers were examined with even greater care to protect the Institution's reputation for complete freedom from political interests.

The Smithsonian publications that command high prices in second-hand dealer's shops are the monographic works on various forms of life and on particular areas. Most of these are Bulletins of the National Museum, and they contain invaluable reference data on mammals, birds, fishes, insects, plants, and many other forms. The editions are necessarily limited, and in a few years after their appearance no more copies are to be had. Single copies eventually find their way into the hands of book dealers, who resell them at high prices determined by the scarcity of the particular numbers. Among those in greatest demand are the works known as *Life Histories of North American Birds,* by Arthur Cleveland Bent. Eighteen volumes in this series have been published as Museum Bulletins, and the Smithsonian

The Smithsonian

This was published by the Smithsonian 30 years ago. Today a similar experiment is being seriously discussed.

Goddard's later work found abundant support by other foundations, but again in 1936, three years before the start of World War II, the Smithsonian published his advanced work on rockets. By this time, of course, the military possibilities of rockets were being explored in several countries. When Goddard's latest paper had been set in type, proof and originals of the illustrations were mailed to him at his experimental laboratory in New Mexico. They never reached him. Later, when the paper had been published, the engravings were shipped back to the Smithsonian from the printer's plant in Baltimore. They never arrived. When Professor Goddard learned of these strange losses, he wrote in February 1936: "There has been an extraordinary interest in this paper, and in fact in all my correspondence with the Institution. While at Clark University, a letter from the Institution, containing a check, was opened, although nothing was taken from it. The package of proof that I received today had been opened along the flap." All these events could not have been pure coincidence; some under-cover agent had evidently been instructed to get advance information on Goddard's work.

The bewildering pace of today's scientific developments is well demonstrated by the rocket, which only 25 years ago was merely an interesting curiosity. Today rockets streak a hundred miles and more into space and bring back photographs of the earth's surface from that height showing clearly the curved edge of the globe on which we live. Serious writers discuss the not remote possibility of interplanetary travel using rocket

and fireworks displays. Backing for research in such a field was difficult to obtain, especially since all that Goddard hoped to gain through rocket development was more knowledge of the upper atmosphere. Such basic investigations designed solely to increase knowledge and with no apparent practical usefulness are exactly the type that has so often received Smithsonian support at a critical stage. As in the case of rockets, the economic value of such work follows inevitably. The Institution also published Goddard's early results with rockets in papers that have since become classics in their field. Having long since gone out of print, they were recently reprinted in full by the American Rocket Society.

An interesting rocket project proposed in one of Goddard's early papers, which was given wide newspaper publicity, was described by him as follows:

"It is of interest to speculate upon the possibility of proving that extreme altitudes had been reached. The only reliable procedure would be to send the smallest mass of flash powder possible to the dark surface of the moon when in conjunction (i.e., the new moon) in such a way that it would be ignited on impact. The light would then be visible in a powerful telescope."

After experimenting with the visibility of varying quantities of flash powder at distances of about 2 miles, Goddard concluded:

"From these experiments it is seen that if this flash powder were exploded on the surface of the moon (distant 220,000 miles), and a telescope of one-foot aperture were used, we should need a mass of flash powder of 2.67 pounds to be just visible, and 13.82 pounds to be strikingly visible."

13,000,000 copies of these works have been distributed. Laid out in a single row, they would reach from the most northerly corner of Maine to the southernmost tip of Florida.

From a world-wide standpoint the Smithsonian is undoubtedly best known for its publications. In this country, it is associated in the public mind primarily with its museum exhibits and art galleries—in fact, most people seem to think the Smithsonian *is* a museum and nothing more. Its pure science researches are not of the spectacular variety, and the great majority of its publications are technical in character, so that the public does not usually see or hear of them. But abroad, Smithsonian publications serve as its good-will ambassadors, for most exhibits do not travel. The seal and torch of learning that identify all Smithsonian publications will be found in libraries in all parts of the world, where they serve the cause of science.

Smithson, seeking through his own best personal efforts to increase knowledge and perpetuate his name, published some 27 scientific papers which might bulk an inch thick. By a final stroke of his pen he set the presses rolling to record new knowledge more than a thousandfold greater in extent. Half a century ago the statement was published that hardly a textbook or encyclopedia existed that did not depend in some degree on Smithsonian publications. The same is undoubtedly true today, for the great majority of its 8,000 publications contain new knowledge that was not previously available to man.

Prof. Robert H. Goddard in the early decades of this century asked for and received from the Smithsonian Institution financial support for his pioneering researches on rockets. Prior to his work rockets had been used for little else than distress signals

XIII. *Spreading Knowledge*

James Smithson, in bequeathing all his worldly goods to the United States of America, put only one condition on the use of the money—that it be used to increase and diffuse knowledge. We have reviewed some of the widely diversified ways by which the Smithsonian has put into effect the "increase" provision; it remains to speak briefly of the "diffusion." Numerous methods have been adopted to implement this phase of the program, but one has predominated and will doubtless continue to do so—the printed word.

One Smithsonian publication was involved in spy-ring activities, another came under Congressional investigation, and many have become so rare and in such demand as to command high prices at second-hand book stores. The total number of separate books and pamphlets published during more than a century of diffusing knowledge has reached nearly 8,000. If one copy each of all these separate publications were piled up in a single stack, it would reach to the top of an eight-story building. Nearly

of recent and living American artists, with the definite aim in view of encouraging and promoting the flowering of art in our own country.

If art and science seem but distantly related, remember that James Smithson visualized his establishment as simply devoted to the increase and diffusion of knowledge, with no borders around the word "knowledge." Art is knowledge as surely as is science, although in a distinct region of man's mental equipment. Through the creation and appreciation of art works man expresses his innate feeling for beauty in line, color, and form. In science he tries to discern the meaning and plan behind the majestic expression of law and order in the universe. In the words of Dr. C. G. Abbot, former Secretary of the Smithsonian, "The enlightenment of the human mind brought about by the study of astronomy, for instance, has a value not to be measured in dollars and cents, but by the safety of life and property from religious persecution and by the advance from superstition and the ignorant fear of nature. It is a stunted mind that sees only things like automobiles and electric lights as the foremost rewards and justification of science. What the sculpture of Phidias, the painting of Raphael, the music of Beethoven, the language of the Bible are to the finer departments of the mind, such also, and quite as wholesome in their influence, are those studies of atoms, the universe, and the march of life, which form science."

At the Smithsonian no discordance is felt between artist and scientist. There they unite to promote the cultural development of man. There opportunity is offered to all to see the highest expression of man's genius.

presented to the National Gallery his Italian paintings and sculpture, called by experts one of the greatest collections of Italian art in existence.

The Kress gift was soon followed by that of the celebrated Widener collection of paintings and sculpture, by Lessing J. Rosenwald's gift of some 11,000 prints and drawings, and by Chester Dale's deposit of important French paintings from his collection. Dozens of other donors have contributed one or more paintings or other art works, until now the National Gallery of Art has well over 16,000 items within its walls.

An interesting item in the National Gallery, somewhat outside the normal scope of its collections, is the Index of American Design. This is an assemblage of 15,000 color plates and 5,000 photographs of American designs used during a period of 200 years on textiles, metalwork, ceramics, glassware, furniture and other products. Not only are these traditional American designs studied at the gallery by artists, designers, and manufacturers, but they are also circulated throughout the country to museums, libraries, art schools, and other organizations that can put them to good use.

In half a century, art at the Smithsonian has developed from a sickly little seedling to a great and flourishing tree with wide-spreading branches. The National Gallery of Art has within its walls a peerless collection of paintings, sculpture, and the graphic arts, "representative of the best in the artistic heritage of America and Europe." At the Freer Gallery, we come among the choicest obtainable examples of the classic arts of the Orient. The National Collection of Fine Arts has a general collection of all these things but leans heavily toward the work

Child painted in Constantinople in the early thirteenth century, at the very inception of Western art. From this very early period it ranges through all the important schools of western European painting spanning some six centuries in time. Especially well represented is the Italian school. Here are shown works of some of the greatest painters of all time—Raphael, Botticelli, Fra Angelico, Titian, Bellini, and others. From this group came some of the world's most renowned paintings, as for example, Raphael's "Alba Madonna," Botticelli's "Adoration of the Magi," and Fra Angelico's "Madonna of Humility."

Most of the great painters of the Flemish school are represented in the Mellon collection, from Jan van Eyck to Rubens and Van Dyck. One of the finest examples of Van Dyck's work is the exceptional portrait of the Marchesa Balbi. For the Dutch school there are outstanding examples of Rembrandt, Frans Hals, Vermeer, Hobbema, and several others. Spanish paintings acquired by Mr. Mellon include Velasquez' renowned portrait of Pope Innocent X from the Hermitage, as well as works by Goya and El Greco. Germany and France are represented by Holbein, Durer, and Chardin; England by Gainsborough, Reynolds, Raeburn, Romney, Lawrence, and several others.

The Mellon collection, the catalogue of which reads like a roll call of the world's greatest painters, is without doubt the most generous art gift ever made by an individual to his country. Mr. Mellon's expressed hope in providing this great art gallery, with one of the world's most outstanding art collections as a nucleus, was that other collectors would be inspired to add to it. The building was not yet completed when this hope was justified by the receipt of the Kress collection. Samuel H. Kress

the National Gallery, it is made a bureau of the Smithsonian Institution, but is to be directed by a separate Board of Trustees, one of whom is the Secretary of the Smithsonian.

The building, designed by John Russell Pope, is one of the world's largest marble structures, for it is 785 feet long and contains over half a million square feet of floor space. Constructed of the finest rose-white Tennessee marble, it cost more than $15,000,000. No expense was spared to make it the ideal art gallery in every detail. The columns in the beautiful rotunda are of dark green marble, quarried in Italy and polished in Vermont. The rotunda floor is of Vermont green marble and Tennessee gray marble, while the exhibition galleries are floored in oak as being easier on the feet of weary sight-seers. In the center of each wing is a large open garden court, complete with fountain and year-round plants and flowers. The galleries themselves are small in size, with backgrounds of stone, wood or cloth as best suits the period of art works shown. As far as possible natural lighting is provided by means of skylights and laylights.

The art collections themselves are even more fabulous than the beautiful building that protects and displays them. They began with Mr. Mellon's own private assemblage, brought together over half a lifetime of extremely discriminating acquisition. He restricted his collecting not only to the greatest masters, but to the very finest examples of the work of each that could be obtained anywhere in the world. He had only about one hundred pictures after forty years of collecting. Yet so high was their level of quality that they were valued intrinsically at not less than fifty million dollars.

The Mellon collection starts with a Byzantine Madonna and

emplify Freer's conception of the basic "underlying principles of artistic production in soundness of thought and workmanship" in art work of all times and all peoples, includes that of James McNeill Whistler in all media, Winslow Homer, John S. Sargent, George de Forest Brush, and many others.

The National Gallery of Art, opened to the public for the first time on March 17, 1941, has in the short span of years since that date become truly a national art center. It displays many of the world's greatest masterpieces, circulates traveling exhibitions, conducts regular series of lectures on the collections, publishes illustrated books on the paintings, prints, and sculptures in the Gallery, and makes available masterful color reproductions of many of its art works. As an example of its service as the National art agency, it was selected as the proper place for the storing, and later for the exhibition, of the 202 priceless paintings from the Berlin museums which were brought to the United States for safekeeping in 1945. During the five and one-half weeks that this unique assemblage of choice European old masters was shown in the National Gallery, a total attendance was recorded of 964,970 visitors, believed to be the highest count ever clocked in any art gallery or museum in the world for a similar period of time.

Within a few years the fabulous National Gallery of Art has established for itself a place among the leading art galleries of the world. The superb building and the nucleus of its art collections were the gift to the American people through the Smithsonian Institution of Andrew W. Mellon. The Gallery was accepted on behalf of the nation by President Franklin D. Roosevelt. In the Congressional Joint Resolution establishing

in desolate places. The night is more agreeable to him than the day, because he can see in the night and not in the day, and prefers solitude. He is a great enemy of the crow, and in the night dominates all the other birds. The asps and snakes flee from his voice. The female owl lays two eggs, one of which restores the hair while the other eradicates it. They are distinguished in the following way: a feather is struck on them; the egg that causes the hair to drop from the feather is the egg which will destroy hair, and the egg, by the touch of which the hair does not come off, is the one that grows and restores the hair. When his flesh and fat are boiled in borax, saffron and vinegar, and dried and beaten fine, they remove all kinds of sores from the body. One of his eyes brings on sleep, the other drives away sleep; in order to distinguish them, they are put in water; the one that produces sleep, settles at the bottom, while the sleepless eye floats. A paralytic face massaged with his blood, while warm, will cure it; and applied in oil to the head, will exterminate the lice. The heart, applied while warm, to a paralytic face, is of great help. The crop taken when dried and pounded, relieves the colic. The bile, taken in the ashes of the tamarisk tree at bedtime will stop one from wetting the bed. The marrow, mixed with oil of the violets and dropped into the nose, relieves the pain of migraine. His dung, when put in the fire, will cause all the wasps to fly away."

The Freer Gallery shows many masterpieces of Chinese painting dating from the eleventh through the eighteenth century. Done in ink, or ink and color, upon either paper or silk, the delicate Chinese paintings exhibit superb design, drawing, and ink-tone. The work of Western painters, exhibited to ex-

In the latter part of the Chou Dynasty, around 600 B.C., bronze mirrors began to appear, and for 1,500 years thereafter much of the finer bronze casting appeared in this form. Mirrors were usually round, with one side polished to give a good reflection. The circle in Chinese thought represents heaven, and the round mirrors with special designs on the back were considered to be a source of magical or supernatural powers. Many of the mirrors bear long inscriptions, one of which on a Sui Dynasty mirror from around A.D. 600 in the Freer Gallery reads:

"Clear as standing water, round as the autumn moon; within there is a blending of purity and brilliance, like the water-chestnut flower rising from the water. Know and reveal your heart's sorrow, and so do away with evil. May I (the mirror) be treasured forever. May the one who looks on me be without years. May the user know great fortune and felicity."

The Near East is represented in the Freer Gallery by various types of art works including manuscripts, paintings, sculpture, pottery, and metalwork. Especially noteworthy are the many examples of Persian manuscripts illustrated with beautiful miniature paintings. The earliest ones still existing date from the thirteenth century, A.D. The text of some of the manuscripts is of particular interest as revealing the thoughts and beliefs of that period in the Near East. One manuscript, a Persian translation of a treatise on the medicinal uses of animals, was originally written by an eleventh century physician named Abū Sa 'īd 'Ubaidallāh ibn Bakhtīshū'. The leaf shown thus describes the beneficial uses of the owl:

"The owl, like the bat, seeks his food in the night and stays

bronzes at the Gallery, and the results have been published in a beautifully illustrated catalogue. The oldest bronzes in the Gallery date from the Shang Dynasty (1766-1122 B.C.) and the Chou Dynasty (1122-249 B.C.). These are the earliest historical periods of China, the previous dynasty called Hsia being purely legendary. Yet even in the remote Shang period, the splendidly executed bronzes bear witness to an elaborate and advanced culture. Their technical perfection cannot be exceeded by the bronze caster of today, and their surprisingly intricate ornamentation gives clear evidence of a rich spiritual life.

The bronzes are in the form of vessels for food, for wine, and for water, weapons, and musical instruments. The elaborate surface decorations were intended as symbols for natural forces, of which the ancient Chinese were greatly in awe. In fact, the various aspects of nature, along with their deceased ancestors, were the objects of worship by the early inhabitants of China. The decorations took the form of dragons and monsters, insects, animals, fish, and birds, as well as circles, spirals, and straight lines.

The designs show infinite variations on the basic themes. Among the most commonly appearing are the "thunder pattern," consisting of small spirals in various shapes, often covering the entire surface of vessels; "monster" motif, being an animal-like face seen from the front; dragon designs of many forms, with no legs or with two or four, with horns of various shapes, and with nostrils ending in a beak, snout, or trunk; representations of the cicada, the insect that still appears in swarms over the North China Plain each summer. All these various designs may be studied at the Freer Gallery.

assortment of architectural motifs along the Mall. Specially designed to show to best advantage the type of art works it contains, the building has two main floors. The upper floor is divided into eighteen interconnecting galleries, all lighted from above, for the display of American and Oriental art works, plus Whistler's famous Peacock Room. In the center of this floor is a beautifully landscaped garden court open to the sky. The ground level floor has the Gallery offices, study and storage rooms, library, auditorium, and workshops.

With the original Freer collection and the very choice additions made yearly, the Freer Gallery now has one of the finest collections of Oriental art in existence. The countries of the Far East and the Near East are represented by many varied types of art work; China—bronze and jade, sculpture, paintings, pottery, and porcelain; Japan—paintings, pottery, and lacquer; Korea—pottery and bronze; India—sculpture, manuscripts, and paintings; Iran—manuscripts, metalwork, paintings, pottery, and sculpture; Egypt and Syria—sculpture, manuscripts, glass, and metalwork. In addition, there are Greek, Aramaic, and Armenian Biblical manuscripts, as well as early Christian painting, gold, and crystal. Outstanding in this group are the fourth-fifth century manuscript of the Gospel according to the Four Evangelists, and a third century Greek (Egypt) papyrus manuscript of the Minor Prophets. These are known as the Washington Manuscripts Nos. III and V, respectively.

Among the most interesting objects on exhibit and in the study series are the ancient Chinese ceremonial bronzes, of which the Freer Gallery has one of the finest collections in existence. A great deal of research has been done on these

picked up in 1887. An interest in Japanese prints led to greater study of the screen paintings and pottery of Japan and eventually in the classic arts of China. So absorbed did Mr. Freer become in collecting the fascinating art of the Orient that he made numerous trips to the East, visiting China, Japan, India, Ceylon, Java, and Egypt.

Mr. A. G. Wenley, present director of the Freer Gallery, says of him: "As a collector, Charles Freer possessed a sensitive and discriminating taste that stood him in good stead as he adventured among the fine arts of the classic antiquity of China, just beginning to be seen by Western eyes. His generous provision for future acquisition and for serious study in this field was significant of his recognition of its importance to scholarship as well as to aesthetics. No scholar himself, he had a sincere and deep regard for truth, for right proportion and exact understanding of the fine arts."

Freer's basic purpose in combining American and Oriental art in one collection is thus stated by Mr. John E. Lodge, first head of the Freer Gallery: "Mr. Freer was convinced that the more nearly a cultural object of any civilization expresses the underlying principles of artistic production in soundness of thought and workmanship, the more nearly it takes its place with other objects of equally high quality produced by any other civilization; and with that in view, he was intent upon bringing together such expressions of Western and Eastern cultures as seemed to him to embody at their best those characteristics which he believed to be inherent in all works of art."

The Freer Gallery building, just west of the Smithsonian building, adds Florentine Renaissance palace style to the

Collection of Fine Arts also encourages artists and craftsmen by sponsoring exhibitions by national and local art organizations. The members of local art clubs are also invited to special exhibitions of foreign art under diplomatic sponsorship. Thus the National Collection concentrates on the encouragement and promotion of contemporary American art—a field quite distinct from those of the Freer Gallery and the National Gallery.

The Freer Gallery of Art, under general direction of the Smithsonian Institution, represents one of the largest and most complete gifts ever made to any nation. For Mr. Freer gave not only his splendid collection of American and Oriental art works, but a beautiful building for their perpetual care and exhibition together with a liberal endowment fund for the acquisition and study of the fine arts of the Orient. This is the gift which inspired President Theodore Roosevelt to bang his fist on the desk and advise the Smithsonian Regents, "Gentlemen, accept this gift whether you can care for it or not!" They did, and today it forms an important unit of the Smithsonian's great art center.

Charles L. Freer, a native of New York State, upon leaving public school worked successively as a cement factory hand, clerk in a general store, and a railroad employee. With Col. Frank J. Hecker he went into the business of making railroad cars, and in twenty years created a fortune of several million dollars. Retiring in 1900, Freer devoted all his time to the study and development of his art collection, started in the 1880's. He first went in for etchings and lithographs, and one of the earliest art works in the whole Freer collection is a Whistler etching

Guardi, Nicolaes Maes, Sir Henry Raeburn, Jan Steen, and J. B. Tiepolo.

In 1929 Mr. John Gellatly of New York gave to the National Collection an extremely valuable assemblage of 1,640 works of art, which is now exhibited together in a special gallery developed for it. Besides 164 paintings and drawings by American and European artists, it contains numerous other types of art objects including French, German, Gothic, and American sculpture, sixteenth-century jewelry, Chinese antiquities, glass from Syria and Egypt, Battersea enamel, and many others. Collectors usually confine their activities to one general field of art, but to Mr. Gellatly any work of art was desirable as long as it harmonized with the collection as a whole and was in itself a thing of beauty.

These large gifts combined with numerous lesser accretions have given the National Collection of Fine Arts a high rank among American art galleries. The particular function of the National Collection among the Smithsonian art bureaus is to promote present-day creation and appreciation of art. Its concern with historical art is primarily in how it affects contemporary American painting, sculpture, and the crafts. Special exhibitions such as the recent "Centennial Exhibition of Paintings by Abbott Handerson Thayer" are designed to reveal the background, interests, and development of individual artists and to measure their achievements in relation to the need of their times. The seventeen paintings of Albert Pinkham Ryder recently assembled in an alcove of the Gellatly gallery bring together the largest and best single collection in existence of this presently very popular American artist. The National

pitable reception and agreeable visit at the White House on the occasion of my tour in the United States.

Believe me that the cordial welcome which was then vouchsafed to me by the American people, & by you as their Chief, can never be effaced from my memory.

I venture to ask you at the same time to remember me kindly to Miss Lane.

<div align="right">

& Believe me,

Dear Mr. Buchanan,

Yours very truly,

Albert Edward."

</div>

The next important gift to come to the National Collection was the collection of 150 paintings by contemporary American artists from Mr. William T. Evans. These represent 106 different artists and together make up one of the finest assemblages in existence of the work of modern American painters. Included are important works by John LaFarge, Frederick Stuart Church, Winslow Homer, William Henry Howe, George Inness, Douglas Volk, Henry Ward Ranger, and many others whose names are well known in American art circles. The Evans collection is free from restrictions that limit the use of other collections, and paintings from it are continually being lent to special exhibitions in other museums all over the country. Following the Evans gift came another from Mr. Ralph Cross Johnson of twenty-four paintings which admirably supplement the Evans collection. For they are outstanding examples of the work of nineteen European old masters. Represented are such great names as John Constable, Goveart Flinck, Francesco

edification of the public, and to promote the understanding and appreciation of art as an aid to cultural advancement.

The oldest of the three Smithsonian art agencies is the National Collection of Fine Arts, originally named the National Gallery of Art as noted above. When Mr. Mellon made his splendid gift to the people of America in 1937, he indicated a desire that the gallery he offered be designated the National Gallery of Art, and since that time the older agency has been officially known as the National Collection of Fine Arts. Without as yet a special building of its own, it occupies the first floor central range of the Natural History Building, which has been converted into an art gallery.

The Harriet Lane Johnston collection mentioned above comprises thirty-one art works including portraits by such British painters as Beechey, Hoppner, Lawrence, and Reynolds. One of the most interesting portraits in the group is that of the Prince of Wales (later King Edward VII) by Sir John Watson Gordon. The prince had visited this country in 1860, and upon his return to England had the portrait painted for presentation to the American president who had entertained him, James Buchanan. In 1862 he sent it to Mr. Buchanan with the following letter, which is preserved with the portrait:

"The Hon'ble James Buchanan,
 Ex-President of the United States,
 U. S. A.

Dear Mr. Buchanan,
 Permit me to request that you will accept the accompanying portrait as a slight mark of my grateful recollection of the hos-

came in succession to the Smithsonian the magnanimous Freer gift of American and Oriental art works and a building for them, the William T. Evans collection of notable American paintings, the Ralph Cross Johnson assemblage of European masterpieces, the John Gellatly collection of widely varied art works, and finally the crowning gift—Andrew Mellon's unrivaled assemblage of old masters and a $15,000,000 building to constitute a real National Gallery of Art.

This tremendous upsurge of art under the Smithsonian aegis, from practically nothing to the enviable position it occupies today, came about all within a span of less than half a century. Stabilized at present as three distinct entities—the National Collection of Fine Arts, with galleries in the National Museum's Natural History Building; the Freer Gallery of Art, with its own building just to the west of the Smithsonian; and the National Gallery of Art, Mr. Mellon's foundation with its magnificent building to the northeast of the Smithsonian—art at the Smithsonian now offers a rich feast for sense and soul for the millions of Americans who come to Washington. The three units supplement each other in content and purpose, and together they constitute a true world art center.

The urge for art expression is one of man's oldest attributes. It has existed from the very dawn of human existence as illustrated by the dramatic animal paintings discovered in Old Stone Age caves in Europe. In varied forms it is woven into the very fabric of the history of our race. It flowers in masterful paintings, rises in splendor as heroic sculpture, adorns the lowliest objects of every-day use. The function of art galleries is to display these varied manifestations for the enjoyment and

241

moments of carelessness, inserted the stove pipe in a ventilating flue instead of a chimney flue; the ensuing fire burned out the whole second floor of the building, including the entire collection of Stanley Indian paintings; and art at the Smithsonian received such a set-back that it might never have recovered but for another minor event.

What little remained of the Smithsonian art collection was scattered, part going to the Library of Congress, part to the Corcoran Gallery. For thirty years art at the Smithsonian languished, and it began to look as though the carelessness of a few workmen had doomed its hopes of future greatness. The bottom of the cycle had evidently been reached, however, for upon the death of Mrs. Harriet Lane Johnston, niece of President Buchanan, in 1903 it was found that she had bequeathed her small private collection of worth-while paintings to the National Gallery of Art, *when one should be established by the Government.* She named a temporary custodian but under conditions that were not acceptable, and a friendly suit was instituted before the District of Columbia Supreme Court. That august body decreed that the Smithsonian art gallery was actually the National Gallery of Art, and the Harriet Lane Johnston collection was thereupon awarded to the Smithsonian.

The seemingly unimportant fact that Mrs. Johnston did not happen to know of the Smithsonian gallery had a very far-reaching effect. The publicity given to the court decision aroused great public interest in the fact that America actually had a national art gallery. Concrete results of this interest soon began to be apparent. Following the valuable Harriet Lane Johnston collection of paintings and other art works, there

XII. *A World Art Center*

It gives us pause at times to observe how seemingly minor events can lead to large and important results. This reflection can be exemplified in two different directions in connection with the art features of the Smithsonian Institution.

An art gallery was specified as a part of the Institution in its act of incorporation, but during the early years art was completely overshadowed by the all-absorbing promotion of science. It is true that some worth-while art works were assembled, including the splendid Marsh collection of engravings and etchings, the Stanley and King Indian portraits, several hundred in number, and a few others.

In the winter of 1865 workmen were rearranging the Indian paintings on the second floor of the Smithsonian Building because of the installation of new exhibition cases. It was a raw, blustery day, and the men found it necessary to set up a stove to make the great hall warm enough to work in. At this point the "minor event" happened. The workmen, through a few

not yet know enough about the requirements of certain animals to be able to keep them successfully. Often certain people have excellent success not only in keeping but in breeding animals that others have said could not be kept in captivity. The sooner we admit that we really know very little about the lives and requirements of wild animals, the sooner we will be in a frame of mind to learn more about the subject, with correspondingly increased success in keeping them.

"Adoption of the rule that 'the animal is always right' will go far toward smoothing the road for both the pet and the owner. We are fond of animals because they are animals; therefore they should be allowed to live the lives of animals rather than forced to ape our lives, actions, and methods."

dried shrimp, and strawberries. Among the largest items on the list are hay (about 200 tons a year), crushed oats (70 tons), corn (30 tons), and in lesser amounts 40,000 pounds of fish, 40,000 pounds of stale bread, 60,000 pounds of potatoes, 15,000 pounds of bananas, and 6,000 pounds of sunflower seed. Most of the animals eat only once a day, but a few—including the elephant and the monkeys—are favored with two meals. As might be expected, the elephant is the hardest guest to keep filled up. In the attempt, he is served every day some 80 pounds of hay, a dozen loaves of bread, and a full bucket of oats. The latest feeding wrinkle in the attempt to beat the high cost of living and stay out of competition for human food is to collect every day from grocery stores the discarded leaves of lettuce, cabbage, and other vegetables. They are entirely suitable for animals, meeting the requirement of many species for greens and at the same time reducing the cost of feeding them.

Mr. Walker, in a Smithsonian publication on "Care of Captive Animals," offers many valuable suggestions for owners of animals, common and uncommon. A few of his general remarks have significance both for owners of household pets and for zoo managers:

"When man takes wild animals into captivity and endeavors to maintain them, he sets up for himself a definite obligation to furnish them with the comforts and necessities to which they are accustomed in their native state. The basis of the entire problem is to view the subject from the standpoint of the animal and its requirements.

"It is sometimes said that certain animals cannot be kept in captivity. A better way of stating the fact would be that we do

parently poisonous to the worm, which almost immediately stops struggling and can be eaten. Vampire bats, which live on blood, possess razor-sharp teeth with which they can shave away a thin layer of skin and suck the victim's blood.

These are but a few examples of the interesting adaptations of animal structure and behavior. Some of these and many others can be observed by the Zoo visitor. Mr. Walker, in order to pursue his studies further, keeps various small creatures in his apartment, producing an unusual environment to which Mrs. Walker has finally become adapted. Some of the pets with which Mr. Walker does his homework are various kinds of mice, flying squirrels, hamsters, and bats.

If you are like most Americans, you doubtless have one or more cats or dogs around the house, the daily feeding of which at times becomes something of a chore. Suppose for a moment that you had 10 pets, all different kinds of creatures, to feed every day. Then imagine there were a hundred—a thousand—three thousand. The last figure approaches the number of animals at the National Zoological Park that look to the keepers for nourishment every day of the year including Sundays, Christmas, and the Fourth of July. And this daily feeding of an animal city is not as simple as feeding cats and dogs. For instance, what would you offer a black-widow spider, a pygmy hippopotamus, an African hornbill, or a 25-foot Indian python? The Zoo's answer, in the order given, is small insects; hay and chopped vegetables; meat balls, fruit, and mice; and chickens and rabbits.

The menu for the entire Zoo calls for some 65 separate items, many of them rather surprising, as, for example, honey, mice,

Wild Animals at Close Range

Gibbons are perfectly constructed for life in the forest. With their long, strong arms and legs, with hands used as hooks and feet that can grasp, they swing through the trees with amazing sureness and speed. Their acrobatic feats in special cages at the Zoo make them a leading attraction. Flying squirrels rest and sleep hanging either end up from fingers or toes, probably because they live in holes in trees, many of which have no bottom to rest on.

The armor-plated armadillo, when threatened, rolls itself up in a ball, baffling most animals that would like to eat it. When the danger is over, the armadillo unrolls and goes about its business. The well-known opossum trick of playing dead by falling limp on its side with mouth hanging open is usually effective against many animal attacks because apparently opossum meat does not appeal to the potential attackers of a living animal.

An outstanding example of the birds of prey which can spot small animals or birds from amazing heights is the falcon. Soaring almost out of sight, these birds will dive at speeds up to 250 miles an hour, producing a whistling sound, and unerringly strike and carry off their prey. Insect-eating birds that find plenty of food in the north in summer use the laborious method of migrating hundreds or thousands of miles south every winter to find an adequate food supply.

Almost the smallest mammal in the world is the lesser short-tailed shrew of the eastern United States. This tiny creature, which weighs about as much as two dimes, cannot by ordinary means even subdue a good-sized earthworm, a major item of its rations. A good nip from the shrew's teeth, however, is ap-

impressed by the way in which each species is specially fitted by its structure and its behavior pattern for survival and for life in the particular kind of habitat it normally occupies. Of course, some kinds are more flexible than others in their tolerance of varying environments, but most animals are specially adapted by evolutionary development for life in particular kinds of surroundings and do not thrive in others. Herein lies man's advantage over all other forms of animal life for escaping extinction in a few million years—the unavoidable fate of nearly all animal species. For man has practically conquered environment—he can live in the frozen north or the sweltering equatorial regions, in burning deserts where rain never falls or in drenched areas of the earth where it hardly ever stops raining.

Among the animals showing interesting adaptations is the little golden hamster of Syria, which lives in a dry, rocky region where food is scarce for long periods at a time, forcing it to store large quantities of food. To aid it in doing this, the hamster has developed very large cheek pouches that reach from its mouth to far back of the shoulders, enabling it to carry large loads of food home to its den from continual foraging expeditions. The giraffe gets its food without competing with other animals, for it eats the foliage from tall shrubs and trees that are well out of reach of most mammals. Zoo visitors never cease to marvel at the giraffe's incredible height. Moles, which live mostly underground, are blind but are equipped with powerful digging hands for traveling through the earth and with fur that will lie in any direction so that the mole can move backward as well as forward in its burrow.

the earth, of gifts and exchanges, and of births and hatching in the Zoo, the population is now maintained at well over 3,000 animals. These guests of the Nation represent adequately the three great classes of animals—mammals, birds, and reptiles—as well as to a lesser extent fishes and insects. Among the most popular with visitors are the primates (apes and monkeys), elephants, the big cats (lions and tigers), hippopotamuses, the bears, and, of course, many of the birds and snakes. The reasons why these and other animals attract particular attention vary greatly. With the elephants it is doubtless sheer size; Jumbo, the famous African elephant stood just short of 11 feet high. The chimpanzees at play are fascinating to watch; the bears are the clowns of the Zoo.

The spotted hyena draws a crowd at feeding time by his ability to crunch up the bones in meat. Even the largest bones are ground up and eaten as easily as we eat pretzels. The polar bears cause visitors considerable worry on scorching summer days in Washington, but the keepers assure them that these bears from the far north do not suffer particularly from the heat. Even the Arctic has hot days in the short summer. The sea lions please the crowd by their amazing ability to catch fish thrown to them. If the throw is anywhere near one of these champion swimmers the fish will never hit the water. The Galápagos tortoises have the special appeal of being probably the longest-lived creatures on earth.

The Zoo is an ideal place for animal study by naturalists, artists, taxidermists, and others. Ernest P. Walker, Assistant Director of the National Zoo, has for many years observed and studied the behavior of all kinds of animals. He is continually

the Gisi tribe, a devout member of the Society, and he went with us and joined all over again, we think to find out if the ritual was the same as in his own tribe. According to him, it was.

"In a dimly lighted hut we were kept at night for four hours. After taking the oath of secrecy we were taught high-signs, pass-words, the procedure of entering a home, the manner of giving a present to a Snake Society brother or receiving one from him, and the symbolism of a large number of fetishes. Next day, inducted into the sacred bush, we were taught again more signs and landmarks, and the secrets of 36 different species of plants were explained to us. Some were medicinal, some used in sorcery. And then our fellow members of the lodge presented to us the ceremonial snake, a rhinoceros viper which we after-ward sent to Washington. Because Mrs. Mann was the first white woman who had ever lived in the village, and the second white woman who had ever joined the lodge, she was made an officer, given a title and certain powers. As Yangwah, she has the authority to 'cut a palaver,' that is, to end an argument, which is a valuable power in West Africa! The native Yang-wah surrendered to her the symbol of office, a harnessed ante-lope horn containing within it the 'medicine' of the Society."

Besides the antelopes, this expedition produced chimpanzees, pygmy hippopotamuses, pottos, civet cats, monkeys, hornbills, monkey-eating eagles, pythons, vipers, cobras, and other inter-esting creatures. Although the war was making the Atlantic very risky by the time the expedition was ready to start back, nevertheless the large American flags painted conspicuously on the ship's side insured a safe passage.

As a result of these and other expeditions to odd corners of

took some very strenuous and dangerous work to get the cages lashed with heavier ropes to solid supports, but it was finally accomplished, and in a few days the strange cargo was unloaded in New York. Dr. Mann was never more glad to see the Statue of Liberty.

The next Zoo expedition was to Liberia in 1940, after the start of World War II but before the United States had entered the war. It was called the Smithsonian-Firestone Expedition in honor of financial backing by the Firestone Rubber Company, which maintains plantations in Liberia. Near the areas cleared for rubber plantings were isolated forests still containing some animals. Rope nets were strung along one side of the forest patches, and groups of native employees each headed by a white manager would spread out into a long single line around the other sides. Advancing with much shouting, the natives would drive the animals into the nets, where some would become entangled and could be captured unharmed. In this way many antelopes were taken, including three kinds of the beautiful little duikers that had not previously been shown in the United States.

Later many trips were made into the bush involving arduous treks over miles of felled timber with no protection from the tropical sun. One such journey of five days' walking into the interior brought the expedition to Belleyella near the French Guinea frontier. Here Dr. and Mrs. Mann were initiated into the mysterious African native Snake Society. Dr. Mann describes the affair thus:

"This Society exists throughout Africa. Each tribe has its own lodge. Our best native companion was Bobo Johnson, of

and numerous other desirable things made up the cargo. Dr. Mann headed the expedition, and when the animals were all assembled and loaded on the ship for home, he thought his troubles were about over. They weren't. The ocean voyage halfway around the world with a cargo of hundreds of animals turned out to spell trouble with a capital T.

Just a few days out of Sumatra the ship ran into a spell of terrific heat, the thermometer registering as high as 117° on deck. The animals did not take kindly to such temperatures. Many of them lost their appetites and either refused to eat or had to be coaxed—and the weather was not conducive to patient coaxing by the humans feeding them. The hot spell dragged on, and one day Dr. Mann had a fright—several of the monkeys were found lying limp on the floor of their cages. He ascertained that they were still alive, and by some quick action and plenty of cold water he revived them. Next the Himalayan bear collapsed and required a lot of working over to save him. Down in the hold where many of the animals were housed, the temperature reached 125°, but fortunately they ran out of the belt of intense heat just in time to avoid loss of the creatures collected with such effort.

Things settled down to the relative calm of feeding and caring for a hundred different kinds of animals, and except for a near miss of a floating mine in the Mediterranean, nothing much happened until the ship ran into a blow off the coast of Newfoundland. Then bedlam broke loose. Huge waves broke over the bow, the cages slipped their moorings and started sliding all over the deck, the animals roared, squealed, or shrieked, the wind howled, and the situation really looked serious. It

tripped over one of his tent ropes. He left the tent in a hurry, but was met by 12 boys entering it at the same speed. The result was that he was thrown and injured his knee so badly on a tent peg that we had to rush him to Dodoma for medical attention."

The expedition was lucky, however, for not only did the rhinos miss their human targets every time, but death was cheated on two other occasions. One man got tangled in the catching net with a full-grown wart hog with its vicious tusks, but came out miraculously unscratched. On another occasion, one of the natives was charged by an enraged African buffalo, known by hunters as the most dangerous of all game animals. The tip of the beast's horn hit the man squarely, but again miraculously it happened to strike one of his ribs. Had it landed a few hairs' breadths higher or lower, the native would not have lived to tell the story.

The Chrysler Expedition brought back to the National Zoo one of the greatest collections of wild creatures ever captured at one time. Before that windfall the Zoo had proudly presented to the public some 1,700 animals. This one expedition almost doubled the population. Among the prizes were giraffes, koodoos, leopards, hyenas, fennecs, and a python measuring 14 feet.

Just ten years later, in 1937, another Noah's Ark cargo arrived in New York Harbor—this one made up of exotic creatures garnered chiefly in Sumatra by a National Zoo expedition financed by the National Geographic Society. Hundreds of small birds, rare reptiles, four Nubian giraffes, a six-foot Komodo dragon, eighteen birds-of-paradise, a pair of Indian gaur,

Ngoro-Ngoro crater. The party started in the direction of the crater, but on the evening of the first day met Mr. Runton and his party coming down. In one week they had seen only four rhinos, no young or signs of young, and since Mando, our best native guide, had told of a district, the Ja-aida swamp country, in which he said there were 'Faro mingi sana' (very many rhinos) we went down into this region and found what he said to be true. Altogether we saw 22 rhinos. Our safari was charged once while on the march, and four times at night rhinos charged through our camp. But in all of these we failed to locate a single young specimen. Five different times we crawled into the scrub 30 or 40 feet from a rhino to see if it had young and were disappointed each time. One locates these rhinos, by the way, through tick birds, which make a loud twittering at the approach of any suspicious object to the rhino on which they are clustered for the purpose of eating the ticks which are so abundant on its body.

"The night charges are simply the result of the stupidity of the rhino. We camped usually in the vicinity of water holes, and when the near-sighted beast came to water late at night or early in the morning he would suddenly notice that there were fires and natives about. Whereupon he would put his head down and charge through in a straight line. On these occasions the natives have a frantic desire to get into the tents to be near the white men and the guns; the white men on the other hand have a frantic desire to get out of their tents, and the result is a collision at the entrance. Two rhinos came into our camp the same night. When the second one came, Le Messurier heard it snort and the sound of its tramp, and just then a native

from its own collection provided someone would come to get them. Mr. Blackburne, then head keeper, was detailed for the job. He arrived back in Washington with some prize specimens, including camels, cheetahs, and, best of all, a pair of African elephants, Jumbo and Jumbina. Jumbo lived only a few years, but Jumbina is still one of the Zoo's leading attractions. The Canadian Government gave the Zoo some fine specimens of the Rocky Mountain sheep. England was represented by eland and Kashmir deer donated by the Duke of Bedford.

The animal collection continued a slow but fairly satisfactory growth through unselective accretions received from various sources. When Dr. Mann became director of the Zoo in 1925 his great ambition was to put an expedition in the field in Africa for the sole purpose of getting new and unusual animals for the benefit of Zoo visitors. He talked expeditions to any-one who would listen, and the very next year he got the thrill of his life in the form of a telegram which read, "Walter P. Chrysler approves African expedition. Go ahead with plans." Dr. Mann and three associates left on the next boat for Europe, and, after laying in equipment in London, went on without delay to Tanganyika, East Africa. Setting up headquarters at Dodoma, some 250 miles inland from Dar-es-Salaam, the ex-pedition split up into four sub-parties, each to work a separate locality.

Dr. Mann was especially anxious to get young rhinos for the Zoo, and although not successful, the experience of searching for them proved exciting, as related by him in the Smithsonian Exploration Pamphlet for 1926:

"We had been told that rhinos were abundant toward the

The Zoo was described at that time as being a pleasant carriage ride from the city of Washington. Today commuters to the city from the suburbs sprawling far out into the adjacent Maryland countryside feel that when they pass the Zoo on the way to work, they are almost downtown. But the Zoo maintains its original picturesque wooded beauty, and at one end merges into famous Rock Creek Park which covers several hundred additional woodland acres.

At first the animal collection grew slowly, for no funds were available to buy animals, and accretions came from unusual sources. Among the early additions was an opossum presented by the President of the United States. It was probably found lurking about the White House grounds and picked up by the White House police as a suspicious character. One year the animals of the Forepaugh Show were permitted to winter at the Zoo, providing an attractive temporary exhibit. Part of the deal was an agreement that half of any animals born during the visit would accrue to the Zoo. As a result of this speculative arrangement, the Zoo's animal collection was increased by one very small kangaroo. Nevertheless, a few years later the Zoo had grown to a point where the tables were turned, and Zoo animals were sent in exchange to the circus.

Many of the most desirable early additions to the collection came from foreign governments or officials as expressions of good-will toward the United States. A lion, several baboons, and an ostrich arrived as a gift from the King of Abyssinia to President Theodore Roosevelt. Five of the interesting chamois came from the government of Switzerland. The Egyptian Government in 1913 offered our Zoo a number of valuable animals

as far away as Maine, Texas, and California. The total number in these school groups was 93,632.

People from distant States take pride in the fact that this is their National Zoo, but ever since its establishment there has been the perennial question of who should pay for its support —the Federal Government or the people of Washington? At first the Government paid the entire cost. Later it was divided between Federal and District of Columbia funds, and for the last several years the entire amount has come out of the District appropriation. The question will doubtless continue to be argued each year when the annual budget is presented to Congress.

Congressmen and their families are frequent visitors to the Zoo. A few years ago, Dr. William M. Mann, the Zoo's famous director, invited a group of Congressmen out for a special tour of the Park. Through a coincidence, several of them were members of the committee that passes upon the Zoo's financial needs. As they entered the bird house, the party was greeted by the talking Javanese mynah with the blunt question, "How about appropriations?" The distinguished visitors couldn't imagine how the bird had learned those unusual words.

The tract of land that Langley selected for the National Zoo lies along the beautifully wooded valley of Rock Creek. In a letter to a Congressman he thus pointed out some of its advantages: "Here not only the wild goats, the mountain sheep and their congeners would find rocky cliffs which are their natural home, but the beavers brooks in which to build their dams; the buffalo places of seclusion in which to breed, and replenish their dying race; aquatic birds and beasts their native homes."

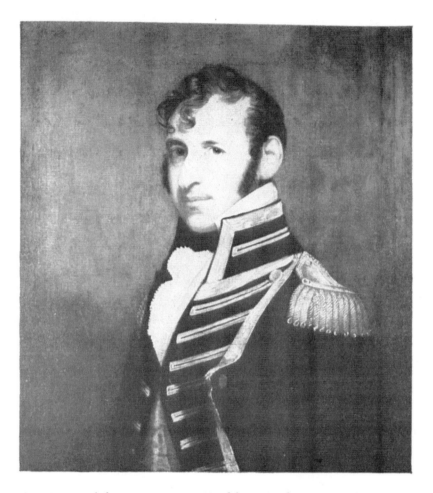

64. Portrait of the great American Naval hero, Stephen Decatur, by Gilbert Stuart, in the National Collection of Fine Arts. The National Collection has a great many fine portraits of American military, naval, and civil leaders.

63. *Above:* Bronze covered Chinese ceremonial vessel of the Chou dynasty. Its color is a smooth grey with a green patina. In the Freer Gallery of Art.

Below: "Indians Hunting Buffalo on the Prairie, 1845," by John Mix Stanley, in the National Collection of Fine Arts. More than a hundred of Stanley's fine Indian paintings were unfortunately destroyed in the Smithsonian fire of 1865.

62. *Above:* Back of Chinese
bronze mirror of the T'ang Dy-
nasty (A.D. 618-907), showing
intricate decoration of grapes,
birds, and animals in relief. One
of the many ancient Chinese
mirrors in the Freer Gallery.

Left: Portrait of Miss Kirk-
patrick by George Romney.
Harriet Lane Johnston Collec-
tion, National Collection of Fine
Arts. It was the Harriet Lane
Johnston bequest that gave the
initial impetus to the Smithso-
nian's present great art center.

The Art Galleries

In addition to the National Gallery of Art, the great Smithsonian art center comprises the Freer Gallery of Art and the National Collection of Fine Arts. The Freer Gallery, Plate 60 (below) was given to the Nation by Charles Lang Freer.

The National Gallery emphasizes the work of the European Old Masters, the Freer Gallery presents the art treasures of the Orient reaching back 3,000 years to the Shang Dynasty, and the National Collection of Fine Arts has a widely diversified art assemblage but specializes in the promotion of the art of our times.

(61). *Opposite page:* A twelfth century Chinese painting in ink and faint colors on silk, Freer Gallery of Art. Depicting a Chinese scholar's mountain retreat, it shows the delicacy and, to our eyes, unusual perspective treatment of Chinese paintings.

59. *Above:* "The Adoration of
the Shepherds," by Giorgione.
It forms part of the Kress Col-
lection in the National Gallery.

Right: Renoir's "A Girl with
a Watering Can." In the Chester
Dale Collection, National Gal-
lery of Art.

58. *Above:* The beautiful rotunda of the National Gallery of Art, with its columns of green marble quarried in Italy. Surmounting the fountain is Giovanni da Bologna's bronze figure of Mercury.

Left: The famous Alba Madonna by Raphael in the National Gallery. One of the collection of 100 choicest Old Masters given by Mellon with the Gallery building.

up, towers 15 feet in the air. Giraffes do not have to compete with other animals for food because their great height enables them to browse on the leaves of trees that are out of reach of animals of ordinary size.

57. *Right:* Mr. Roy Jennier of the Zoo staff holding a pair of baby chimpanzees brought to Washington from Liberia by the Smithsonian-Firestone Expedition. "Chimps" are probably the Zoo favorites because they play like children and seem perfectly oblivious of onlookers.

56. *Above:* These Nubian giraffes at the National Zoo had only been there a short time when this picture was taken, and they seem as interested in the visitors as the visitors do in them. The tallest of these giraffes, when he holds his head

Left: In order to study the ways of small animals, Mr. Ernest P. Walker, Assistant Director of the National Zoo, keeps bats, flying squirrels, and hamsters in his city apartment. He has rigged an ultra-fast camera with which he can photograph bats in flight.

55. The National Gallery of Art in Washington as seen from the Mall. The Gallery was given to the Smithsonian for the American people by the late Andrew W. Mellon. It is a bureau of the Smithsonian but is operated by a separate Board of Trustees. The $15,000,000 Tennessee pink marble building is 785 feet long, making it one of the largest marble buildings in the world. Its art collections include some of the world's finest paintings and sculpture.

54. *Above:* Baby Bactrian camel born at the Zoo taking a bottle of milk from Mr. Blackburne, head keeper at the Zoo from its very beginning up until just a few years ago. Mr. Blackburne loved animals and knew each of his charges personally. He was often bitten and clawed, but never seriously.

Below: Mamma hippopotamus and baby born at the Zoo. Baby appears bored and a bit blasé, but mamma is frankly pleased and proud. The animals do their utmost to keep the Zoo's population at a high level.

53. At the National Zoological Park in Washington, visitors see all kinds of animals from every part of the world. Also, the animals see all kinds of visitors; here the Zoo's elephant is studying a cross section of his public. Elephants are among the most popular of all Zoo animals because of their huge bulk and interesting ways. Jumbo, the Zoo's male African elephant who died some years ago, stood almost 11 feet high at the shoulder.

With its 175 acres of outdoor and indoor living quarters for more than 3,500 individual animals, the National Zoological Park is one of the finest in the world. It is visited by from three to four million people each year from all parts of the world, including bus loads of school children from states as far apart as Maine and Texas.

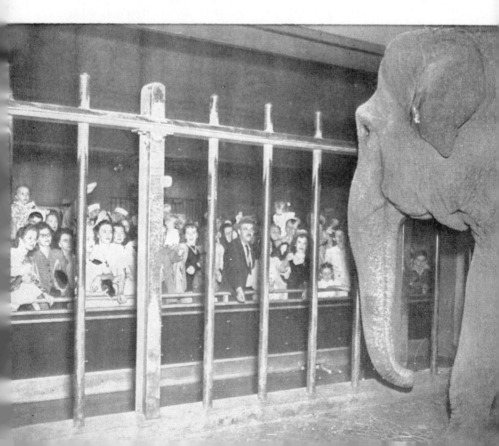

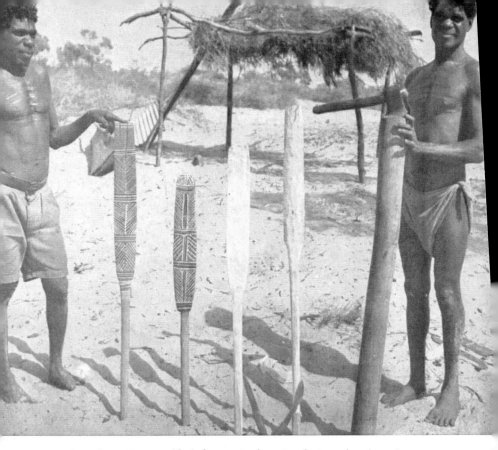

52. *Above:* Natives of little-known Arnhem Land, Australia, show the steps in making one of their beautiful canoe paddles. The Smithsonian collaborated with Australia and the National Geographic Society in an expedition to Arnhem Land in 1948.

Left: Curious courtship posturing of Emperor penguins in the Antarctic as recorded by Smithsonian explorer.

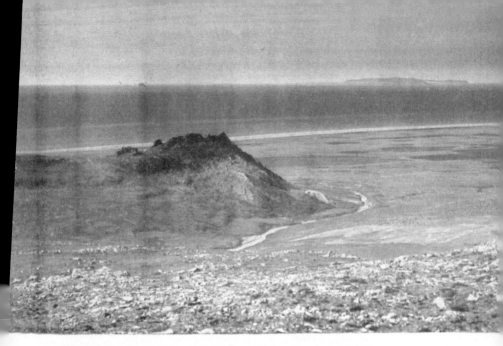

51. *Above:* Cape Prince of Wales, Alaska. An ancient Eskimo site was excavated just above the point from which this picture was taken. At the extreme upper right is East Cape, Siberia, only 56 miles away. At the left of East Cape are the two Diomede Islands, merged. One belongs to America, the other to Russia.

Below: Hauling the marine dredge in the ice-field off Greenland. Captain "Bob" Bartlett for many years collected for the Smithsonian in Arctic waters.

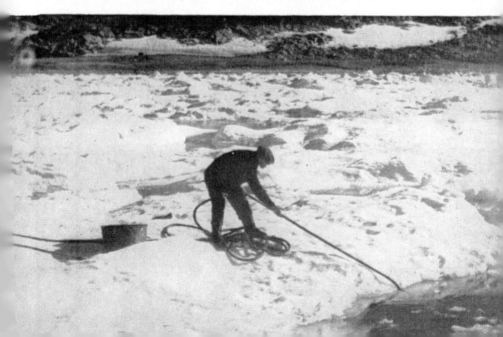

mountains of St. Vincent, an island of the Lesser Antilles. The valley, which had previously been seen by only two other white men, is practically encircled by a ridge nearly 2,000 feet high, the only gap being effectively shut off by a roaring cascade 100 feet in height. The place is shunned by the natives, who call the valley with its dense, tangled tropical jungle the "place of the werewolves." The Smithsonian botanist who succeeded in penetrating into the valley reported no werewolves, but did collect some 5,000 interesting plant specimens, some of them new to science. Another unusual locality from which a number of valuable plant collections have come to the National Herbarium is the lofty mountain area of the Orinoco River headwaters in South America. One of the flat-topped mountains in this area was the scene of Conan Doyle's fantasy, "The Lost World"—which is not a bad description of such an isolated, mist-drenched mountain top with its twisted shrubs and giant pitcher-plants that trap and absorb unwary insects in their curiously shaped leaves.

A separate unit of the Smithsonian that is not connected with the National Museum, but that is definitely connected with the subject of this chapter on the myriad forms of life, is the Canal Zone Biological Area. When Gatun Lake was created in the course of building the Panama Canal, the upper part of a high hill in the flooded area became Barro Colorado Island. The unspoiled jungle with its animals and plants thus set apart from the rest of the area was created a scientific reserve by Governor J. J. Morrow in 1923. Here a splendid field laboratory has been developed, supported in part by the Smithsonian and certain universities and other private organizations, in

part by the United States Government. In 1946 it was placed under Smithsonian administration. Living quarters and laboratories provide a means for visiting scientists to conduct unique researches under real jungle conditions but without the usual diseases, hardships, and difficulties.

Literally from the front porch of the laboratory scientists can observe jungle animals and birds in their normal surroundings. Marked trails lead off into the dense jungle so that continued field studies may go on without danger of the investigators being lost. A wide variety of researches have proceeded at the Island. These have been headlined by a very extensive set-up for experimenting with termite-proofing of wood, studies of the deterioration of textiles, plywood, and containers under tropical conditions, and the effect of the ever-present fungi on optical glass. And of course biologists come in numbers to study the animals and plants of a real tropical jungle. More than 500 publications have resulted from all these unique researches that provide a very practical source of information on jungle inhabitants and conditions.

The body of the National Museum comprises its buildings and the public exhibits within them; its soul lives and moves behind the scenes in the great study collections, laboratories and workrooms. The exhibits are entertaining and educational, but the unobtrusive, highly specialized researches of the scientific staff discover new knowledge for the benefit of mankind, much of it directly applicable to his welfare. Particularly is this true of the two biological departments—zoology and botany, for animals and plants affect the lives of men much more than is generally realized.

The Myriad Forms of Life

The individual specimen from which a new species of mammal, bird, fish, insect, or plant is described becomes the type specimen, which must be referred to in all future identifications and systematic work in its group. From the vast amount of biological research done in the National Museum, there have accumulated tens of thousands of type specimens, making of the Museum a national "bureau of standards" in biology.

The practical uses of plant studies have been cited; basic researches in the various branches of zoology are no less practical in their end results. Some mammals are of great commercial value, as for example, whales and fur seals. Dr. Remington Kellogg, present Director of the National Museum and a leading authority on whales, has furnished much expert information on how to prevent depletion of the supply of whales and assists in formulating international treaties for the regulation of whaling. Similar authoritative advice has contributed greatly to the protection and maintenance of the fur-seal herds. Other mammals are carriers of diseases affecting man, and the Division of Mammals cooperates continually with the Public Health Service, the Army and Navy, and other governmental and private agencies by identifications of suspected mammals.

By identifying and classifying specimens on the basis of the world's largest research collection, the Division of Fishes aids numerous organizations in the conservation and economic use of all kinds of marine and fresh-water fishes, a major food resource. The work of the Insect Division is very close to human welfare. Adequate food production demands continuing war against insect pests of innumerable varieties; exact identification is the first battle in this war. Mosquitoes, fleas, lice, and

73

mites transmit a dozen varieties of serious diseases, and here again health workers are helpless without precise knowledge of the species involved. The National Museum's Division of Insects examines and reports upon as many as 1,200 separate lots of insects in a single year. During the war, when insect control was vital on the fighting fronts, Army and Navy entomologists were prepared for control work in foreign lands by a period of study in the Division of Insects.

The Division of Marine Invertebrates supplies basic information to economic workers attempting to increase or improve the supply of lobsters, crabs, and shrimps, another important food element. The study of snapping shrimp and other sound-producing marine animals seemed of purely academic interest until the perfection of sonar during World War II. Now the geographic distribution of these creatures and the nature of their supersonic utterances have become a matter of vital significance in submarine and anti-submarine warfare.

Mollusks include not only edible forms such as the oyster, which ranks third in money value of all seafoods, but also destructive and dangerous forms. The shipworm that destroys piling and other waterfront structures did $21,000,000 worth of damage in San Francisco Bay in two years. Another mollusk is the intermediate host of the Oriental blood fluke, the cause of the schistosomiasis that afflicts some 100,000,000 people in China. The Museum's Mollusk Division with its vast study collection and expert knowledge is an essential source of fundamental facts needed by all who work with these various types of mollusks.

Many more such practical uses of zoological collections and

research could be cited, but enough have been mentioned to indicate that what goes on behind the scenes in a large Museum not only increases man's stock of knowledge but also serves him in the most direct ways.

IV. *Man Himself*

We often hear statements to the effect that mankind has changed but little, despite great material advances, since the days of the Pharaohs in Egypt several thousand years ago. His physical make-up and mental capabilities seem to be about the same, he still wages wars, crime is still a major problem, and in many other ways it seems that in four or five thousand years but little basic progress has been made. Unfortunately, this is in one sense true. Although steady increase in knowledge has vastly bettered man's lot and largely freed him from the deadening superstitious dogma and terror of earlier times, yet five thousand years is far too short a period to observe any marked evolutionary changes.

To see the tremendous gain that mankind has really made we should draw aside the curtain of time and look far back into the dawn period of the human race. We can do this literally in the anthropological exhibits of the National Museum. For here are casts made from the actual fossil skulls of our remotest

ancestors. The first group, labeled "The Most Primitive Humans," includes the famous Java Man (Pithecanthropus) and Peking Man (Sinanthropus). Geological methods of dating put these two cousins back almost a million years. If we met one of the cousins on the street today, it would put a strain on our imaginations to recognize him as a human being—in fact, when the fossil skulls were first found, a great controversy arose as to whether they belonged to men or apes. They are now definitely accepted as humans, although excessively primitive. They had large, jutting brow ridges, low forehead, small brain, and large, protruding jaws, but at least they walked erect like men.

We do not know exactly what kind of stone tools these most ancient relatives used, but in Europe at approximately the same period clumsy, crudely chipped stone axes and other primitive tools were being laboriously made.

The second group in the exhibit is headed "More Advanced Human Forms." Here appear casts of the famous Rhodesian, Heidelberg, Neanderthal, and Solo skulls, which belonged to still ancient but less primitive-looking men. They show a definite evolutionary advance toward modern man—brow ridges were smaller, foreheads less sloping, brains much larger, and jaws less protruding. The best known are the Neanderthalers, who appeared in many parts of the Old World some 180,000 years ago. Their stone tools also show marked advance, being smaller, more delicately chipped, and with sharper cutting edges.

Strangely enough, a more modern-looking type of man lived contemporaneously with the Neanderthalers in Western Eu-

rope. He leads the third and last group in the exhibit, "Modern Forms of Ancient Man." Here are skull casts named after the places where they were found—Choukoutien, Galley Hill, Combe Capelle, Cro-Magnon, and Obercassel. The owners of these skulls were ancestors that we need not be embarrassed about. In fact, if Mr. Cro-Magnon were dressed in a modern suit of clothes and given a hair-cut, he would pass unnoticed on the streets of any of our cities today. His people made the Upper Paleolithic, or Late Old Stone Age, stone tools that were far advanced in design and execution over the older forms. The people who made these tools in Europe some 50,000 years ago developed much more efficient hunting methods, clothing, and housing. They even went in for art, and their cave paintings and sculpture are famous.

From this point on, these relatively modern ancestors of ours blended into the peoples we learn of in the dawn of actually recorded history in Egypt, Asia Minor, and elsewhere. If, therefore, the progress of mankind at times seems discouragingly slow, or even at a standstill, we must put ourselves in a cosmic frame of mind in which a thousand years is as a day. If we look back sufficiently far, we will see that man has made tremendous strides. Moreover, it is probable that evolution will proceed faster at this end of the scale, for it took hundreds of thousands of years to get out of the era of crude stone tools and an animal-like existence.

All mankind of our times belongs to a single species—*Homo sapiens*—but the variations on the theme are endless and extreme. At one end of the scale are the Einsteins and other intellectual giants of the white race, at the other end the very

primitive Australian aborigines. In between are men of every hue from white to black, every size from near giants to pygmies, and of every degree of civilization from very much to hardly any. For comparative studies and to learn the trends and relationships of the components of this great human potpourri the National Museum has brought together a vast collection that to some may seem a little on the gruesome side—some 17,000 human skulls and a smaller collection of human brains. A serious-minded former curator is said to have remarked at a staff meeting, "The Division now has plenty of skulls—what we need is brains." This was the same curator who took a number of student assistants on an archeological field expedition to Alaska one summer. After a particularly arduous day of digging in the hot sun, he recorded in his diary, "The boys did so well today that I gave them a two-hour lecture this evening on physical anthropology—they deserved it."

The Smithsonian's vast collection of skulls constitutes a great body of reference data for the study of the races of man. Cast up, as it were, on the beach of the great ocean of humanity, these thousands of representative skulls are leading to a better knowledge of the characteristics, intermingling, and migrations of human groups, past and present. Scientifically measured and classified by Smithsonian experts, they provide a ready means of group comparison, as well as quick identification of any doubtful ancient or modern skeletal remains.

The skull and skeletal collections and the knowledge gained from their study serve a very practical purpose, also. Dr. T. Dale Stewart, present Smithsonian curator of physical anthropology, is called upon frequently by the F. B. I. to aid in solving tough

mysteries. Once they brought him a nearly complete skeleton and parts of a Marine uniform that had been found in an abandoned well near a Virginia town. Dr. Stewart took a good look at the skull and bones of this victim of foul play and promptly provided the F. B. I. agent with the man's age and height. He then added that the Marine had been left-handed and had been afflicted with pyorrhea. With this very definite description, the murdered man was soon identified through Marine Corps records, and his murderer was tracked down and convicted.

On another occasion, the F. B. I. brought in a human hand that had been found on an Oklahoma farm. After a careful study of the gruesome relic, Dr. Stewart reported—that it belonged to an Egyptian mummy! On the basis of this unexpected finding, Dr. Stewart let himself in for considerable ribbing. What would a mummy be doing on an Oklahoma farm? That was the gist of newspaper stories on the report, but to one Oklahoma woman it wasn't funny. Seeing one of these stories, she wrote the F. B. I. requesting the return of the hand which had been stolen from her private mummy collection. Science triumphed again.

In North and South America man is relatively a newcomer. For hundreds of thousands of years while primal man in the Old World was slowly and painfully developing into something like our own kind, the Americas were populated only by animals. Just a few years ago, a representative of one of the First Families of America—who settled here between 10,000 and 25,000 years ago—flew to Washington for a reconstruction job. He was found on the beach of an ancient Mexican lake along with bones of the extinct mammoth. In the suitcase of

the Mexican anthropologist Dr. Xavier Romero, the skeleton of this venerable American, Tepexpan Man, came by plane to the Smithsonian to be compared with other ancient men. After his skeleton was studied and reconstructed by Smithsonian anthropologists, and after casts were made and a bust of him was sculptured for Smithsonian visitors to see, the original Tepexpan Man went back to his homeland to take a place of honor among Mexico's treasures. He may prove to be the oldest known inhabitant of the New World.

Coming back swiftly to more modern times in the National Museum, we arrive at the most popular of all the anthropological exhibits—the racial groups. Visitors like realism in exhibits. Indian blankets, beaded moccasins, buckskin shirts, and feather headdresses do not have great appeal for the public if shown simply as specimens, but put them on realistic life-size figures of Indians and pose the figures in familiar Indian occupations and the response is instant. Visitors crowd around the Indian and other groups and take away with them lasting impressions of the life and ways of widely diversified peoples. The groups present not only Indian tribes of many parts of North and South America, but also some of the peoples of Africa, Malaysia, Polynesia, and Japan. Single figures also appear, depicting the physical appearance and dress of many other tribes including the Jivaro head-hunters of Ecuador, the Wolof of Africa, the wild Dyak of Borneo, and the Maori of New Zealand, as well as aborigines of Tibet, Mongolia, India, Korea, and Arabia.

One of the most spectacular of the American Indian groups is that presenting an episode of the Hopi snake dance, a weird

ceremony that has been witnessed by thousands of Americans. The Hopi are an agricultural tribe occupying pueblos, sometimes called aboriginal apartment houses, in northeastern Arizona. They need rain for their crops—mainly corn—and to be sure of getting it, they celebrate every other year a remarkable ceremony of several days' duration as an appeal to their rain-controlling gods. The Museum group shows three Snake priests—the "carrier," the "sustainer," and the "collector"; a line of priests of the Antelope Society, who serve as chorus; and a maid and matron, whose duty it is to scatter sacred meal on the participants as a sacrifice to the gods.

The dance takes place in the village plaza, where the keeper of the snakes sits in a bower with jars containing poisonous reptiles, which he hands out at intervals to the carriers. The dancers march in file around the plaza, each stamping on a board in front of the bower as he passes, as a notification to the gods of the underworld that a ceremony is in progress. After lining up in two files for a few minutes, with the Antelope Society chorus swaying and chanting and shaking rattles, the Snake priests break up into groups of three and weave around in a circle, receiving the deadly snakes as they pass the bower. The carrier holds one or more of the squirming reptiles in his mouth, and the sustainer diverts the attention of the snakes with a feather wand, the collector grabbing any stray snakes before they get away. After dancing thus for a while, they drop the snakes on the ground. The collectors seize them and hold them in their hands until the ceremony is over, when the priests carry the snakes swiftly to the country below the mesa and release them.

The Smithsonian

Snakes are thought by the Hopi to have sprung from a super-natural source and are therefore believed to be in close touch with the gods that control rain, a life and death matter in the arid lands of the Hopi. No Hopi would knowingly kill snakes, poisonous or harmless, as they are regarded as sacred and imbued with some of the powers of the gods. Rattlesnakes are generally used in the ceremony, but owing to the care and skill in handling them, accidents very rarely occur.

The Smithsonian pioneered among American museums in the development of realistic, life-size groups as a medium for showing the public the physical characteristics, clothing, tools, weapons, and handicrafts of primitive peoples. After studying techniques employed in various European cities, such as Castan's "Panopticum" in Berlin and Madam Tussuad's popular wax museum in London, the National Museum staff gradually perfected a method of producing life-size figures. They were first modeled in clay, then cast in plaster of paris, and finally painted natural color with oil paints. Lastly, wigs of real hair were added.

In modeling the figures the sculptors worked from the most accurate data available. In some cases life masks were made from living Indians who visited Washington, and the heads of the figures were cast from these masks, insuring accurate detail in the facial appearance of the life-size models. Other figures were modeled from photographs taken in the field by Smithsonian expeditions. The clothing, weapons, tools, and utensils appearing in the groups are actual ethnological speci-mens from the National Museum's collections. If the necessary trappings could not be found in the collections, ethnologists.

went out to the lands of the tribes involved and brought back the missing objects.

The groups have through the years been enlarged and revised, and new groups and single figures have been added until today the Halls of Racial Groups present for the visitor a pageant of the races of man accurate to the last detail and startling in its realism. So lifelike were the groups to one woman visitor when they first went on exhibit that she wrote her Congressman demanding that the Smithsonian be forced to stop killing Indians and stuffing and mounting their skins.

In long rows of cases flanking these "almost alive" groups are a collector's dream of Indian specimens that might be called a graphic dictionary of American Indian culture. Incredible numbers of costumes, baskets, blankets, pottery of all shapes and colors and beautifully ornamented, silverwork, weapons, tools—in fact, everything used in the daily lives of Indians of many tribes—are there, fully classified, documented, and available for study. If you have anything Indian and want to identify it, it is a safe bet that in the National Museum you are almost sure to find specimens that will match it. The labels will tell you what tribe in what part of the country made such things and what purpose they served.

Thus far we have been speaking of the cultures of living tribes of today or of the recent historic past. In the adjoining Halls of American Archeology we slip back into the mysterious prehistoric time zone of long-forgotten Indian ancestors. Here is a kaleidoscopic view of all the ancient cultures of North, South, and Middle America. Beautifully carved ivory harpoon heads of the Eskimo mingle with hideous Aztec idols to whom

have been sacrificed thousands of living human beings. There are innumerable examples of stone weapons and tools from crude to highly perfected, actual ears of corn dug up in perfect preservation from prehistoric Indian ruins, pottery, textiles, and thousands of specimens of all the material things left behind by the long-vanished early peoples of the Americas.

Turning the time clock back even farther we must journey overseas again on the Museum's magic carpet to see the world's most ancient relics of human activity in the Hall of Old World Archeology. A whole range is devoted to Old World antiquities, divided into two categories, prehistoric and historic. The prehistoric material begins with the rude stone implements of the Paleolithic or Old Stone Age, which goes back nearly to the first appearance of humans on earth. Following these are the more refined tools and artifacts of the Neolithic, or younger Stone Age. France is the classic source of Stone Age remains, and the Museum has considerable collections from famous French sites such as Chelles, St. Acheul, Le Moustier, and others. Also shown are plaster casts to illustrate the art of the Paleolithic period. From the latter part of this ancient period there have been bequeathed to us an amazing art gallery of several hundred engravings, sculptures, and paintings. The paintings, chiefly on the walls and ceilings of caves, show almost exclusively the animals hunted by these remote ancestors of ours.

Coming down to historic times in the Old World, though still several thousand years ago, we join the crowd usually found gazing thoughtfully at the Egyptian mummy of the period of the Ptolemies around 300 B.C. This particular

mummy was found at Luxor, Egypt, and was presented to the Smithsonian by an American diplomat. The ancient Egyptians thought of man as comprising three distinct parts: the body, the soul, and the *Ka*—the double or genius of the individual. After death, the *Ka* continued to exist as the representative of the human person. So that the *Ka* might be able to take possession of the body whenever it wished to do so, it was thought necessary to preserve the body from decay and other destructive agencies within the tomb. For this purpose, the Egyptians mummified the bodies of their dead, built tombs that were well-nigh indestructible, inscribed magic formulae on the coffins and on the tombs to thwart the attacks of demons, and provided statues, household goods, and even food so that the "house of eternity" might look as much as possible like the deceased's earthly home.

The method of embalming varied with the position and wealth of the individual. A top-notch job for a leading citizen would cost about one talent of silver, or $1,250. The brain and viscera were removed, and the body cavities were rinsed with palm wine, then filled with myrrh, cassia, and other aromatics. After being soaked for 70 days in natron (sodium subcarbonate), the entire body was then washed, swathed in linen bandages, and smeared with gum.

Then followed an elaborate funeral ceremony. The mummy in its coffin was transported in solemn grandeur across the Nile, accompanied by priests and mourners, wailing women and attendants carrying offerings. Upon arrival on the western bank, where the Egyptians built their cemeteries, the procession continued to the tomb and laid out offerings of food and

drink before the mummy. A priest touched the eyes and mouth of the deceased with an iron instrument so that he might regain the use of his body and mind which had been lost in the embalming process. With the slaughter of a bull, the ceremony came to an end.

Many weird stories have been circulated of the train of sinister happenings that follow the opening of an Egyptian tomb by modern archeologists, but these have been explained away by scientists as pure coincidence.

Egypt, as one of three oldest centers of real civilization, has left a strong imprint on the cultural development of mankind. Many fascinating and instructive sidelights on the people and ways of this ancient land are presented in the National Museum by casts of famous statues, busts, and inscriptions, the originals of which are in Old World museums. A cast of the beautiful statue of Chefren, third king of the fourth dynasty—about 3000 B.C.—is of particular interest. Chefren was the builder of the second largest of the famous pyramids of El Gizeh.

A facsimile of an Egyptian "Book of the Dead" contains invocations, prayers to the gods, and other religious texts written in hieroglyphs, intended for the protection of the dead in their weird "world beyond the grave."

The key to the Egyptian hieroglyphic inscriptions that puzzled the world for a long time was the famous Rosetta Stone, found by a French officer near the mouth of the Nile in 1799. This stone, a cast of which is shown in the National Museum, is a long decree of the Egyptian priests written in the year 196 B.C. The same text is given both in hieroglyphics and in

Greek characters, providing a simple clue to the solution of the long-standing puzzle. Other casts of statues or statuettes, the originals of which are now in various Old World museums are of Rameses II, King of Egypt about 1300-1230 B.C., thought to be the Pharaoh of the Oppression; Amenhotep IV, the reformer king of about 1375 B.C. who introduced a monotheistic worship of the sun god; the god Osiris, Egyptian god of the dead, and his wife Isis.

An Old World exhibit of deep interest is the selection of antiquities to which references are made in the Bible. Among these are a sling from Damascus of the type used by David to slay Goliath; seals, signets, necklaces, and nose rings from Bible lands; and actual coins of Bible days.

Coined money is supposed to have originated in Lydia about 700 B.C. The piece of money most referred to in the Bible is the shekel, which really means "weight." Before the use of coins, money was simply metal in various forms which was usually weighed to determine its value. The coins shown include, among others, shekels; the coin of Agrippa II, the last Jewish king; tetradrachms of Sidon and Tyre; coins of Babylon, Syria, Ephesus and Tarsus, Macedonia, and Athens. One particularly significant coin is the denarius, or Roman tribute penny. These the Jews used to pay their tribute money to Rome, and it was one of these coins that was shown to Christ with the question, "Is it lawful to give tribute to Caesar or not?" (Matthew xxii, 17.)

In one corner of the anthropology exhibit area is one of the most complete and spectacular units in the whole National Museum. In a specially designed room the Herbert Ward Afri-

can Collection sums up the primitive cultures of a large sector of the Dark Continent. The dynamic life-size figures of African savages in the dimly lighted gallery give an impression which, according to the late Dr. W. H. Holmes, "is that of the weird and mysterious, with a distinct suggestion of the dramatic or even of the tragic, and this impression is intensified as one catches glimpses of the walls glistening with a confused, yet beautifully arranged array of strange implements and sinister-looking weapons."

Herbert Ward, son of an English naturalist and sculptor, left home at the age of 16 and shipped on a small sailing vessel for New Zealand. There followed for him several years of wild and vivid adventure, at times a desperate struggle for very existence. He was thrown among the toughest of the dregs of humanity but somehow preserved his balance and the high ideals that were a part of his nature. He had a try at every kind of job—from range riding, mining, sailmaking, kauri gum digging, to acrobatics with a traveling circus. He later took a job with the British North Borneo Company in the almost unknown interior of Borneo among the head-hunting Dyaks, where he almost died of jungle fever.

Love of adventure next drew him to Africa, where he spent five years in the employ of the Belgian Government and later of the Sanford Exploring Company in the region of the Congo. Since boyhood, Ward had had a strong leaning toward art, and in Africa his pen and pencil were constantly busy with notes and sketches of the Congo cannibals. One by one he collected the native weapons and implements, trading for them bright-

colored handkerchiefs, cans of beef, or even the meal he was about to eat.

Back in Europe, he took up art seriously, and after 1900 concentrated on sculpture. The idea grew on him of epitomizing in life-size sculptured figures the primitive life of the Central African natives. In five years spent among them he had come to know them well. He became blood brothers with Congo chiefs, doctored their babies, shared their food, and was much loved by them wherever he went.

For ten years Ward worked at his sculpture and received many honors and awards in Europe for the spectacular and unique African figures. On a visit to Washington in 1910 he became impressed with the ideals and aims of the Smithsonian, and decided eventually to place his entire collection there as a "portrayal of the soul of Africa." Ward died in 1919, and two years later the entire collection arrived in Washington and was installed in the National Museum with the assistance of Mrs. Ward.

Besides eleven of the dramatic life-size sculptured figures, there are 2,714 specimens representing more than a hundred different tribes. They cover every phase of Congo native life—weapons, ivory artifacts of all kinds, wood carving, musical instruments, articles of costume and adornment, and textiles. It is a splendid collection that could never be duplicated, because the Congo natives with increasing white contact have already abandoned some of their aboriginal ways. Of the sculptures, Sterling Heilig, a writer-friend of Ward's, says:

"The sculptor has infused into the dead bronze the pathos,

the dignity, and the genius of the African forest dweller. He has brought home to us the infinite tragedy of the Congo in these marvelous reproductions of Central African types, which tell all who see them of that unknown world of primitives, with its mysteries, its savagery, its suffering and its promise. Nothing but sheer power could have forced upon western cultured superficiality the interest which Ward's work excites—interest in a race long persecuted with pitiless cruelty, a race of another color, remote, incomprehensible to the western mind."

A unique exhibit recently placed on view in the Department of Anthropology, and one around which a heated controversy has raged for more than half a century, is the famed Kensington Stone with its long inscription carved in Norse runes. This stone was found by a farmer near Kensington, Minnesota, in 1898, under the roots of a large tree, and for many years was thought to be simply a clever fraud. Over the years, however, more and more favorable evidence has come to light until now many archeologists believe it is worthy of detailed investigation by runologists. The runic inscription tells a dramatic story of a band of Norwegian and Swedish explorers who in the year 1362—one hundred and thirty years before Columbus—had penetrated deep into the North American Continent. They were probably part of an expedition sent out by the king of Norway to search for the lost colony of Greenland who had apparently left that ice-bound island for the American mainland.

A translation of the inscription reads:

"(We are) eight Goths (Swedes) and twenty-two Norwegians on (an) exploration journey from Vineland through (or

across) the West. We had camp by (a lake with) two skerries one day's journey north from this stone. We were out and fished one day. After we came home (we) found ten (of our) men red with blood and dead. AVM (presumably Hail Mary). Save us from evil. (We) have ten of our party by the sea to look after our ships fourteen days' journey from this island. Year 1362."

Smithsonian archeologists have not yet definitely committed themselves as to the authenticity of the stone. However, the fact that they accepted it as a loan from the Alexandria, Minnesota, Chamber of Commerce and exhibited it to the public, coupled with the proposed publication by the Smithsonian of a favorable article on the stone by the Danish language expert Thalbitzer, indicates an open mind on the question.

The Kensington Stone makes a strong appeal to the public. Visitors are often seen studying the stone long and closely, as though they were trying to decipher for themselves the strange-looking runic characters. Its label bears a translation of what sounds like the despairing last words of a doomed Norse expedition. The desperate remaining members of the band doubtless felt that they might never return to their homelands—which apparently they never did—and they wished to leave a runic record for posterity testifying to the extent of their penetration into the new continent.

The top anthropological mystery of all time, however, is Easter Island, represented in the National Museum by one of its famous huge stone statues, with their "empty eyes and scornful expressions." Dr. Alfred Métraux, former Smithsonian anthropologist, visited Easter Island some years ago to try his hand at solving the mystery of these incredible monstrosities.

A few quotations from his report will indicate the interest of this strange land.

"A treeless volcanic rock, scarcely 13 miles long and 7 miles wide, slowly being eaten away by the waves and lost in the great emptiness of the Pacific Ocean—2,000 miles off the coast of Chile and 1,500 miles from the nearest Polynesian archipelago—this is Easter Island, the most isolated spot ever inhabited by man. Today it supports a mere handful of natives, mostly half-castes, and many of them lepers.

"There are few spectacles in the world more impressive than the sight of the stone quarry on the slopes of the volcano, Ranoraraku. The place is indeed sinister. Imagine a half-crumbled volcano, a black shore line, and huge cliffs which rise up from the sea with smooth green pastures above them. Guarding the quarry, near the volcano, is an army of giant stone figures scattered in the most picturesque disorder. Most of them still stand out boldly. Successive landslides have partially covered others, so that only their heads emerge from the ground, like those of a cursed race buried alive in quicksand. Behind the rows of the erect statues, along the slopes of the volcano, there are 150 figures still in the process of being born. Wherever one looks in the quarry, one sees half-finished sculpture. Caves have been opened in which statues rest like those on medieval sepulchers in the crypt of some great cathedral.

"There is something weird in the sight of this deserted workshop with the dead giants all about. At every step, one stumbles over discarded stone hammers. It is as if the quarry had been abandoned on the eve of some holiday, and the workers were expecting on the day after to return and resume their tasks.

Such an abrupt stoppage in the sculptor's activity suggests some unforeseen catastrophe, some extraordinary event which upset the entire life of the place. There is a legend among the natives that an old sorceress, forgotten perhaps at a feast, in her rage put a curse on the quarry which frightened the workers away forever. Whatever the truth about the end of their work, it appears that the last of the stone carvers were under the spell of a megalomaniac dream. Some of the unfinished statues are of enormous size, one of them 60 feet tall. Others are to be found in places out of which it seems impossible that they could have been taken."

Dr. Métraux did not succeed in solving the mystery of the giant stone figures, but he did satisfy himself that the first settlers of Easter Island were Polynesians, probably arriving there about the twelfth century A.D. from one of the island groups far to the westward.

Back in the National Museum and the Department of Anthropology, we find certain collections that seem almost like sidelines, yet they definitely represent the activities of man of Colonial times. These are the very extensive and priceless assemblages of antiques, old silver and ceramics, lamps and candlesticks, and musical instruments that attract so much popular attention and require so much of the curators' time to answer questions concerning them.

A very recent addition is the unique collection of American antiquities assembled over a long period by Mrs. Arthur M. Greenwood, of Marlboro, Massachusetts, and presented by her to the Smithsonian in memory of her late husband. It is unique because it was brought together largely in New England before

antique collectors had combed that section of the country and because it contains all the actual things used on farms and in villages from so far back in our history that they were made at home or in small, local shops. The collection adds up to nearly 2,000 items ranging from home-made pottery dishes and leather ale pitchers to a complete tin-peddler's cart with all the trimmings. There is even school-room equipment from the original "Mary's Little Lamb" school.

Another unrivaled collection in the Museum is that of keyboard instruments, made up chiefly of the 173 specimens presented by the late Hugo Worch of Washington. Mr. Worch spent a good part of his lifetime in seeking out rare instruments to show the entire process of development of the piano and the forms that preceded it. The instruments range from that rarest of all forms, the clavicytherium, to the rather over-elaborate gold-leaf-covered Steinway grand that graced the White House during Theodore Roosevelt's administration. It includes beautifully decorated harpsichords that go back to the 1600's, spinets, melodeons, and the delicate early pianos of the Federal period. There is the first American-made upright made by John Isaac Hawkins in Philadelphia in 1801 and described by Thomas Jefferson as "one of the prettiest improvements in the pianoforte I have ever seen."

The Museum has also a very extensive general collection of the amazingly diversified musical instruments of all countries and all times. An unusual twist to the curator's duties is the answering of hundreds of letters from people who are sure they have original Stradivarius violins. The work of the great master-builder has been so widely imitated—even to adding

17. *Right:* Bust by Sir William G. John of Herbert Ward, explorer and sculptor, who gave the Ward African Collection to the Smithsonian. Ward lived for five years among the primitive cannabalistic African natives whose homelands stretched along a thousand miles of the mighty Congo. His life-size bronze sculptures symbolize this "unknown world of primitives, with its mysteries, its savagery, its suffering, and its promise." As a background, he collected nearly 3,000 specimens of their weapons and other objects of their arts and industries.

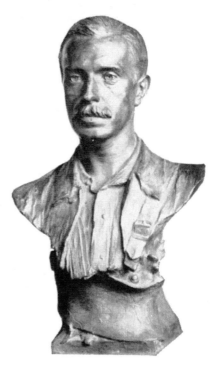

Below: "The Congo Artist," by Herbert Ward. The primitive artist is concentrating intently on scoring the figure of a serpent in the soft clay.

18. *Above:* "Defiance," by Herbert **Ward.** One of the best of Ward's statues of Congo natives. It represents a primitive fighter with every sinew knotted in complete readiness for immediate and deadly combat. Dr. W. H. Holmes said of it: "This remarkable statue depicts the human savage, the primitive man not yet freed from the shadow of the wild."

Left: "The Idol Maker," by Herbert Ward, represents another phase of primitive Congo art — wood-carving.

19. *Above:* "The Wood Carrier," by Herbert Ward. The nude slave woman is bringing from the forest the customary heavy load of fagots.

Right: "The Chief of the Tribe," by Herbert Ward. A Congo chieftain seated on a lion skin and reclining against a strange native chair on the back of which are suspended human skulls, attesting to his prowess in battle and symbolizing his office.

20. A visitor studies "Le Sorcier," or The Charm Doctor, by Herbert Ward. The Congo tribes believe that mystic powers control the destiny of their people, and the Charm Doctor is assumed to have magical power. He works himself into a frenzy through such wild antics as depicted in this statue. *Courtesy National Geographic Magazine.*

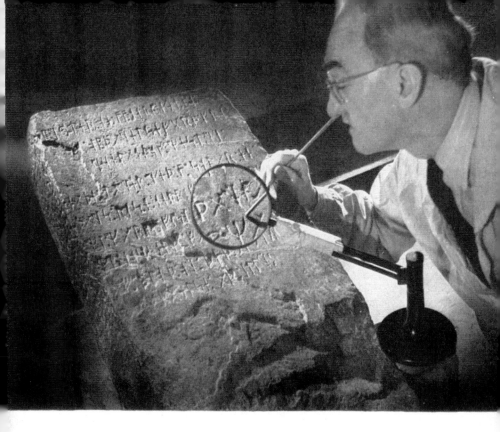

Vikings in Minnesota?

21. Smithsonian archeologist studying the runic inscription on the famous Kensington Stone. For half a century a controversy has raged over the genuineness of this interesting historical relic. It was found under the roots of a tree in Minnesota in 1898, but scholars branded it a fake. Gradually evidence has come to light indicating that the stone may be genuine after all. The runic inscription records the desperate plight of a Norwegian exploring expedition surrounded by hostile Indians in Minnesota in the year 1362. At the Smithsonian the stone fascinates visitors with its mysterious inscription. *Copyright National Geographic Magazine.*

22. *Above:* Cast of the original Rosetta Stone, which provided the key to the translation of Egyptian hieroglyphic inscriptions. It contains a decree by Egyptian priests in 196 B. C. written in both hieroglyphics and Greek, enabling scholars to work out the meaning of the inscriptions on Egypt's ancient monuments.

Right: Egyptian mummy in the National Museum. More than 2,000 years old, it was found at Luxor, Egypt, in 1886. The Egyptians preserved the bodies of their dead so that the *ka*, or double, could take possession of the body again whenever it wished to do so.

23. *Above:* Polynesian fishhooks and lures skilfully contrived by natives of the South Pacific islands.

Left: One of the mysterious giant stone statues from Easter Island with its "empty eyes and scornful expression." The mystery of who made these stone monstrosities on a tiny island lost in the vast reaches of the Pacific has never been solved. This particular statue is 10 feet high, but some reached a height of 60 feet.

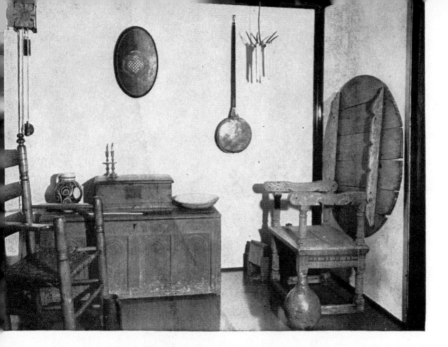

24. *Above:* From the Green-
wood collection of New Eng-
land early Colonial antiques.
The chest at left is a carved oak
and pine wainscot chest made
in Massachusetts about 1660; at
right is an oak chair-table made
in Connecticut around 1680.

Below: From the same collec-
tion. The early Colonial house-
wife expressed her artistic lean-
ings through needlework, em-
broidery, and textiles, most of
her work showing imagination
and good color sense. The
wooden object in the center,
resembling an anchor, is a
"niddy noddy" for winding
yarn.

THE ORIGINAL JOHN BULL LOCOMOTIVE

25. The John Bull was built in England and first used on the Camden and Amboy Railroad in New Jersey on November 12, 1831. It is the oldest complete locomotive in America.

This locomotive, the largest single exhibit in the entire Arts and Industries Building of the National Museum, was the forerunner of our vast railroad system. For many decades, steam transport was considered impractical compared with horse-drawn canal boats.

Oliver Evans, one of America's pioneers in railroading prophesied early in the last century; "The time will come when people will travel in stages moved by steam engines from one city to another almost as fast as birds fly—15 to 20 miles an hour. Passing through the air with such velocity changing the scenes with rapid succession will be the most exhilarating, delightful exercise."

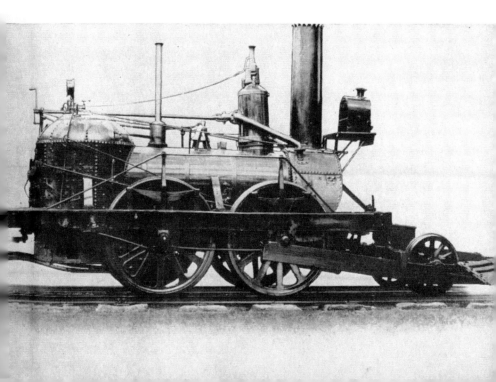

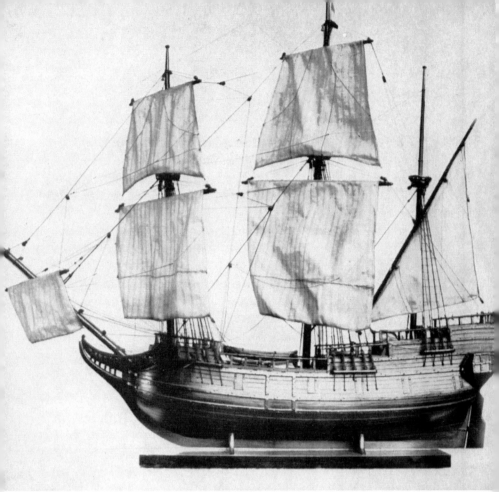

THE PILGRIMS' BARK, *Mayflower*

26. Model of the *Mayflower*, made in the National Museum's shops. This ship on which the English colonists came to the New World in 1620 was a three-masted, double-decked, bark-rigged merchant ship with a normal speed of 2½ miles per hour. She was approximately 90 feet from stem to stern, with a beam of 26 feet.

On September 16, 1620, she sailed from England with 102 passengers and crew. Cape Cod was sighted on November 19, and the site of Plymouth, Massachusetts, was reached on December 21. On the 26th the *Mayflower* sailed into Plymouth Harbor where she remained until houses could be built for the new settlement.

27. *Above:* Model of Fitch's steamboat of 1787. John Fitch successfully demonstrated his steamboat on the Delaware River at Philadelphia on August 22, 1787. Fitch reaped no reward for his invention.

Below: Model of Robert Fulton's steamboat, called the North River Steamboat of Clermont, that made a successful trial trip on the Hudson River from New York to Albany and return, starting on August 17, 1807.

28. *Above:* Model of Rumsey's steamboat, publicly operated on the Potomac at Shepherdstown, West Virginia, on December 3, 1787, about three months after Fitch's demonstration. Rumsey's boat operated by pumping a stream of water out through the stern under water.

Below: Model of a Viking ship made after an actual old ship excavated from a "King's Mound" in Norway. The ship itself was contemporaneous with the voyage of Leif Ericsson to the American continent in the year 1001.

Below: Typewriter patented in 1868 by Sholes, Glidden, and Soule. This machine was the basis for the first commercially successful typewriter.

29. *Above:* Original model of the Whitney cotton gin presented to the National Museum in 1864 by Eli Whitney, Jr.

Below: Original sewing machine built by Elias Howe, Jr., in 1845—forerunner of millions of later machines.

Above: Original patent model of Singer's sewing machine.

30. *Above:* Experimental apparatus used by Samuel F. B. Morse in New York in 1837 to demonstrate his electromagnetic telegraph. Below the apparatus is shown the actual tape of Morse's first telegraph message transmitted from Baltimore to Washington in 1844: "What hath God wrought."

Below: Two of Graham Bell's early telephone instruments. These may be the very models submitted with his patent application.

31. Appliquéd "stuffed work" quilt in the National Museum's Division of Textiles. The textile exhibit is a fascinating exposition—especially for lady visitors—of the use of color, design, and texture in every conceivable type of fabric. Some of the original hand-made textiles of our Colonial ancestors are among the most appealing because of their originality of design and the great amount of loving work that went into them. Along with the textiles are displayed the machines used in making them.

32. VETERANS OF THE AUTOMOBILE WORLD AT THE NATIONAL MUSEUM.

Left:

1. Duryea gasoline automobile of 1893-94. Built on the lines of the buggy of the day, it had a 1-cylinder, 4-horse-power water-cooled engine. It was first operated on the streets of Springfield, Massachusetts, in September 1893.

2. Olds gasoline automobile of 1897. This is one of four cars built in that year by the Olds Motor Vehicle Co. With four passengers it could make 10 miles an hour.

Right:

3. Winton, 1898. This is the first Winton ever sold, going to Robert Allison of Port Carbon, Pa., who was 70 years old at the time. It had pneumatic tires.

4. Franklin, 1902. This is the third Franklin built and the first one ever sold. The air-cooled engine was mounted crosswise under the hood. It sold for $1,250.

replicas of the Stradivarius labels—that the uninitiated are continually being duped into the belief that a fortune is within their grasp. It has been necessary to compose a mimeographed statement on the matter to simplify the handling of the volume of correspondence. It is explained that record of ownership has been kept on practically every genuine violin. So seldom has it been that an undocumented violin has been identified as genuine that *any violin bearing a Stradivarius label but not accompanied by a historical record must be considered a reproduction.* The statement hastens to add: "Do not send your violin to the Smithsonian for appraisal. The Institution has in its collections no violins made by Antonius Stradivarius."

The Smithsonian Institution has throughout its existence taken a leading part in advancing the science of anthropology, particularly in relation to the New World and its aborigines. It has cooperated with a great number of organizations concerned with the anthropology of the Americas, and has long served as a clearing-house for the coordination of efforts in this field.

The Smithsonian has three distinct agencies engaged in the promotion of anthropological studies—one, the National Museum's Department of Anthropology, headed by Frank M. Setzler, which is described briefly in this chapter; the Bureau of American Ethnology, directed by Dr. M. W. Stirling, covered in a later chapter; and an autonomous unit of the Bureau, the Institute of Social Anthropology, established in 1943 to conduct cooperative anthropological teaching and research in the other American republics. The three agencies do not overlap; rather, the work of each supplements that of the others. The

first-named works from the museum angle—that of assembling adequate collections to represent the peoples of the world for exhibition and research; the second restricts itself to studies in the field of the present and prehistoric aborigines of the Americas and to publication of its findings; and the third has a double objective: (1) to introduce modern social science theories and techniques to other countries so that they may train their own scholars for such work, and (2) to accumulate basic social science data about the rural populations in those countries.

The work of these three Smithsonian anthropological agencies, together with their very comprehensive publication programs, has contributed largely to the advancement of the "science of man," particularly in the New World.

V. *Man's Achievements*

To see the things that have raised mankind from a primitive way of life to our present state of what we hopefully call civilization, we leave the Natural History Building and walk across Washington's beautiful Mall to the Arts and Industries Building. These two structures of the Smithsonian group are on opposite sides of the Smithsonian Park, an area of some 19 acres almost directly in the center of the Mall. At one end of the Mall is the Washington Monument; at the other, the United States Capitol, as shown on Major L'Enfant's plan for the development of Washington. About halfway across the Mall most of the camera fans among the thousands who visit the Smithsonian daily stop to snap pictures in each direction of these two famous structures. They must be among the most photographed buildings in the world.

In the Arts and Industries Building are just two departments —Engineering and Industries, and History. More visitors are clocked at the door of this building than at that of the Natural

History Building, probably because here are two exhibits that no one wants to miss—the Wright and Lindbergh planes and the presidents' wives' dresses. But there are many other things that are nearly as popular—for instance, the early automobiles. Lined up in double rank like a group of old veterans, some twenty-five old cars stand more or less at attention. They are the survivors of the turn-of-the-century competition with the horse and buggy to determine man's best means of transportation.

The oldest is the Duryea, built by Charles E. and J. Frank Duryea at Springfield, Massachusetts, and operated on the streets there in September 1893 and again in January 1894. It resembles an ordinary buggy of the period, complete with iron steps and buggy top, but is equipped with a one-cylinder gasoline engine, a transmission providing two speeds forward and reverse, a differential, and a steering tiller. In 1896 the Duryea Motor Wagon Company built thirteen cars all alike— America's first mass production of automobiles. The first gasoline automobile sold in America was one of these cars.

The automobile is not strictly an American invention. Steam carriages that carried passengers over the highways were built and operated in France and England in the early part of the nineteenth century. In England they encountered opposition, and in 1865 these road steamers were effectively halted by an Act setting a conservative open country speed limit of four miles an hour, and two miles an hour in town. To complete the suppression of these forerunners of the automobile, the law required that a man walk ahead of them carrying a red flag. This obstructive law was repealed in 1896. Vehicles with internal

combustion engines began to appear in Europe after the middle of the century. Models and drawings of some of these early European devices, as well as of a few attempted in the United States, are shown in the Museum.

One of the oddest of the American steam vehicles was John C. Praul's tractor patented in 1879. It was propelled by two pairs of mechanical walking legs, which by means of complicated linkages moved up and down and forward and backward very much like the movements of a cow's hind legs.

Following the Duryea in the National Museum come the very first car built by Haynes in 1894, one of the four built by Olds in 1897 (the earliest surviving Olds), an 1898 Winton, the first of that make ever sold, and also the Winton that in 1903 made the first transcontinental automobile trip. H. Nelson Jackson drove this two-cylinder Winton from San Francisco to New York in 63 days, but only 44 of these days were spent in actual travel. Much of the trip was over roads and trails that we would call impassable.

The White steamer shown was made in 1901, the first year of automobile manufacture by—of all things—the White Sewing Machine Co. of Cleveland. These steamers had several interesting features. Having no transmission or clutch, they resembled the no-gear-shift cars of today in simplicity of operation. The steam was superheated and after doing its work was passed through a muffler, making the exhaust practically invisible and noiseless. Nevertheless, steamers were not to survive competition with gasoline-powered cars, although for a few years it had looked as though they would be the ultimate in self-propelled vehicles.

Another old-timer is the first Franklin automobile ever sold. It was built in 1902 and was priced at $1,250. It had several unusual features: its engine was placed crosswise under the hood and was air-cooled, and its steering wheel was on the right-hand side of the front seat instead of the usual left position of today. The Cadillac of 1903—its first year of manufacture—looks somehow different from the Cadillac of today. It had a one-cylinder engine, its ignition system included a set of dry cells under the floor boards, entrance to the back seat or tonneau was through a narrow door at the back, and it had no top or windshield. Optional equipment included kerosene headlights, a bulb horn, and large wicker baskets on each of the rear fenders. It sold for $850.

Skipping over a number of makes that followed, we come to a familiar sight that gives old-timers a fit of nostalgia—a 1913 model-T Ford. Fifteen million model-T's were made, and many are still in daily use. They started the automobile era that we still live in—if we look both ways before crossing the street.

The old automobiles come under the Division of Engineering, one of the four divisions of the Department of Engineering and Industries. The other three are Crafts and Industries, Graphic Arts, and Medicine and Public Health. The purpose of the entire department is to exhibit, study, and document the inventions and products that have made our way of life what it is today. To put it another way, it records through public exhibits and study collections the history of our present amazing development in the diverse fields of transportation, communication, power production, engineering, manufactures, engraving and printing, and medicine. By their nature these subjects over-

lap to some extent in the various divisions, and we will not attempt to follow organizational lines in presenting them. Instead we will simply sketch a few of the most popular and important phases of man's material achievements.

It has been said that the greatest American invention was our method of invention and patenting. At any rate, the list of truly American inventions is impressive. A poll of scientists and industrialists taken a few years ago listed the following as America's most important basic contributions to the modern industrial world:

Air brake	Reaper
Airplane	Sewing machine
Aluminum production	Steamboat (commercial)
Cotton gin	Telegraph
Incandescent lamp	Telephone
Induction motor	Thermosetting plastics
Linotype	Three-electrode vacuum tube
Motion-picture projector	Typewriter
Oil cracking	Vulcanization of rubber
Phonograph	

To realize their importance, read the list again and imagine life without them. In the National Museum many of them are traced from their very inception.

The two in the communication field, each of which marks a definite turning point in the American way of life, are especially well represented. The receiver is there which Samuel Morse used to demonstrate the electromagnetic telegraph in 1837, seven years before he sent the historic first message, "What hath God wrought?" over the line from Washington

to Baltimore, along with the actual paper tape across which marched the dots and dashes of that famous message. For the telephone there are instruments presented to the Museum by Alexander Graham Bell, including a receiver and a transmitter which could be the originals sketched and described in the patent of March 7, 1876. Among other relics of early telephone history is the 1880 New York City phone directory. Less than a quarter of an inch thick, it contains 84 small pages including the business directory.

Another less-known Bell invention shown in the Museum is what he called the photophone, a novel device that he used in 1880 to talk to a friend over a city block away, using as a conductor nothing but a beam of light. The transmitter was a reflecting diaphragm, the receiver a bowl-shaped device that reflected the incoming light beam onto a selenium cell at its focus, hooked up to a telephone receiver and a battery. When the diaphragm was vibrated by a speaker's voice, it sent to the distant receiver an undulating beam of light which the selenium cell translated back into the sound of the speaker's voice. This apparatus was successfully operated by Dr. Bell and Mr. Tainter between the top of a schoolhouse at 13th and I Streets in Washington and the window of Bell's laboratory at 1325 L Street, more than 700 feet away.

On November 2, 1920, a pre-announced radio broadcast went feebly out to the few, mostly home-made "tube-sets" then in American homes. The broadcast, consisting of news bulletins of the Harding-Cox election returns, came from station KDKA of Pittsburgh. It was the first announced broadcast ever transmitted in this country. The microphone used—called a "tomato

can"—is in the Museum's historical radio exhibit, along with a progressive series of later "mikes."

From any part of the communications exhibits can be heard an intermittent mournful sound like a whistling buoy on a foggy night. Approaching its source, we find that it comes from the most modern exhibit in the communications field—a fascinating audio-visual demonstration of radar contact with the moon. It is operated by a push button, and few can resist the urge to try it out. On June 10, 1946, Army Signal Corps engineers at Belmar, New Jersey, sent out a powerful radar pulse signal and detected echoes of the signal bounced back from the moon. The exhibit that dramatically demonstrates this first human contact with any heavenly body is an illuminated ten-foot-long diorama with the globe of the earth at one end and the glowing orb of the full moon at the other, a velvety, star-studded sky stretching between. When the button is pressed, a plaintive sound simulates the radar signal sent out, and weird purple waves of light vibrate from earth to moon and back to earth, a weaker sound recording the arrival of the echo at the receiving instruments.

The basic mechanical elements by means of which man began to lift himself out of an animal-like existence are the lever, the inclined plane, the roller, the pulley, the wheel and axle, and the screw. Originally they merely augmented the muscular efforts of men and animals, but gradually they were incorporated into more and more complex machines that use the various types of natural energy. A few of the universally used modern devices that utilize the basic mechanical powers to accomplish manual labor are faucet levers, tool handles,

steering wheels, golf clubs, typewriter keys, and gear-shift levers.

To illustrate the later applications of power elements, the Museum shows a bewildering array of mechanical devices from animal treadmills, windmills, and water wheels through all the stages of steam-engine development to internal-combustion engines and refrigerating machines. Some of the early engines exhibited are of great interest historically as well as mechanically, as for example the steam engine built by John Stevens of Hoboken, New Jersey, and used by him to propel a steamboat on the Hudson in 1804. It is believed to be the oldest American-built steam engine in existence.

Crossing the threshold of the adjoining hall we enter another world—the world of ships. Here we seem to catch a pungent breath of sea salt and tarred line, hear in fancy the hoarse blast of a great steamship cutting across the frantic tooting of harbor tugs. The ship's clock amidships sounds five bells as we arrive in the midst of hundreds of models and full-size craft—models of almost every known type of boat from Chinese junk to sleek modern liner. The entire hall is simply crammed with sails, spars, and rigging. Here is a wealth of enjoyment and instruction for boat lover, naval architect, and historian.

Bringing back to memory all the romance and adventure of the days when sailing ships ruled the seas, the block models of American-built packet ships are of particular interest. The trim, fast lines of these famous merchant ships were developed under pressure of the necessity of showing a clean pair of heels to pirates, hostile war vessels, and privateers of the early part of the nineteenth century. The strong, swift, and beautiful

packets, American designed and built, were the envy of European shippers. Fast ocean voyages paid large dividends to owners, and rival captains competed for speed records. The packets staggered across the Atlantic under a cloud of canvas in the heaviest weather. Yet so well were they designed for such rugged service, and so courageous and capable were their officers and crews, that they seldom met with disaster. Captain John Johnston, commander of the New York to Le Havre packet service, said, "In all my career I never knew the wind to blow but twice." One of the two occasions was on August 16, 1839, when a full hurricane blew away every stitch of canvas from the *Rhone,* the ship he commanded at the time.

The experience gained by American builders in constructing packet ships equipped them for their crowning achievement—the great white-winged clippers. Such ships had never before sailed the seas, and for years they were the wonder of the world. The speed of the clippers was phenomenal. The *Red Jacket* made 325 miles a day for a whole week. The *Sovereign of the Seas,* on a trip from Hawaii to New York which she made in 82 days, recorded one 24-hour run of 437 miles. According to the marine historian Henry Hall, writing in 1880, this was the fastest time ever made for a day's run by any vessel, sailer or steamer. The *Comet,* a clipper built in 1851 in New York by William H. Webb from the actual block model shown in the Museum, once made the run from San Francisco around South America to New York in 76 days. The *Comet* was described as "remarkable for speed, seaworthiness, strength, productiveness, and good luck."

A typical American story of inventiveness and persistence

is the development of the steamboat. The National Museum has well-documented models made in its own shops of the earliest steam-driven craft. Although Robert Fulton is generally credited with the invention of the steamboat, actually others preceded him with practical demonstrations, including the three Americans, John Fitch, James Rumsey, and John Stevens. Fitch, and three months later Rumsey, successfully operated small steamboats in the year 1787. In 1804 Stevens operated a small twin-screw steamboat in New York Harbor. It remained for Fulton, however, to demonstrate the feasibility of commercial use of the steamboat by the successful trip of his *Clermont* from New York to Albany and return in 1807.

Fitch, the very first to achieve success, was prevented by ill luck and lack of support from carrying his invention through to practical usefulness. Near the beginning of his work with steamboats, he wrote: "I know of nothing so perplexing and vexatious to a man of feelings, as a turbulent Wife and Steam Boat building. I experienced the former and quit in season, and had I been in my right sences I should undoubtedly have treated the latter in the same manner, but for one to be teised with both, he must be looked upon as the most unfortunate man of this world." At the end of his account he prophesied: "The day will come when some more powerful man will get fame and riches from my invention, but nobody will believe that poor John Fitch can do anything worthy of attention." Nine years afterward Robert Fulton reaped the rewards that "poor John Fitch" missed. Fulton gave the world the first practical and commercially successful steamboat. For this he de-

serves high honor, but not for the invention of the steamboat, a claim he himself never made.

As we wander about the boat hall we are struck with the amazing diversity of craft from different parts of the world and from different periods of history. The boats used by primitive peoples are particularly interesting as illustrating the various means arrived at independently for providing water transportation adequate for their needs. Among the unusual forms is the grass boat or balsa used by Indians of Mexico and Peru. It consists of three or more cigar-shaped bundles of dried reeds lashed together and propelled with paddles or simple sail. Another is the bull boat of the Hidatsa Indians, a round, bowl-shaped craft made by stretching a buffalo hide over a circular framework of pliable saplings and branches. The Irish fisherman's curragh is built somewhat on the same principle, being a round-bowed, square-sterned craft made by stretching tarred canvas over a frame consisting of a stout wooden gunwale and a basket-like bottom formed of willow withes. The curragh rides on the water like a cork, and the fishermen used to go miles out on the open Atlantic in them in the roughest weather when an ordinary boat would soon be swamped. Other queer craft are the Eskimo kayak and oomiak made of sealskin; the East Indian coracle, a saucer-shaped one-man boat made by covering a light framework of rattan with oilcloth; the machva, or Bombay fishing boat, one of the world's most distinctive types with its upcurved keel—when beached, it rests on only two points at bow and stern; and the amazingly speedy Malay outrigger canoes.

American watercraft are naturally best represented in the Museum. Government and merchant vessels, river craft, fishing boats of all types, and yachts and pleasure boats all find a place in the National collection. Among the hundreds of fully rigged models of sailing vessels the student of naval architecture will learn how the form, construction, and rig of such craft have been modified to meet special requirements of trade or of varying local environments.

A valuable adjunct to the Watercraft Collection is the Historic American Merchant Marine Survey started during the depression of the 1930's to give employment to shipyard workers and marine architects. Containing hundreds of drawings and photographs of old vessels of all types, this invaluable archive illustrates the development of American watercraft from great ocean-going sailing craft down to small fishing boats of many localities. The collection is used extensively by marine architects, model makers, historians, hobbyists, and collectors. More than 350 prints and photographs are furnished at cost each year.

From here on, the visitor to the Engineering and Industries Department can choose from among the widest range of man's material achievements the things that appeal most to his tastes and interests. For there are large sections of the exhibition halls devoted to such diversified subjects as time-keepers of all ages, ancient and modern firearms, manufactures such as rubber, leather, and ceramics, textiles of every description and the machines that make them, the woods of the world and their manifold uses, medicine and public health from their crude beginnings to the amazing developments of recent years, and

graphic arts including photography. The main graphic arts exhibit is shown in the Smithsonian Building.

The time-keeping devices appeal to all visitors because of their extreme diversity and ingenuity. The most primitive is a short length of knotted rope made of twisted vines or grass. Certain aboriginal peoples used as a measure of time the period required to burn the rope, the knots determining the time intervals. There is a large candle marked off in sections with painted lines and numbers, each section calculated to burn for a predetermined period of time. And of course the familiar hourglass appears in all sizes and shapes. From these and other ancient devices for keeping track of the passage of time, an astounding variety of clocks and watches used through several centuries lead up to the ultimate in modern complexity—a clock with 93 dials made by Louis Zimmer of Lier, Belgium. This clock not only tells standard and daylight time at ten different parts of the world, but also indicates the tides at various localities, shows the movements of the planets and certain stars, foretells moon events, and furnishes the year, month, and day.

An unusual clock of both mechanical and historical interest is a tower clock made by hand in 1796-97. This giant time-keeper, equipped with a 14-foot pendulum, operated as the town clock of Frederick, Maryland, from 1797 to 1928. Having served faithfully and well for 131 years, it has been retired to the National Museum, where it still runs—and keeps good time. For those interested in seeing what makes a watch tick, there is a man's pocket watch in a special case with the back removed, showing the works in operation. It is identical with the watch you carry except for one thing—it is about fifteen inches in

diameter, with all the wheels and springs of proportionately giant size, so that the motions of the various parts can be easily observed.

Another hall that holds particular interest for feminine visitors is that devoted to textiles. Here the old and the new meet and blend in pleasing harmony. The painstaking and beautiful handiwork of our ancestors appears in the form of delightfully old-fashioned samplers, quilts, and raised woolwork. Intricate and striking designs feature the coverlets woven on hand-operated Jacquard machines. These lead into the fully machine-made fabrics of all materials and of every description that culminate in the beautiful ultra-modern fabrics woven of metallic yarns. Textile machines also are shown from old hand looms to modern Jacquard machines, braiders, and spinning frames for spinning cotton yarn.

In a rather obscure corner of the textile hall is an unspectacular exhibit telling the story of a device that has changed the face of our civilization perhaps as much as any other machine ever invented—the sewing machine. Less than one hundred years ago it has been estimated that nearly half the human race was occupied chiefly in making clothes. The pitiful plight of England's many thousands of seamstresses is made all too plain in Thomas Hood's "Song of the Shirt":

> With fingers weary and worn,
> With eyelids heavy and red,
> A woman sat, in unwomanly rags,
> Plying her needle and thread,—
> Stitch! stitch! stitch!
> In poverty, hunger, and dirt;

Man's Achievements

And still with a voice of dolorous pitch—
Would that its tone could reach the rich!—
She sang this "Song of the Shirt!"

With the advent of the sewing machine all this was gradually changed. Women released from hand-sewing drudgery began to invade all occupations, and the sweeping changes in women's status in relation to law, business, and society can be ascribed in considerable measure to the sewing machine.

A former curator of the National Museum's Division of Textiles, Dr. Frederick L. Lewton, made a very thorough study of the invention and development of the sewing machine, based on the Museum's extensive representation of originals and models of some of the earliest machines. The story contains all the elements of human drama—conflict, failure, success, tragedy, comedy. The first scene is laid in England in 1790, when one Thomas Saint received a patent on a machine for sewing leather. It had some of the essential features of our machines of today, but the inventor failed to carry it past the experimental stage. The next scene moves to France, where a poor tailor named Barthelemy Thimonnier became so absorbed with the idea of a machine to sew seams that he almost starved himself and his family while trying to make one. He succeeded, though, and was given a patent in 1830. Soon after, he had eighty machines at work making army uniforms, but an infuriated mob of worried tailors smashed all his machines and he had to flee for his life. He started all over to improve his machine, but fate was against him and he died in poverty in 1857. One of his machines, together with several made in England and one from America, was shown at the Crystal Palace Exhibi-

113

tion held in London in 1851. No one paid any attention to them except a surprised Italian newspaper reporter who wrote about them thus:

"A little further on you stop before a small brass machine, about the size of a quart bottle; you fancy it is a meat roaster; not at all. Ha! Ha! It is a tailor! Yes, a veritable stitcher. Present a piece of cloth to it; suddenly it becomes agitated, it twists about, screams audibly,—a pair of scissors are projected forth —the cloth is cut; a needle set to work, and lo and behold, the process of sewing goes on with feverish activity, and before you have taken three steps a pair of inexpressibles are thrown down at your feet, and the impatient machine, all fretting and fuming, seems to expect a second piece of cloth at your hands."

The final scenes are in America, where the action proceeds more rapidly. In New York City Walter Hunt built a successful sewing machine some time between 1832 and 1834. Hunt was a Quaker who had already invented a dozen or more devices from repeating rifles to safety pins. His draughtsman wrote that Hunt worked out the idea for the safety pin, made a model out of an old piece of wire, and sold the invention for $400 within a period of three hours to pay a debt of $15. His sewing machine worked, but was dropped temporarily because of the difficulty of obtaining support.

In Boston in 1839 a young machinist named Elias Howe, Jr., heard the remark in a machine shop that the builder of a sewing machine would reap a fortune. The idea obsessed him, and after some years of working on it under conditions of desperate poverty for himself and his wife and three children, he actually produced in 1845 a machine that would sew and obtained a

patent the following year. This very machine—pioneer of millions of sewing machines that followed it—crossed the ocean several times, appeared on the witness stand in many court trials, and at length reached its final resting place in the National Museum for all to see.

The next contender was Isaac M. Singer. Also working in Boston, he produced a sewing machine with a number of marked improvements over previous machines and received a patent on it in 1851. As soon as he started to manufacture his machines, however, Howe was at his door demanding a large sum for patent infringement. The courts sustained Howe, and Singer had to buy a license under the Howe patent.

There were others in the sewing-machine drama, such as Wilson, Gibbs, and Grover, but to Howe and Singer must go respectively the credit for the first introduction of the sewing machine to the prominent position that it now occupies and for developing the first practical sewing machine for domestic use.

The story is typical of so many inventions. Some of the pioneers failed. Others succeeded but reaped no reward. A few succeeded both mechanically and financially. Poor Barthelemy Thimonnier spent his life in struggle and poverty trying to promote his machine, but in vain. Walter Hunt built a machine that would sew, but could not promote it. Howe and Singer each built good sewing machines and each reaped a rich harvest. Singer was actively engaged in manufacturing machines for only about ten years, but when he died his estate was valued at $13,000,000. The sewing machine is typical also of the Department of Engineering and Industries' endeavor

to preserve and document the great inventions that have made possible our present way of life.

Other exhibits of the department visualize the development of great industries such as the utilization of rubber, leather, and wood; also the ceramic and chemical industries. The great advances in medicine and surgery, pharmacy, and public health are documented by extensive exhibits in each of these fields. The source and classification of drugs and medicines are particularly well shown, even up to the miraculous sulfonamides, streptomycin, and penicillin. A single exhibit, perhaps unique in the entire world, is a complete two-room apothecary shop of the period of 1750 complete to the last detail of authentic fixtures, bottles, utensils, and books collected in Europe.

In the field of graphic arts, very complete material sets forth the whole story of printing, engraving, etching, and all other of man's methods of expressing ideas and recording images. Not only are examples shown of the etchings and wood cuts of great masters of these arts such as Durer, Rembrandt, and Whistler, but also and to a far greater extent the beautiful products of modern photomechanical methods of reproducing pictures and images. The Halls of Graphic Arts, located in the adjoining Smithsonian Building, form one of the Museum's most directly educational exhibits, for the methods of printing and engraving are clearly explained step by step through all their intricate processes.

Among unusual media of art expression is an oil painting on a cobweb. Done with the most delicate tiny brushes and very thin paints, the surprisingly creditable result is mounted between sheets of glass to prevent its disintegration. A group of

small mosaics includes an oval example only half an inch wide
and less than an inch high. In this minute space, a good repro-
duction of a brown dog lying on the grass is formed by some
three hundred pieces of colored glass. To show the possibili-
ties of microengraving, there is displayed under a microscope
the incredible feat of engraving the entire Lord's Prayer inside
the eye of a needle.

Coming back to where we started on this tour of man's ma-
terial achievements, we stand before the largest single exhibit
in the entire Arts and Industries Building—the original steam
locomotive *John Bull*. This, the oldest complete locomotive
in America, was built in England and put in service on the Cam-
den and Amboy Railroad of New Jersey on November 12,
1831. Three other small railroad companies had been organized
a few years before, and the era of steam transport in America
was opened. These revolutionary improvements that seem to
us now so obvious were brought about only after years of heart-
breaking struggle against almost universal opposition. One of
the pioneers was Oliver Evans, who is credited with being
America's first manufacturer of practical steam engines. Evans
saw the inevitability of steam transport and tried desperately
for thirty years to convince the Government and the people
that it would be infinitely better than canal boats and horse-
drawn vehicles. He died before his vision was proved to be
correct, but a few years before his death he penned his beliefs
and his disappointment thus:

"The time will come when people will travel in stages moved
by steam engines from one city to another almost as fast as
birds fly—15 to 20 miles an hour. Passing through the air with

such velocity changing the scenes with rapid succession will be the most exhilarating, delightful exercise. A carriage will set out from Washington in the morning and the passengers will breakfast at Baltimore, dine at Philadelphia, and sup at New York the same day.

"To accomplish this, two sets of railways will be laid, made of wood or iron, on smooth paths of broken stone or gravel with a rail to guide the carriages so that they may pass each other in different directions and travel by night as well as by day; and the passengers will sleep in these stages as comfortably as they do now in steam stage boats. And it will come to pass that the memory of those sordid and wicked wretches who oppose such improvements will be execrated by every good man, as they ought to be now."

As we announced in the beginning of this chapter, we have done no more than mention some of the highlights of the great exposition that is the Department of Engineering and Industries. The whole constitutes a priceless and stimulating record of man's mechanical and industrial achievements. Our modern miracles of transportation, communication, labor-saving devices, and manufactured products have come so thick and fast in the past half century that our minds are dulled against a proper appreciation of the great benefits they confer upon us. Things that a century ago would have seemed utterly incredible we use every day with never a thought of the wonder of them or of the years of struggle, discouragement, and dogged persistence that made them possible. A thoughtful study of the National Museum's pageant of America's material progress

should give a healthful jar to our complacent acceptance of the advantages we enjoy over our forefathers. It will also bring forcibly to our minds how much we owe to a small number of great inventors.

VI. *History Before Our Eyes*

"Oh, say, can you see, by the dawn's early light,
What so proudly we hailed at the twilight's last gleaming,
Whose broad stripes and bright stars through the perilous fight,
O'er the ramparts we watched were so gallantly streaming?"

These words that now symbolize the greatness of America came spontaneously to the mind of Francis Scott Key who had anxiously watched all through the night of September 13, 1814, the bombardment of Fort McHenry, Baltimore, by the British. Detained with the British fleet, he could do no more than hope that the American garrison under Col. George Armistead would hold out and that the morning would see its gallant flag still aloft. As the light crept up in the eastern sky, it finally reached the ramparts of the battered fort and picked out the stars and stripes, frayed and riddled with holes, but still flying. That very flag, now enshrined in the United States National Museum, typifies the purpose of the Museum's great historical collections

—to vitalize for present and future generations of Americans the outstanding events and personalities of our past history.

This original "Star Spangled Banner," which inspired Key to write our National Anthem, makes an imposing display, for even now it measures 28 by 32 feet. Through the ravages of time and battle it has lost some two feet in width and ten feet in length. Originally 30 by 42 feet in size, it was made to order for Fort McHenry by Mary Young Pickersgill, of Baltimore, at a cost of $405.90. After the historic action in Baltimore Harbor, this garrison flag was presented to Colonel Armistead in honor of his gallant defense. Eventually it came into the hands of the Colonel's grandson, Eben Appleton, who lent it and finally presented it to the United States National Museum in December 1912. Two years later the hundred-year-old banner was patiently and lovingly restored by Mrs. Amelia Fowler, assisted by a corps of expert needlewomen. Ever since, protected in a huge glass-covered wall case, it has been one of the top attractions among the historical exhibits.

The Star Spangled Banner is typical also of the way in which important historic objects reach the National Museum. Such things are handed down in families from one generation to the next, each guarding it jealously and cherishing the traditions associated with it. There comes a time, however, when some descendant realizes that the precious heirloom should be placed where it will have perpetual care and where all Americans may see it. For these priceless relics of former days inject life into history. Names and events in textbooks, no matter how eloquently they may be described, remain simply words on paper for the average readers, especially those of school age. On the

other hand, the actual flag, sword, uniform, furniture, or other personal belonging of a historic personage, seen at close range, brings that person and the things he accomplished much closer to reality.

The Department of History comprises five divisions—civil, military, and naval history, numismatics, and philately. The last two named, covering coins and stamps, contain by their nature many times more individual specimens than all the rest of the department together. Yet even without those two divisions, there are nearly 70,000 objects of historical interest in the national collection. As would be expected in the United States National Museum, the great majority of these relate to American history, only a small percentage representing other parts of the world. They start with the settling of America and march in unbroken sequence across the pages of our history right down to the present day. Personal mementos of great living Americans presented in recent times to the Smithsonian are the news of today and the history of tomorrow.

A very recently set up exhibit illustrates this last point. It features furniture relating to great leaders and statesmen in American history from its beginning to the present day. Starting with an original pine chest used by George Washington at Mount Vernon, it includes chairs, tables, and other pieces of furniture associated with the lives of Benjamin Franklin, Alexander Hamilton, James Madison, Marquis de Lafayette, John Marshall, Henry Clay, Gen. Ulysses S. Grant, Theodore Roosevelt, and Gen. John J. Pershing, and concludes with the desk and chair used by Gen. Dwight D. Eisenhower at the Allied Military Headquarters in Italy during World War II.

The Smithsonian

History in the National Museum is a great pageant of the patriots and heroes of America. The list of former owners of the swords alone in the national collection reads like a roster of America's top military and naval men—Gen. George Washington, Maj. Gen. Richard Montgomery, Col. Return Jonathan Meigs, Maj. Gen. George B. McClellan, Gen. Ulysses S. Grant, Gen. William Tecumseh Sherman, Gen. Philip H. Sheridan, Maj. Gen. George A. Custer, Rear Adm. Winfield S. Schley, Rear Adm. Charles D. Sigsbee, Adm. David G. Farragut, and many others. Great names these—names that highlight the saga of our country and personify its struggles and achievements.

The historical exhibits reward close study, for some of the least conspicuous objects stand as the only tangible reminders of great Americans and their deeds of valor. For example, a plain gold ring has a well-documented pedigree going straight back to the famous American Naval victory at Tripoli in the early years of our republic and to one of the earliest and most picturesque of all our Naval heroes—Commodore Stephen Decatur. Decatur, it will be remembered, was a young lieutenant in the equally young United States Navy when, in 1804, he was serving on one of the small force of naval vessels sent to the Mediterranean to do something about the Barbary pirates. Under orders from the Bey of Tunis, the pirates were raiding the shipping of all nations—taking sailors for slaves, demanding ransom and tribute. Powerful maritime nations had tried to put a stop to these practices, but without success, and they eyed with amusement the proposed attempt on the part of the infant U. S. Navy.

Just before Commodore Edward Preble was given the job of attacking the strong port of Tripoli, pirate headquarters, the American ship *Philadelphia* had run aground and been captured by the pirate fleet and anchored in the harbor until she could be refitted and used against the Americans. Young Lieutenant Stephen Decatur requested and received permission from Commodore Preble to make a surprise attack on the *Philadelphia* under cover of darkness and set her afire, which would greatly improve the American fleet's chances in the assault on the main defenses.

With the *Intrepid*, a small, fast ketch, and a hand-picked crew, Lieutenant Decatur crept toward the harbor after dark with lights doused. As he approached the *Philadelphia*, a sharp hail came from her startled crew. Decatur's Spanish-speaking pilot replied that this was one of their own ships that had lost both anchors riding out a gale and requested permission to tie up to the *Philadelphia* overnight. The pirate crew was satisfied and permitted Decatur to warp alongside. The minute the two ships touched, his men swarmed over the side, cut down the crew or forced them over the side, set fire to the ship in several places, and cut her adrift. By the time the shore batteries had waked up to what was going on and opened fire, Decatur and his ship were well on the way back to the American fleet. The burning *Philadelphia* drifted straight toward the shore defenses, and her loaded cannon, touched off by the heat, fired a salvo straight into the fort.

For this clever and daring feat Decatur received much acclaim when he finally arrived back in America. His action and the subsequent victory over the pirates went far toward es-

tablishing the standing of the United States Navy in the eyes of the rest of the world.

Later the same year, the *Intrepid* was loaded with a large cargo of gunpowder and sent under cover of darkness into the harbor of Tripoli under command of Captain Richard Somers to be exploded in the midst of the enemy's ships. It was hoped thus to destroy some of their gunboats and perhaps damage the defenses of the town. As Captain Somers left Decatur's ship to board the *Intrepid* for this extremely hazardous mission, he took a gold ring from his finger and, perhaps with a premonition of disaster, solemnly gave it to his close friend Decatur. Before the *Intrepid* could get into the harbor, the Tripolitans sighted her, and opening fire with their shore guns, blew her up prematurely. The entire crew, including Captain Somers, went down with their ship.

Thus does a simple gold band preserved in the national historical collections symbolize the courage and sacrifice of our early Naval heroes.

The Father of our Country is not likely to be forgotten by visitors to the Nation's Capital, the city named in his honor. The splendid white shaft of his monument is visible from almost any part of the metropolitan area, and his beautiful Potomac River home, Mount Vernon, is a mecca for visitors. In the National Museum his great spirit is brought nearer to us by many intimate things of his every-day life at home and during the campaigns of the Revolution. They cover his lifespan almost from birth to death, for they include the white brocade silk infant's garment used on the occasion of his chris-

tening and a plain wing-back easy chair used in his bedroom shortly before he passed away.

Paradoxically, the memento that brings to us most poignantly George Washington's longing, after the bitter war years, to return to his beloved Mount Vernon is a complete Continental Army uniform. For this simple uniform—blue coat, buff waist-coat and knee breeches, with no military insignia—was worn by Washington when he resigned before Congress his commission as Commander in Chief of the Continental Army. The ceremony took place at Annapolis on December 23, 1783, and the very next morning he was on his way to Mount Vernon to spend Christmas at home with his family.

This was a happy time for the tired, honor-weary General. Arriving at Mount Vernon at dusk of Christmas Eve, he was given a joyful welcome by his wife, his friends, and his Negro servants. Simple farmer Washington, who had become one of the world's most famous men, was home again. The dear familiar surroundings filled him with a nostalgic longing to throw off the cares of office for good and settle down on his beloved plantation.

Christmas morning, George Washington was up before daybreak as usual, inspected the stables, and breakfasted at 7, after which all the Negroes came to wish him and Mrs. Washington a Merry Christmas. The great yule log was dragged in and lighted from a still burning brand of the previous year's log. Neighbors dropped in and stayed for one of the old-time Mount Vernon Christmas dinners that lasted until dark. After dinner, music on the harpsichord and Christmas songs around the

glowing fireside lasted far into the night. This was without doubt the happiest Christmas that George Washington ever had, for soon his country called him back to the arduous duties of high office. His dream of becoming once again a simple country gentleman was never to be realized.

Among a great number of other Washington relics are a toilet mirror presented by the General to Mrs. Washington in 1795. The glass is in two sections, the whole inclosed in a narrow walnut frame; the upper section of the glass is decorated in gilt with a lacquered design of roses and leaves. A brass candelabrum with reflector helped light our country into existence, for by its illumination Washington studied war maps, plans, and official documents during the darkest days of the Revolution.

Tableware includes silver-plated knives and forks with the Washington crest—a raven issuing from a coronet; salt cellars of blue Bohemian glass with an eight-pointed star on the bottom of each; wine-bottle stands of oak encircled by a heavy band of silver; and blue Canton-ware china in every-day use at Mount Vernon. A tent used by General Washington during the Revolution is made of home-woven white linen. Other mementos that make that war seem very real are his camp mess kit fitted with tin cooking pans, gridiron, tinder box, plates, knives and forks; brass field glass used in battle; and even his field shaving glass in a wooden case with drawer.

Another great American closely associated with the birth of our nation—Thomas Jefferson—is represented in the history collections by a most intriguing relic, the little portable desk on which he wrote the Declaration of Independence. It is a

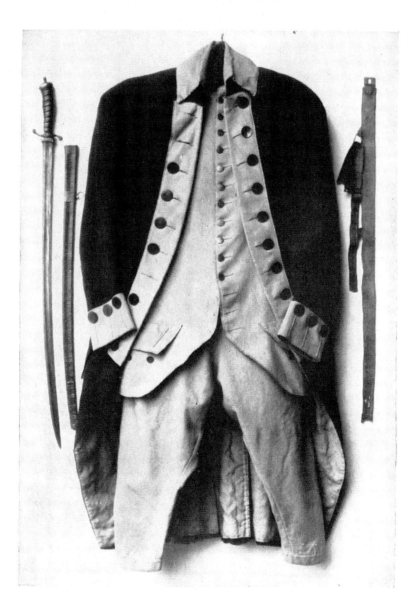

33. George Washington wore this plain buff and blue uniform with no military insignia when he went to Annapolis in 1783 to resign as Commander in Chief of the Continental Army after the Revolution. The next day he went back to his beloved Mount Vernon for a joyous Christmas.

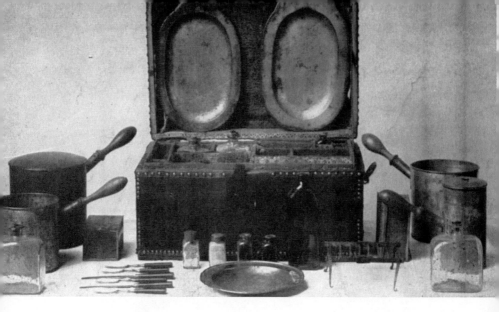

34. *Above:* A vivid reminder of the dark days of the American Revolution. George Washington used this field mess kit during many of his campaigns.

Below: The actual flag that flew over Fort McHenry in Baltimore Harbor during the British bombardment in 1814, inspiring Francis Scott Key to write The Star Spangled Banner.

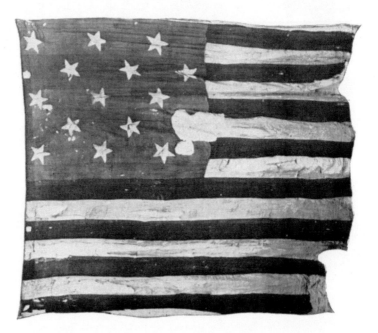

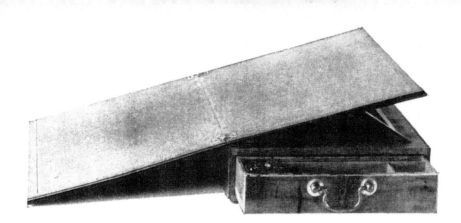

35. *Above:* Thomas Jefferson's little portable writing desk made after his own design by a Philadelphia cabinetmaker. On this very desk he wrote the Declaration of Independence. One lesson that might be learned from this plain little desk is that fancy equipment is not essential for the highest achievement.

Below: These two masks made from the living face of Abraham Lincoln tell the tragic story of our Civil War. The one on the left, made before the war, shows a vigorous, almost youthful expression. That on the right, made after the war, looks old and weary, seared by the bitter war years.

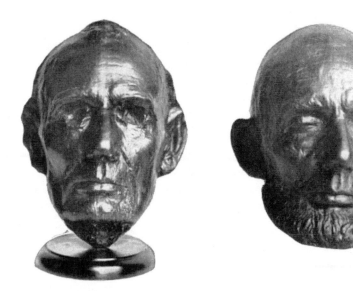

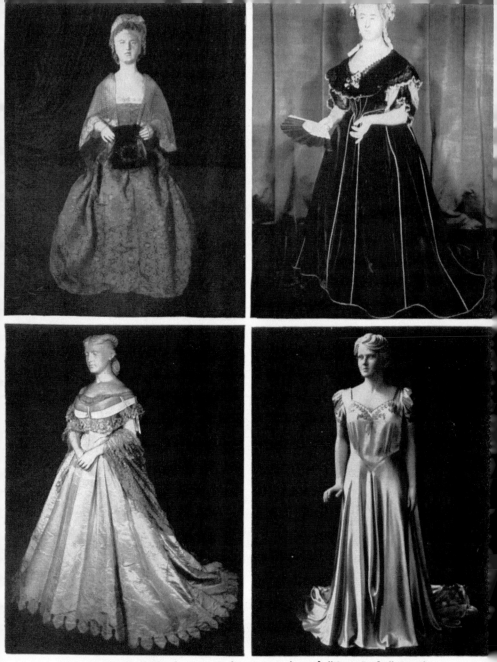

36. *Top row: Left,* dress worn by America's real "First Lady," Martha Washington. *Right,* velvet dress of Mary Todd Lincoln, wife of Abraham Lincoln and White House hostess from 1861 to 1865.

Bottom row: Left, dress of Harriet Lane Johnston, niece of President Buchanan and White House hostess between 1857 and 1861. *Right,* dress worn by Eleanor Roosevelt at the third inauguration of President Franklin D. Roosevelt.

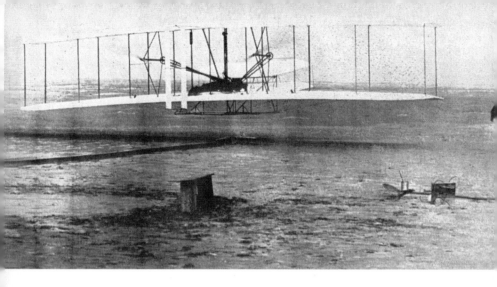

37. *Above:* The original Wright Brothers' aeroplane of 1903 in flight at Kitty Hawk, North Carolina. "The world's first power-driven heavier-than-air craft in which man made free, controlled, and sustained flight." This very machine now hangs at the entrance of the National Museum's Arts and Industries Building.

Below: Samuel P. Langley succeeded in 1896 in flying an unmanned steam-powered model airplane with a wing span of 13 feet. Later he was commissioned to build a full-size plane. The picture shows Langley's full-size "aerodrome" ready to be launched from a houseboat in the Potomac in 1903. The launching mechanism failed, and it never got into the air.

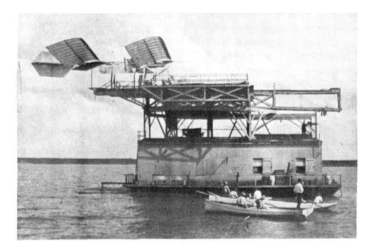

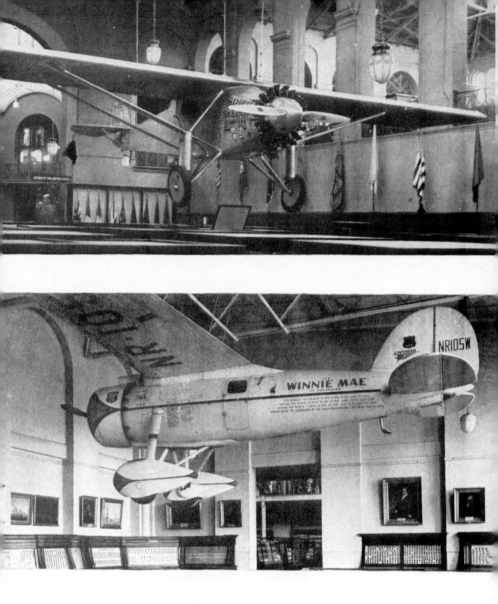

38. *Upper:* Lindbergh's *Spirit of St. Louis,* for many years the No. 1 attraction of the entire National Museum. In it he made the first solo nonstop flight across the Atlantic in 1927.

Lower: Wiley Post's *Winnie Mae,* in which he set a round-the-world record of 8 days 15 hours back in 1931.

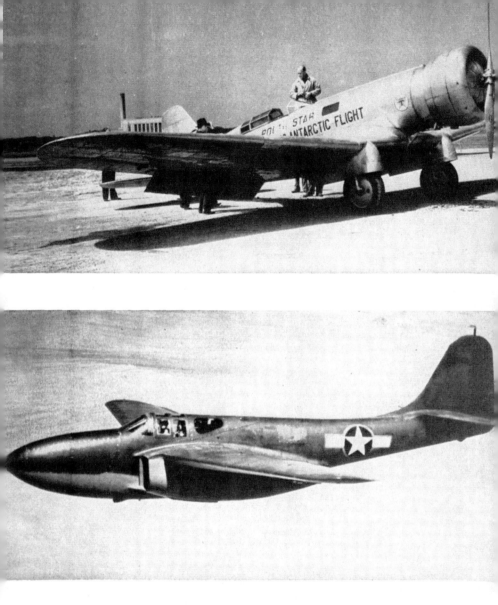

39. *Upper:* The *Polar Star,* in which Lincoln Ellsworth made the first aerial crossing of the Antarctic continent, the world's most inhospitable land area.

Lower: America's first jet plane in flight. This same plane, known as the Bell *Airacomet,* is now on exhibition by the National Air Museum.

40. In this vast storage facility at Park Ridge, Illinois, a bomber plant during the last war, are stored a hundred or more planes of many types awaiting the construction of a building for the National Air Museum in the Wash-ington area. In the center is a German V-2 rocket, and directly to the left of it is a German buzz-bomb, the mysterious weapon that plagued England toward the end of the war.

41. *Above:* Desolate Mount Montezuma, in the Atacama Desert region of Chile. Here Smithsonian observers live in complete isolation for three-year stretches, recording the exact amount of radiation from the sun.

Below: With the devices shown, the sun's beam is directed into an observing tunnel drilled into the top of Mount Montezuma, where it can be measured under exactly controlled conditions. After complex calculations, a final value is obtained for each day's solar radiation, which is cabled to the Smithsonian.

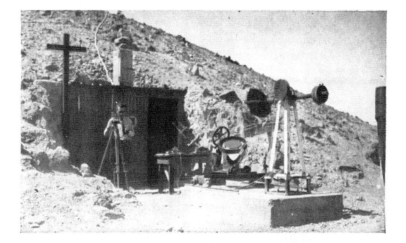

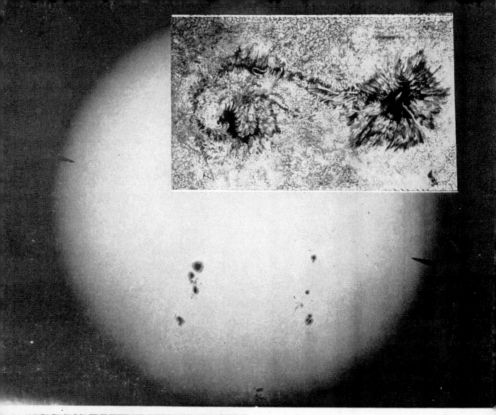

42. *Above:* Photograph of the sun showing a group of sunspots, which, because of the sun's rotation, seem to march across its face. *Inset,* detailed drawing of a sunspot made by Smithsonian Secretary S. P. Langley in 1873 as a result of the observation of numerous such spots.

Left: Dr. C. G. Abbot with his latest solar heat collector. A curved mirror focuses the sun's rays on a glass tube enclosing a small flash boiler. Steam is raised almost instantaneously and can be used to run a small steam engine.

The Smithsonian has three agencies engaged in the study of man—The National Museum's Department of Anthropology, The Institute of Social Anthropology and the Bureau of American Ethnology. The latter is devoted to the present and prehistoric aboriginal peoples of the Americas. It's records of American Indian customs are outstanding.

43. An Iroquois Indian council in session at Buffalo Creek, New York, around 1827. Painting by John Mix Stanley, the famous painter of Indians. The renowned leader of the pagan faction of the Seneca Nation, Red Jacket, is being tried for the crime of witchcraft, which was punishable by death. Red Jacket is shown appearing in his own defense, which he conducted so effectively that he was promptly acquitted. He has the reputation of having been one of the greatest of all Indian orators.

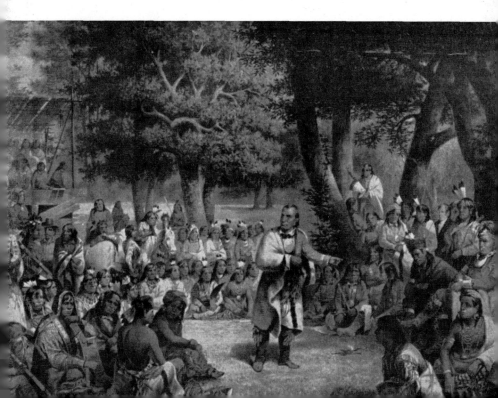

44. *Above:* Painting by Henry C. Pitz of Major J. W. Powell's hazardous first journey by boat down the length of the Colorado River.

Below: Actual photograph of the famous Hopi Snake Dance in Arizona in 1885.

45. Paiute Indians of the arid West, close relatives of the very primitive desert Gosiute. This photograph was taken by Hillers in 1873 before the western Indians were much changed by White contact. Hillers titled the picture "The arrow maker and his daughter."

Another Paiute photograph by Hillers. The woman is weaving a basket at the entrance of the very primitive brush house used by families of this tribe.

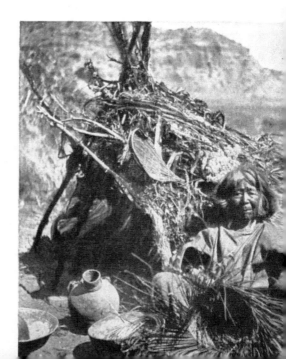

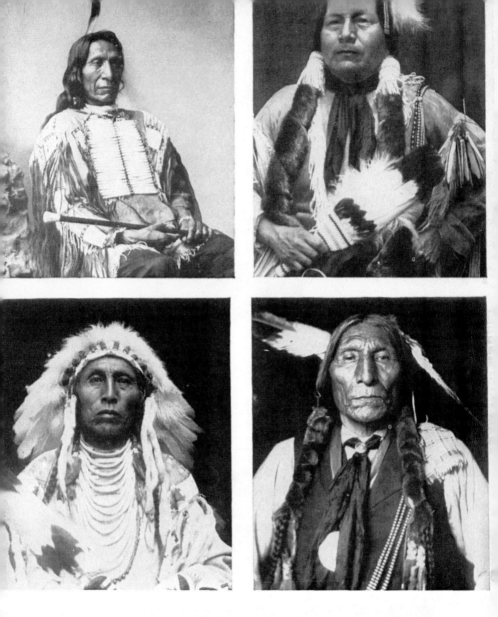

46. Four famous Indian chiefs from the Bureau of American Ethnology's great file of Indian portraits. The Bureau's more than 10,000 negatives are now of inestimable value, for most of them were taken before Indian culture was obliterated or modified by White contact. *Upper left,* Red Cloud, of the Oglala tribe; *upper right,* Lone Tipi, a Comanche; *lower left,* Medicine Crow, of the Crow tribe; and *lower right,* Wolf Robe, a southern Cheyenne.

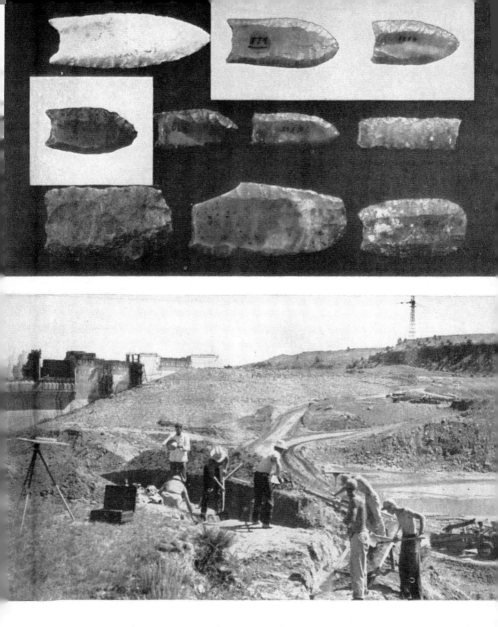

47. *Upper:* The mysterious Folsom projectile points. The three on white backgrounds are most typical. They were made by Folsom men, shadowy figures inhabiting America between 10,000 and 25,000 years ago. Strangely, no bones of Folsom Man have yet been found.

Lower: Part of the urgent archeological project in which the Smithsonian is now engaged. The present widespread program of river basin development threatens the loss of innumerable prehistoric Indian sites along our river banks. This picture shows hurried excavation of an old Indian site at the Angostura Reservoir project in South Dakota in the shadow of the nearly completed dam in the background.

48. *Above:* Family group and temporary house of the head-hunting Jivaro Indians of Ecuador. Their main business is blood-revenge feuding with their neighbors and head-hunting.

Below: Left, a human head shrunk to the size of an orange. *Right,* a Jivaro warrior with lance and shield. The standing of a warrior depends on the number of human heads he has collected.

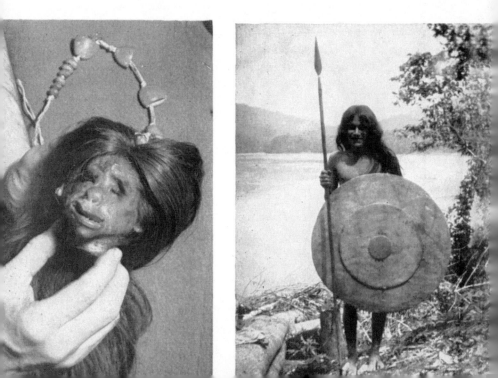

mahogany "writing box," made from Jefferson's own design. Lined with green baize, it bears attached to the interior an inscription in Jefferson's own handwriting, which reads:

"Thomas Jefferson gives this writing-desk to Joseph Coolidge, Jr., as a memorial of his affection. It was made from a drawing of his own by Ben. Randall, cabinet-maker of Philadelphia, with whom he first lodged on his arrival in that city, in May, 1776, and is the identical one on which he wrote the Declaration of Independence.

"Politics as well as religion has its superstitions. These, gaining strength with time, may one day give imaginary value to this relic for its association with the birth of the great charter of our independence.

Monticello, November 18, 1825."

The desk is unusually well documented. Jefferson presented it to Joseph Coolidge, Jr., as attested by his own note attached. In 1880 Coolidge's heirs presented it to the United States. At that time, Governor Robert C. Winthrop of Massachusetts handed it personally to President Rutherford B. Hayes. President Hayes transmitted the offer to Congress, Congress accepted the desk by Joint Resolution, and it was deposited in the Department of State. That department transferred it in 1923 to the United States National Museum.

Joseph Coolidge was deeply touched by the gift from Jefferson, as shown by his letter of acknowledgment published by the Massachusetts Historical Society:

"The desk arrived safely, furnished with a precious docu-

ment which adds very greatly to its value; for the same hand which, half a century ago, traced upon it the words which have gone abroad upon the earth, now attests its authenticity and consigns it to myself. When I think of the desk 'in connection with the great charter of our independence,' I feel a sentiment almost of awe, and approach it with respect; but when I remember that it has served you fifty years, been the faithful depository of your cherished thoughts, that upon it have been written your letters to illustrious and excellent men, good plans for the advancement of civil and religious liberty and of art and science, that it has, in fact, been the companion of your studies and the instrument of diffusing their results, that it has been a witness of a philosophy which calumny could not subdue, and of an enthusiasm which eighty winters have not chilled,—I would fain consider it as no longer inanimate and mute, but as something to be interrogated and caressed."

The historical exhibit that vies with the Wright and Lindbergh planes for first place in popularity with visitors—especially feminine visitors—is the collection of dresses of First Ladies of the White House. The exhibit has a dual interest: first, in showing the actual gowns worn by the wives or hostesses of all our presidents from George Washington to Franklin D. Roosevelt; and second, in illustrating American period costume during the entire history of our country as an independent nation.

The Costume Hall has the quiet dignity of a spacious reception room. The sculptured figures of the 35 distinguished ladies stand in mahogany cases—except for Martha Washington, who as the real First Lady is seated to receive the public. The faces

of the figures are all the same except for varying expressions. Each coiffure, on the other hand, is actually designed from a portrait, photograph, or other likeness of the lady herself.

The present author, a mere male, would not presume to describe the creations that span nearly two centuries of feminine costume and run through several cycles of change in style. The notes that follow on two of the most interesting of the dresses originated with Miss Margaret W. Brown, in charge of these costumes as well as other civil history collections.

Martha Washington is shown wearing a salmon pink faille dress of the style typical of the last half of the eighteenth century, with a very full skirt and tight pointed bodice which laces up the back. The faille is hand-painted with gray-white ribbonlike chain that forms medallions all over the dress. Each medallion is joined to the next with an emerald-green square. In the larger of the medallions are painted the native wild flowers of North America—the violet, buttercup, daisy, morning glory, arbutus; in the smaller spaces are painted our native insects, the grasshopper, spider, fly, ladybug, and wasp.

Around the shoulders of the figure a soft white shawl of Mechlin lace is draped, and she wears lace mitts on her hands. She wears on her head a "mob cap" such as Mrs. Washington always wore. The brown satin bag in her hands is one that Mrs. Washington made and embroidered with ribbon work. The name "Mrs. Washington" is worked on the front of the bag in old-fashioned script.

Skipping over almost a century of changes in feminine styles and several crucial periods of American history—the Revolution, the War of 1812, and the Civil War—we arrive at the

year 1866, when Harriet Lane, niece of President James Buchanan, married Henry Elliot Johnston of Baltimore. The dress she wore at this happy event is displayed at the National Museum and is one of the most admired gowns in the collection of dresses of Ladies of the White House. Harriet Lane was hostess at the White House for her bachelor uncle.

The style of her wedding gown is the graceful, pleasing style of the hoop-skirt period. It is made of heavy white moire taffeta, which has mellowed with age to an ivory tone. The low off-the-shoulder neckline, trimmed with net, satin, and lace, was designed to display the beautiful neck and shoulders which were among Miss Lane's many claims to beauty. The tabbed hem of the dramatic skirt allows just a peep at white satin wedding slippers without any heels. An interesting little pocket in one of the front folds of the skirt holds a dainty point lace handkerchief. The bridal veil of point lace is draped about the shoulders of the figure in the semblance of a shawl.

Returning to the lives of great figures in American history, we are brought literally face to face with Abraham Lincoln. For in a case with his somber black broadcloth suit and silk hat and a few other personal mementos are two casts made from the living face of Lincoln. One was made in 1860 just before the Civil War, the other only a few months before his death, after the grim war years. One is comparatively young-looking, vigorous; the other, worn, lined, weary. Those few years took a terrible toll from Abraham Lincoln, the man with all the bitter decisions to make. Visitors look with reverence upon these before and after the war face casts of a simple American with a very great soul.

History Before Our Eyes

The World War I story as told through Museum exhibits has only recently been enriched by a bequest from the great American military leader during that conflict, General John J. Pershing, Commander in Chief of the American Expeditionary Forces in France. Upon General Pershing's lamented death, it was learned that he had bequeathed to the Smithsonian for the American people his uniforms worn in many campaigns and the inspiring array of medals and decorations conferred upon him by many foreign nations. The National Museum already had the Order of Battle map used by General Pershing and his staff at American Headquarters at Chaumont, France. This historic map, about ten feet square, shows by means of hundreds of little paper stickers and pins of different colors the exact location of every Allied and enemy unit on the day of the Armistice, November 11, 1918.

A dramatic little exhibit in a case by itself is the metallic primer used to fire the last shot against the Germans in World War I. It was used on an American 14-inch railway gun at Thierville, France, and was fired at exactly 10:57½ A.M. on November 11, 1918, aimed at the Longuyon Railway Junction near the Luxemburg border. The range was 38,000 yards, or a little over 21 miles. There is no record of the arrival of this 14-inch last shell at its target.

American history from the discovery of the continent to the period of World War I is epitomized in a valuable series of seventy-one paintings by the late J. L. Gerome Ferris of Philadelphia, presented to the National Museum by the widow of the artist. Typical of the great interest of this visual history are the following titles of a few of the pictures: The Fleet of

133

Columbus, Signing the Mayflower Compact, The Fall of New Amsterdam, Drafting the Declaration of Independence, The News of Yorktown, Washington's Inauguration, The Battle of Lake Erie, The Gettysburg Speech, and The Meeting of Grant and Lee.

A unique exhibit that records history in the making, and that to future generations of Americans will be of fascinating interest, is the group of fifty bronze statuettes entitled "The Living Hall of Washington, 1944." In the turmoil of World War II the busiest men in Washington, nerve center of the war, agreed to give sculptor Max Kalish two half-hour sittings. He did the entire group in the incredible time of six months.

Selection of the fifty to represent the outstanding public figures of the war period in government, Army and Navy, labor, industry, and other categories, was made by a committee headed by Washington newspaperman W. M. Kiplinger, who presented the statues to the Smithsonian. Many of the men eternally recorded in bronze in the "Living Hall of Washington" are no longer in the land of the living. Here is the roster of "Fifty Notable Men of Wartime":

President Franklin D. Roosevelt, Vice President Henry A. Wallace; Thomas E. Dewey, John W. Bricker, Wendell Willkie; Chief Justice Stone, Senator Truman, Speaker Rayburn; Secretary of State Hull, Secretary of the Treasury Morgenthau, Secretary of War Stimson, Attorney General Biddle, Postmaster General Walker, Secretary of the Navy Knox and his successor Forrestal, Secretary of the Interior Ickes, Secretary of Agriculture Wickard, Secretary of Commerce Jones, Secretary of Labor

Perkins (the only woman in the group), Under Secretary of State Stettinius, Under Secretary of War Patterson.

Admiral Leahy, General Marshall, Admiral King, General Arnold. Leaders of various government activities, Harry L. Hopkins, James F. Byrnes, Donald M. Nelson, Charles E. Wilson, Admiral Emory S. Land, Chester Bowles, Vannevar Bush, Paul V. McNutt, Marvin Jones, Bernard M. Baruch, William M. Jeffers, J. Edgar Hoover, Byron Price, Nelson A. Rockefeller.

Labor leaders, William Green, Philip Murray, John L. Lewis; industrialists, Henry J. Kaiser, Eric A. Johnston; news men, Raymond Clapper, Ernie Pyle, Walter Lippmann; war-camp entertainer, Bob Hope.

Unfortunately the sculptor died before he had completed the statues of General MacArthur, General Eisenhower, Admiral Nimitz, Admiral Halsey, and Elmer Davis.

The little two-foot statues are installed in special eye-height cases, several to a case. The hall looks for all the world like an informal gathering of Washington war leaders in miniature. In the years to come, these figures will provide invaluable material for historians, writers, sculptors, and artists. For twenty-first-century school children, they will make World War II history come alive, as the older historical mementos do for the children of today.

A distinct division of the Department of History is the National Numismatic Collection, comprising coins, medals, and paper money. This collection, which boasts over 60,000 specimens, had its start back in 1793 at the United States Mint in Philadelphia. Each year the chief coiner would put aside

a sample of each type and date which fell from the old-fashioned coining presses, and when the Mint cabinet was authorized by Congress in 1838, a sizable collection had already been formed. To this collection of our own coins were added issues of foreign countries of all periods in various metals from base metal to gold and platinum. Today, while not the largest in the world, the National Numismatic Collection is one of the finest ever formed.

The question most frequently asked by visitors regarding the collection is, "How much is it worth?" This question cannot be answered, for the collection contains many unique pieces that have never been offered on the coin market and so there is no basis by which to estimate their value. Whatever monetary value might be placed on the collection would be small in comparison with its artistic and historical worth. As a slight indication of the actual money value, however, among the many rare coins in the collection is one which a private collector offered to buy for $35,000.

The earliest coins represented are the staters of Lydia, in Asia Minor, which were coined about 700 B.C. These crude little globular-shaped pieces were made from a natural alloy containing seventy-five percent gold and twenty-five percent silver. These are the first coins "invented" by man. Examples of the first silver coins, silver staters from the island of Aegina, are also in the collection, and these date from about 600 B.C.

Beginning with Ptolemy I of Egypt, 323-285 B.C., the first man to place his portrait on a coin, nearly every famous person in history will be found portrayed on coins and medals in the collection. This adds greatly to its historical value, for in many

History Before Our Eyes

instances such portraits are not to be found in any other medium of art. Of particular interest is the long series of Roman portrait coins which begins with Julius Caesar and continues to the late Roman Empire some 500 years later. While the Romans never surpassed the Greeks in art, they did excel in portraiture, and their rulers are realistically depicted.

Many coin denominations are closely interwoven with history and literature, and such pieces cannot fail to arouse the curiosity and interest of the visitor. Among the ancient coins will be found the widow's mite and the tribute penny mentioned in the Bible. The Venetian ducat, the florin of Florence, and the Spanish doubloon, which for centuries ruled the money marts of the world, are on view, as are other denominations of lasting fame.

Of unusual interest in the United States series are the denominations that were once in circulation but for some reason proved to be neither necessary nor popular. These include the half-cent, two-, three-, and twenty-cent pieces, and the trade dollar—all orphans of our National coinage. One section of the United States display is devoted to the pattern or experimental pieces that were made at the Mint as early as 1792 and continued up until fairly recent years. Many of these designs were never adopted, but they served a useful purpose in helping our designers produce coins that would be attractive as well as resistant to wear.

The exhibit of paper money is divided into seven periods, the first of which is devoted to the notes issued by the thirteen colonies before the Revolution. This is followed by the issues authorized by Continental Congress from 1775 to 1779. Next

is a representative exhibit of the notes issued by private banks from 1800 to 1860, U. S. fractional notes from three to fifty cents, Confederate currency, and U. S. Government notes. The latest acquisition is a complete set in duplicate of all U. S. current paper money from the $1 to $10,000 bill. These were especially prepared by the U. S. Bureau of Engraving and Printing, and while they have no face or "spending" value, they never fail to fascinate the passers-by.

An increasingly popular division of the Department of History is that of philately—postage stamps like the ones everybody collects. The National Museum has one advantage over us, however; for almost forty years it has received through the Post Office Department every new stamp that has been issued by every foreign country belonging to the Universal Postal Union, and from the Bureau of Engraving and Printing three specimens of each new United States issue. Stamps from these sources, plus those in numerous large private collections presented to the Smithsonian, now add up to almost 90,000 varieties, or just about half a million individual stamps.

The world's first adhesive postage stamp, the famous British "Penny Black," carrying the bas-relief of Queen Victoria, was first used on May 6, 1840. The sending of letters by messenger, of course, goes clear back to Old Testament days, and around 500 B.C. King Cyrus of Persia organized a "postal" service through posting men along the main roads to relay official documents and messages. A thousand years passed, however, before the idea developed into anything like a service for ordinary people and letters, and not until the seventeenth century was the first public postal service put into operation in Eng-

land. For 200 years more the service wavered between good and bad, and in 1833 Parliament ordered an investigation—a phrase with a familiar ring today. The result was real postal reform, with weight schedules and the first adhesive stamps. The first United States Government postage stamps appeared on July 1, 1847—the now scarce 5-cent brown carrying Benjamin Franklin's portrait and the 10-cent black with George Washington's. The Museum collection, of course, shows the British Penny Black and these first two official U. S. stamps.

The stamp exhibit is an unusually attractive one. In rows of specially designed gleaming mahogany cabinets, easy-sliding vertical frames at convenient height display groups of the world's stamps with their brilliant colors and beautiful designs. United States stamps come first, followed by those of other nations arranged alphabetically. Each frame is labeled with country and date of issue and other essential information. In a conspicuous place at the end of each cabinet is a special frame for the display of current issues or items of unusual interest. Increasing thousands of stamp enthusiasts use the exhibit for recreation and study.

The United States stamps are all unused except certain rarities such as provisional issues by postmasters; inverted medallions, 1869 issue; 12- and 24-cent 1870 with grill; and the 6- and 8-cent 1895 issue on revenue paper. Among the most valuable single items in the collection is a complete sheet of 2-cent carmine, 1917 issue imperforate, that contains three stamps printed by error as 5 cents. This sheet is worth at least $5,000.

Among other rarities in the United States section that are

of great interest to stamp experts are the 4-cent blue (error in color) Columbian issue; 1-cent, 2-cent, and 4-cent 1901 issue with inverted centers; pre-stamp covers; sets of specimen stamps; cut square envelopes including many rare die varieties of 1853, 1864, and 1904; die proofs; and general Confederate issues.

High on the list of private collections added to the Museum's philatelic material is the A. Eugene Michel assemblage of postal stationery comprising 40,000 specimens. Representing fifty years of intensive effort on the part of the donor, the Michel collection boasts ninety-seven percent of all listed varieties, including many rarities that could not now be obtained at any price. This is a percentage of completeness seldom attained in philatelic endeavors.

Mrs. Catherine L. Manning, in charge of the stamp collection, writes concerning it:

"The National Philatelic Collection has been built up and organized on the basis that it is better to generalize than to specialize—that a good all-around international collection is of more value in terms of education and enjoyment than the mere pursuit of oddities. In the years since 1908, when the government collection began to expand, philately has developed from something about which grown men were rather ashamed to admit an interest, into one of the most popular, instructive, and valuable hobbies that exist. Now the stamp exhibit is one of the most popular at the Institution, and the study series are being increasingly utilized by both amateurs and specialists."

In the very center of the Halls of History, looking serenely

down upon the pageant of brave men and glorious deeds that have made America the great nation she is today, stands the famous Statue of Freedom—the original plaster model from which was cast the bronze statue surmounting the dome of the United States Capitol. The 20-foot-tall statue is the work of the American sculptor Thomas Crawford. The figure is that of a woman in flowing draperies, one hand upon the hilt of a sheathed sword. On her head is a star-encircled helmet surmounted by a crest of feathers and an eagle's head.

The bronze statue was cast in five sections, and at exactly twelve noon on December 2, 1863, the top section consisting of head and shoulders was started on its 300-foot ascension to the top of the Capitol dome. Twenty minutes later it was in place and firmly fastened. The American flag was unfurled over Freedom's head, and the national salute of thirty-five guns blazed from a field battery on Capitol Hill.

Facing directly east, the Statue of Freedom atop the Capitol dome is probably the first object to greet the rising sun in the entire city of Washington, where much of our nation's history has been made.

VII. *Grounded Planes*

Famous airplanes, like famous race horses, are turned out to pasture when they have outlived their usefulness. In the case of planes, the pasture is the Smithsonian Institution's great aeronautical collection, now probably the most extensive in the world. There visitors may see the Wright "Kitty Hawk" plane of 1903, Lindbergh's *Spirit of St. Louis,* Wiley Post's *Winnie Mae,* Lincoln Ellsworth's *Polar Star,* General Billy Mitchell's Spad of World War I, the gondola of the balloon that reached the highest altitude ever attained by man, a Japanese suicide plane, the first jet plane made in this country, and hundreds of other exhibits including planes of many types, engines, models, and other aeronautical material. The historic planes are not models or reproductions—they are the actual machines that came through the hazardous and exciting adventures incident to man's comparatively recent conquest of the air.

Appropriate to this air age, the very latest bureau of the

The Smithsonian

Smithsonian, established by Congress in 1946, is the National Air Museum. General "Hap" Arnold, brilliant Air Force leader of World War II, conceived the idea, with the thought in mind of saving for the people of America the history-making planes of that war as well as examples of the various types which are so swiftly superseded in today's rapid aviation development. The Smithsonian was the logical administrator of this new bureau; it had already what was probably the largest aeronautical collection in the world. The Air Museum has no building yet. Its planes and other collections are exhibited in the Smithsonian's Arts and Industries Building and in the Aircraft Building, a large metal hangar-like structure left over from World War I. Before many years, however, there will rise in the Washington area a colossal temple of aviation that will surely form a leading attraction for all visitors to the Nation's capital. For there they will see in spacious exhibition halls a hundred—perhaps two hundred—of the planes that have made history, from the smallest to the recent giants of the airways.

One feature planned for this permanent aeronautical exposition is a special central exhibit area for the father of all flying machines, the Wright Brothers' aeroplane of 1903. At the present time this venerable machine occupies a place of honor in the Arts and Industries Building, but it will remain there only until a building is provided for this latest Smithsonian bureau—the National Air Museum.

One of the things the Smithsonian has learned by painful experience is to refrain from saying that any particular object is the "first." Such a claim invariably brings on a violent re-

action from someone who either himself produced the same thing earlier, or who knows someone among his relatives or friends who did. There is, however, one notable exception to this rule. The Wright Brothers' "Kitty Hawk" aeroplane is universally acknowledged to be "the world's first power-driven heavier-than-air machine in which man made free, controlled, and sustained flight."

The story of that contrivance of spruce, wire, muslin, and glue is one of the most fascinating epics of human achievement. In 1903, flying was still in the class of crack-pot ideas that would never work, and even if it did would be of no practical use. The Wright Brothers thought otherwise. Drawn from boyhood by the magnetic thrill of imagining themselves flying through the air, they set to in earnest to change their youthful dreams into reality. Starting modestly with gliders that they built themselves according to the best information they could find, they spent several years in patient and determined experiment, research, and trial. Finding defects in the recorded data of other early experimenters, they built themselves a wind tunnel and obtained first-hand results that they could rely on. After evolving a successful glider, the next problem was a power plant. No suitable engines could be purchased, so they built one themselves. Data on marine propellers were not satisfactory for their purpose, so they designed and constructed special propellers that turned out to be highly efficient.

Finally, in 1903, the entire machine was completed and shipped to Kitty Hawk, North Carolina, for tests. This place with the strange name had been selected by the Wrights for several reasons: there was almost always a good breeze for

their gliding experiments, as well as sand hills from which to take off; also in this sparsely inhabited region there were no crowds to complicate their trials. It is a rather desolate area of the Atlantic coast, but the Wrights were young men of simple tastes, their absorbing interest in their dreams of flying leaving little time to think of mere living conditions or surroundings.

In a sense, however, the lonesomeness of Kitty Hawk had a bearing on the date of the first human flight in history. Toward the middle of December the shake-down tests of their latest machine had been completed and necessary changes worked out. On the 14th a trial was made, but a too eager attempt by Wilbur to gain elevation stalled the craft. After minor repairs, everything was again in readiness, and the next trial was planned for December 17th. The brothers got up that morning to look out with bitter disappointment on a cold, gray day with a piercing wind howling over the desolate sand dunes. Nostalgically, they thought of home with Christmas only a few days away, but so firmly were their desires centered on a successful test of their flying machine that no idea of postponing the project entered their minds. Instead the thought of Christmas at home spurred them on to attempt a seemingly impossible trial that morning.

The plane was brought out, and the launching rail was laid on the level instead of down a slope, the brothers figuring that with a strong head wind the plane would get the same lift that a down-hill start would give it. The engine was warmed up, and the historic moment was at hand. The only witnesses were three men from the Kill Devil Life Saving Station, another man from the town of Mateo, and a small boy from Nags Head.

That small boy, John Moore, is today the only living witness of the trial.

It was Orville's turn. He took his position lying flat on his face, one hand on the elevator lever and his hips in the saddle arrangement through which by switching from side to side he could control the balance through cables to rudder and wings. It is interesting that in the very latest midget planes of today the pilot assumes the same position.

Orville raced the engine to be sure it was running smoothly. The very next moment was to be a turning point in the history of mankind, but it is doubtful if any one of the seven men there realized it. There was tense excitement in the air, however, for although the piercing wind continued to whistle in off the gray sea, and ice was forming on the puddles of rain water, no one seemed to notice. The flimsy machine started slowly down the track, gathered speed, and before reaching the end soared into the air—and stayed in the air. A man was flying! History was made—and the Wrights could go home for Christmas. Orville himself thus described the epoch-making event:

"The first flight lasted only twelve seconds, a flight very modest compared with that of birds, but it was nevertheless the first in the history of the world in which a machine carrying a man had raised itself by its own power into the air in free flight, had sailed forward on a level course without reduction in speed, and had finally landed without being wrecked. The second and third flights were a little longer, and the fourth lasted 59 seconds, covering a distance of 852 feet over the ground against a 20-mile wind."

After the fourth trial, a gust of wind caught the machine and up-ended it, damaging it so badly that there could be no thought of further trials that year. The Wrights went home, well satisfied, and the plane went into their shop at Dayton, Ohio. While the brothers went on from success to success, the "Kitty Hawk" plane gathered dust and cobwebs in the back of that shop.

For thirteen years it reposed there, until in 1916 Orville rescued it, had it restored using all the original parts available, and sent it to the Massachusetts Institute of Technology for exhibition. Later it starred in early air shows, and in 1928 he sent it to the Science Museum in London, England, as a loan. This action resulted from the unfortunate controversy between himself and the Smithsonian Institution over unwarranted claims the Institution had made for Langley's aerodrome of 1903. The Institution later retracted those claims, settling the controversy, and when Orville died in 1948, papers in his files showed that he wanted the "Kitty Hawk" plane to be brought back to America and displayed for his countrymen in the National Museum.

In November of 1948 the plane was crated in London, transported across the Atlantic in the *Mauretania*, escorted to Washington by the United States Navy, and delivered safely to the Museum. On December 17 of the same year, the forty-fifth anniversary of its historic first flight, it was formally presented to the National Museum by Milton Wright on behalf of Orville's estate and accepted by Chief Justice Fred M. Vinson, Chancellor of the Smithsonian Institution. More than 1,000 guests attended the impressive ceremony, including top-

flight government, military, and naval officials and a large representation of the Early Birds, that group of fliers of the pioneer days of aviation, some of them actual pupils of Wilbur and Orville Wright.

So today the "Kitty Hawk" plane hangs at the entrance of the National Museum's Arts and Industries Building, where thousands of visitors each day stand in silent awe before it. For that crude device of wood, wire, and cloth ushered in a new age of man—the air age, an age fraught with staggering possibilities. An airplane can go on errands of mercy, dropping food and medicine to isolated sufferers in the frozen north, or it can drop an atom bomb and reduce an entire city to a bloody shambles. Perhaps before long it will escape the gravitational pull of this planet entirely and be off through the silent cold of interstellar space to investigate life on other worlds. The Wright Brothers gave us the air age; whether it will be turned toward the benefit of mankind or toward his ultimate destruction lies in the hands of man himself.

It is a strange fact that the first object in the Smithsonian's great aeronautical collection was accessioned as far back as 1889. Even stranger is the fact that the very earliest model in the collection begins to show some inkling of the right approach to the problem of human flight; it dates from the fifteenth century. That great Italian Leonardo da Vinci, who lived from 1452 to 1519, included among his many accomplishments the designing of mechanical devices to enable man to fly. From drawings in da Vinci's notebooks a Smithsonian curator made up a model to illustrate the early inventor's ideas. It came out as a surprisingly efficient-looking flying mechanism, al-

The Smithsonian

though it had one slight defect—it had no power plant. Flight was supposed to be accomplished in the manner of birds; the pilot had levers for his hands and pedals for his feet, by the alternate use of which the large batlike wings were to be flapped up and down. Unfortunately, no human being could develop enough muscle to get it into the air in this manner.

The sixteenth, seventeenth, and most of the eighteenth centuries went by with only a few similar attempts and, of course, no success. It had begun to look as though mankind was destined to remain earthbound when suddenly a new idea for flying entered the picture. The Montgolfier brothers of France imprisoned hot air in a bag and sailed high over Paris for twenty minutes, traversing more than five miles. With the discovery that hydrogen gas was far better than hot air for lifting purposes, the art of ballooning spread rapidly. Jeffries and Blanchard sailed across the English Channel; in America Thaddeus Lowe suggested and accomplished the first use of balloons for military observation during the Civil War, and Paris maintained connections with the rest of the country by balloons when it was besieged during the Franco-Prussian War in 1870-71. Engines were evolved, and the development of dirigible—or steerable—balloons, or airships, began. The Smithsonian has fascinating exhibits to illustrate the development of ballooning from its beginning to the period of the great trans-Atlantic airships of the 1930s.

But this was not true free flight, as England's Sir George Cayley realized at the beginning of the 19th century. He returned to a study of the true "flying machine," or heavier-than-air craft, and actually built a workable glider in 1810. Next

150

came Henson, who proposed an "aerial steam carriage," and his partner, Stringfellow, who in 1868 won the prize for the lightest engine offered by the world's first aeronautical exposition held in England by the Royal Aeronautical Society. This actual engine, accessioned in 1889, and a reproduction of the triplane exhibited by Stringfellow with his engine are now in the Smithsonian's aeronautical collection.

Toward the close of the nineteenth century gliding became the favorite method of attack on the problem of human flight. Lilienthal of Germany and Montgomery and Chanute of America achieved outstanding successes in the art of soaring through the air without power. Full-size gliders and models illustrate this phase in the Smithsonian collections. In spite of fatal accidents, mankind persisted doggedly in his attempt to conquer the air. And with the next entry into the lists, the centuries-old problem showed signs of yielding. This contestant was Samuel Pierpont Langley, third secretary of the Smithsonian Institution. The Smithsonian naturally has a large amount of material to illustrate Langley's work.

Dr. Langley was a renowned astronomer and physicist whose interest in flying had been aroused by his observations of the wonderful soaring abilities of buzzards and other birds. For years he investigated the aerodynamic properties of various forms and shapes, and tested his findings with more than a hundred small models powered by rubber bands. He then advanced to large-size models, constructing his own light-weight steam engines to power them. In May of 1896, such an unmanned model with a wing span of 14 feet was catapulted into the air from a houseboat on the Potomac. Dr. Langley and a few

observers were thrilled to see it fly steadily through the air, describing three large circles over the water, and coming down only when its fuel was exhausted. It had flown for a minute and a half and had covered a course totaling more than half a mile. Two more successful flights were made the same year, the last one covering more than three-quarters of a mile.

Dr. Langley felt that the success of these large models, although unmanned, demonstrated without question the practicability of human flight, and he considered his work to be finished. However, the United States Board of Ordnance and Fortifications made him a grant of funds to build a full-size, man-carrying "aerodrome," as Langley called his machines. It was a long, arduous task, and not until 1903 was the machine ready for trial. In the two attempts to catapult it into the air from the top of a houseboat, the launching device failed to function properly, according to the official report of the Board of Ordnance and Fortifications, and Langley's aerodrome never got into the air. Nine days after Langley's second trial, the Wright brothers at Kitty Hawk achieved success, realizing man's age-old dream of flying.

The Wrights in the ensuing years made rapid progress, and by 1909 had satisfied War Department requirements and sold to the Government the plane that passed the tests, making the United States the first Government to own a military airplane.

With the coming of World War I in 1914 aeronautical development advanced by leaps and bounds. Many types of planes were manufactured both here and abroad with the United States inaugurating the mass production of planes and engines. During this war men first learned to fight above the clouds;

several battle-scarred World War I planes are shown at the Smithsonian. After the war, the newly developed types of planes and the skilled pilots turned to various peace-time aerial activities, including numerous spectacular flying feats. The Navy *NC-4* made the first trans-Atlantic flight, although with two stops. The Army *T-2* flew nonstop for the first time from the Atlantic to the Pacific. In 1924 four Army Douglas Cruisers accomplished the first round-the-world flight. The *NC-4*, the *T-2*, and the flagplane of the world fliers are all in the Smithsonian collection.

One of the high spots of all aviation history is the first solo nonstop trans-Atlantic flight by the immortal Charles Lindbergh. That flight is now a whole generation in the past, and as the *Spirit of St. Louis* is still the most asked-for exhibit at the Smithsonian, it may not be amiss to review the Lindbergh story briefly. A prize of $25,000 offered for a nonstop flight from New York to Paris by Raymond Orteig in 1919 stood unclaimed for several years, but with the marked improvements in planes and fuel of the mid-20's, interest in the juicy prize revived. Three tries were made and six men were lost. Others came forward to fill the ranks, however, among them an unknown youth from out west named Lindbergh who had learned to fly in a second-hand plane. He brought perfection to his natural gift through Army training courses and flying the mail. With the assistance of a group of friends in St. Louis, he acquired a specially built Ryan monoplane and joined the two other planes waiting on Long Island for perfect flying weather.

The other two fliers had such good press agents that the eyes of the world began to focus on Long Island and the waiting

contestants. Lindbergh, on the contrary, made his preparations quietly, and the days went by with a gradual loss of interest on the part of the press.

But suddenly the story broke. Morning papers of May 20, 1927, carried banner headlines, "Lindbergh Takes Off for Paris," and the whole world crossed its fingers and hoped for the best. He had got the *Spirit of St. Louis* in the air with its heavy load of gasoline before seven in the morning. All through that first day he winged along the New England coast, over the Canadian Maritime Provinces, and finally across Newfoundland, the last land of the Western Hemisphere.

The sun was sinking as he pointed the plane out over the ocean—and gulped down one of his five ham sandwiches, the entire food supply for the journey. Perhaps the icy fingers of panic gripped Charles Lindbergh's heart for an instant as darkness shut down over the lonely stretches of the North Atlantic. An optimistic weather report went wrong somewhere, for with the blackness of night came head winds and rain. To add to his troubles, fog began to blanket out even the surface of the water. As a final threat the rain turned to sleet and ice formed on the wings.

The sturdy plane droned on, however, and dawn still showed nothing but an endless expanse of gray water. Not until afternoon of the next day did the world see the welcome headlines, "Lindbergh Sighted Over Ireland." He had spanned the Atlantic and come out within two miles of the spot aimed at. A few hours later he stepped out of the *Spirit* at Le Bourget airport, Paris, after flying 3,600 miles in the amazing time for those days of just 33½ hours. It had never occurred to this modest American

youth that any great number of people would follow his flight. Not knowing that most of Paris had been watching for hours hoping against hope for the sight of wings against the sky, he stuck out his hand to the first official to reach him and introduced himself—"I'm Charles Lindbergh."

The useless introduction was swallowed up in the tumultuous welcome Lindbergh received—in France, in England, and finally in America, to which he made a triumphal return with his plane on an American battleship. After a speaking tour, during which he flew the *Spirit* more than 22,000 miles and visited 70-odd cities to urge the building of airports, and a 3,200-mile Pan American tour, he flew the plane from St. Louis to Washington, where it was taken into the National Museum's Arts and Industries Building and suspended from the ceiling in the main hall. Here it became at once the number one attraction of all Smithsonian exhibits. There was something about that flight that ranks it with the immortal deeds of all time. The *Spirit* is a magnet for young boys, for middle-aged boys, and in fact for all those who thrill to deeds of adventure and daring. The *Spirit of St. Louis* and Charles Lindbergh will live through the ages as American pioneers of the airways.

One of the most interesting planes in the National collection is one used for an unusual purpose—the first aerial crossing of the frozen continent of Antarctica. Appropriately named the *Polar Star*, it is a low-wing Northrup Gamma plane specially built for Lincoln Ellsworth, the famous explorer. Standing there on the floor of the Aircraft Building, it is no more completely immobilized than it was on November 27, 1935, in the

middle of Antarctica when Ellsworth and his pilot, Hollick-Kenyon, looked hopelessly at it from their tent through a blinding blizzard, with the plane already almost out of sight in the snow.

Lincoln Ellsworth had 11 years before flown a plane to within 120 miles of the North Pole, and in 1926 in the dirigible *Norge* had passed directly over the pole. After a few years, the relentless urge that drives the born explorer turned his thoughts toward the Antarctic. Admiral Byrd had flown to the South Pole and back, but none had spanned the ice-bound continent from sea to sea. Shackleton, Wilkins, Watkins, and Larsen had all made the attempt, but without even approaching success. By 1934 Ellsworth was ready to make his bid, but his plane was damaged by ice even before the start. It took a whole year to get everything in shape for another try, and in November of 1935 he and Hollick-Kenyon took off from the ice in the *Polar Star* from an island in the Weddell Sea. Their goal was Little America, the base set up by Admiral Byrd on the Ross Sea, more than 2,100 miles across the most desolate and inhospitable land in the world.

All went well on the first lap except that the radio went out, and they found themselves cut off from all communication with the outside world. Several mountain ranges were crossed; one, a mass of jagged black peaks previously unmapped, Ellsworth named Eternity Range because, as he wrote later, the endless expanse of a dead white world below them caused his mind to revert frequently to thoughts of eternity and of man's insignificance. After flying for 13 hours, they were forced down on a high, windy tableland by that scourge of the Antarctic—

poor visibility. Here at their first camp they had to wait a day and a half before another try—and made just 60 miles when the same handicap forced them to the ice again. After one more similar hop and another forced landing, the Antarctic weather took over in earnest. A shrieking, blinding blizzard closed in, and for three days their world was a tiny tent.

On December 1, the snow slackened and they emerged to find the plane practically buried in huge drifts, the cockpit completely filled with snow. They spent the entire day digging down to the plane, and finished by scooping powdery snow from around the controls with a teacup. They tried vainly to start the engine, but succeeded only in burning out the magneto. The outlook at that moment was not bright. They were six or seven hundred miles from Little America, with apparently no hope of getting there.

That proved to be the low point of the expedition, however, for they immediately started repair work on the plane and were able to keep ahead of the snow with their shovels. Three days later, on December 4, they got the engine going, taxied out of the drifts, and were ready to tackle the last lap. After a hop of several hundred miles, they had to land again. Observations showed that there was still 150 miles to go; they also showed the plane to be nearly out of gas. They decided to take off, fly till the gas was exhausted, and take a chance on a suitable landing place. Luck was with them, for with the engine's last gasp they glided to a safe landing and found themselves only 16 miles from Little America.

That last 16 miles took six days of sledging, which brought them to the most desolate-looking habitations Ellsworth had

ever seen in all his polar expeditions—Admiral Byrd's old head-quarters. About all that showed above the snow drifts were a few stovepipes, and they got into one of the buildings only by smashing a skylight and dropping through the roof. It proved to be the radio shack, fortunately stocked with enough provisions to supplement their own store. There they holed up for a month before being spotted by a rescue ship sent out by the British Royal Research Society. Ellsworth's own supply ship then steamed into the bay, sent crew men back to rescue the *Polar Star* took the explorers and their plane aboard and headed back to civilization. Now the *Polar Star* drowses in the warmth and security of the Smithsonian Aircraft Building with nothing to suggest its dangerous days at the bottom of the world except a few scuff marks left by a snow shovel.

World War II shook aeronautics out of its steady, gradual development and turned loose on the world a stream of new types of planes—bombers, fighters, cargo planes, and others. In fact, the last war might be called the air war because of the dominant part played by bombing from the air. The air blitz of England, the methodical destruction of German industries from the air, the saturation bombing of Jap-held Pacific islands, and finally the decisive dropping of atom bombs on two Japanese cities—all these were indeed major scenes in that titanic drama. A great many of the wartime types of planes are in the possession of the Smithsonian National Air Museum, but for lack of exhibition space to show them to the public, they are now held in a storage facility near Chicago pending the construction of the Air Museum's proposed building in the Washington area.

Grounded Planes

Man's conquest of the air is surely one of the most spectacular of his achievements. Little wonder that the story of that long struggle as portrayed at the Smithsonian by the very planes that took part in it is among the most popular of subjects displayed there. Perhaps the most amazing part of that story is the fact that the time elapsed from the first actual human flight to the world-wide airlines and the incredible aerial feats of today is hardly more than half a long lifetime.

Emphasis in aeronautical research is now on jet and rocket engines and on plane performance at supersonic speeds. At the latest reported speeds of at least 1,000 miles an hour, planes will actually be beating the sun. For instance, such a plane leaving New York at 12 noon would arrive at San Francisco at about 11:30—half an hour before it left. This will complicate air schedules of the future. Yet generations now unborn looking at these marvels of today when they are turned out to pasture in the Smithsonian, will doubtless smile with tolerant amusement as we do now over the "crates" of the early part of the century.

VIII. *The Star We Live By*

Some of the most interesting things that go on at the Smithsonian are never seen by the public. Such an activity that collects no specimens and produces nothing to put on exhibition is the Institution's Astrophysical Observatory, the only organization in the world devoted exclusively to the study of the sun. It is also probably the world's strangest observatory, for its observing is done in dark tunnels drilled into the tops of mountains, and it uses no telescope.

No branch of study could be more fundamental than that of the sun, for it is literally the star we live by. Although it is some 93,000,000 miles distant from us, yet its gravitational pull keeps our little earth forever spinning around it at just the right distance. Upon the radiation we receive from it through that immense distance depend our climate and weather, and indeed our very lives, for all human food comes directly or indirectly from plants, which cannot grow without sunlight. Suppose that the sun for some reason suddenly cooled off and

its rays were thus cut off at the source. The earth would be plunged at once into almost complete darkness and the temperature would start dropping—down below freezing, below zero, below the point any thermometer could register, down to the temperature of the cold side of the moon where even mercury would freeze. The earth would very soon become a dead planet, devoid of light, warmth—and life.

It would naturally be expected that in view of the vital concern of the sun to all of us, more knowledge would have accumulated regarding it than of any other of the heavenly bodies. Yet only since the beginning of this century has there been even accurate measurement of the *amount* of solar radiation that reaches the earth. Professor Samuel P. Langley, third Secretary of the Smithsonian, was an astronomer of international reputation before he came to Washington. His chief interest had always been the study of the sun, and he expressed his feelings about it in these words:

"If the observation of the amount of heat the sun sends the earth is among the most important and difficult in astronomical physics, it may also be termed the fundamental problem of meteorology, nearly all of whose phenomena would become predictable if we knew both the original quantity and kind of this heat; how it affects the constituents of the atmosphere on its passage earthward; how much of it reaches the soil; how, through the aid of the atmosphere, it maintains the surface temperature of this planet; and how in diminished quantity and altered kind it is returned to outer space."

Among Professor Langley's first acts as Secretary of the Smithsonian was the setting up of the Astrophysical Observa-

tory. Its sole aim was to investigate the sun, and after 1902, more specifically to make determinations of the amount of its radiation. At first thought this would seem an easy task until we recall that simple measurements of the heat that reaches the surface of the earth would be valueless because they would vary continually with the season, time of day, amount of cloud, haze or water vapor in the atmosphere, and several other factors. The only measurements of value, as representing the actual amount of radiation sent out by the sun, are of the rays as they would be *outside our atmosphere.* This means not only elimination by intricate processes of all the atmospheric hindrances, but doing this for each of the rays in the solar spectrum —the well-known colors in the visible part as well as the ultraviolet and infrared rays. For each of these various rays differs in its ability to penetrate the atmosphere. Each part of the spectrum must, therefore, be processed separately, then the whole put back together for the final value of the radiation emitted by the sun.

Ever since the beginning of this century the Smithsonian has pursued this difficult investigation, developing new and improved instruments of almost unbelievable sensitiveness, refining and speeding up methods of computations following the daily observations, until a definitive value of the "solar constant" of radiation has emerged. This value is now accepted throughout the world as the actual measure of the heat sent earthward by the sun as it is entirely *outside our atmosphere.* It is a fundamental cosmic unit of inestimable value in all sorts of physical and meteorological researches. Although called the "solar constant," actually the value has through the years

showed a mysterious rhythmic fluctuation which may be of the greatest practical value to mankind.

Although the sun appears to be so vastly bigger and brighter than all the other stars, actually it is only very average in both size and luminosity. If it were to move out in space to the distance of some of the brighter stars we see, it would barely be visible to the naked eye. A good way to look at our personal troubles in a better perspective and to realize the insignificance of our planet in the cosmic scheme is to go out into the country on a moonless night and take a good long look up at the blazing firmament of stars that bespeak the vastness and beauty of creation. And what can be seen in the night sky are but a small proportion of the some hundred billion stars like the sun that make up our own private star system or galaxy. This galaxy itself is not so small, however, for it takes light, traveling at a speed of 186,000 miles per second, something like 100,000 years to go from one end of it to the other.

Heading out into space from our galaxy and traveling about a million light-years (one light-year is nearly six trillion miles) we begin to encounter other galaxies or "island universes," very much like our own. Within the distance our largest telescopes can probe out into infinity there are estimated to be some one hundred million galaxies—and at the limit of seeing there seems to be no thinning out in numbers. In this vast sweep of the universe, with each star separated from every other star by unimaginable distances, our own little planet appears as only a speck of cosmic dust revolving helplessly around an inconspicuous star—one among a billion billion other stars.

Yet to us the most important objects in that whole vast uni-

verse are our earth—and the sun. Considering its great distance from the earth, we now have a surprisingly large body of information about the sun. We know, for example, that it is an immense gaseous sphere whose diameter is more than a thousand times that of the earth's diameter; that its temperature even at the surface is well over 10,000 degrees Fahrenheit, while in the raging inferno deep inside the sun it would have to be measured in millions of degrees; that few chemical compounds can exist at the sun's temperatures and that even atoms are torn apart in the consuming heat. Some astronomers have held that electrons torn from atoms are annihilated in the process of transforming matter into radiation; on this theory, enough matter exists in the sun to continue its present output of energy for fifteen thousand billion years. The latest theory of the liberation of energy within the sun or any star is that at their extreme temperatures, four hydrogen atoms combine to form a helium atom. Four hydrogen atoms weigh 0.7 percent more than one helium atom, so the additional mass is released as energy and can be radiated by the star.

An interesting detail of the sun's make-up is the existence at intervals on its surface of dark spots and groups of spots that seem to march slowly across its face through the sun's rotation. Although these sunspots look small to us as compared with the size of the sun itself, actually some of them are so large that the entire earth could be dropped into one without scraping the sides. The sunspots are swirling, raging storms within the matter of the sun itself, somewhat in the manner of our tornadoes or "twisters" in the earth's atmosphere. The cause of the spots is not definitely known, but some of their effects are very

evident to us. With them are associated changes in magnetic conditions on earth, affecting radio and even telegraphy, and also producing brilliant displays of the *Aurora Borealis,* or Northern Lights. Sunspots appear in regular cycles, and with these cycles scientists, statisticians, and others have correlated all sorts of earthly happenings, such as increase in rabbit population, greater catches of fish, probability of nations going to war, and even stock-market fluctuations.

To determine how much heat the sun is sending earthward, or the "solar constant of radiation," the Smithsonian requires very special observing stations. This "solar constant" is simply the unit adopted to measure the sun's heat; it is thus explained by Dr. C. G. Abbot, who succeeded Professor Langley as Director of the Astrophysical Observatory and later as Secretary of the Smithsonian:

"If there could be a cube of water one centimeter (0.4 inch) on each edge, so black that it would fully absorb sun rays, situated on the moon, where there is no atmosphere, in March when the sun is at its mean distance, and exposed with its surface at right angles to the sunbeam, then its temperature would rise 1.94 degrees C. (3.49 degrees F.) in one minute of time." In other words the sun's heat, if collected outside our atmosphere, would measure 1.94 calories per square centimeter per minute.

The first requirement for making this extremely delicate and complex measurement is clear skies. Smithsonian men have been in all the most promising parts of the world to find the best all-around spots for the purpose, and one of the very best in the whole world is on Mount Montezuma, Chile, in the Atacama desert and near the great Chilean nitrate fields. This

is one of the driest and most barren regions on earth. Near the top of the 9,000-foot mountain a Smithsonian station has been in operation since 1920. Here on nearly every day of the year trained observers go through the complex ritual of measuring and recording the sun's radiation.

The observing station itself is not *on* the mountain, but *in* the mountain. The delicate measuring devices are set up in a tunnel drilled straight back toward the heart of the mountain. Far back in this dark hole the temperature remains nearly the same day and night, summer and winter. A beam of the sun's rays is reflected into the tunnel by an ingenious device which by the use of mirrors and a clocklike mechanism follows the sun and holds its beam at the desired spot within the tunnel. The beam is split up into its component colors by a spectroscope, and the energy in each band of the spectrum is measured by an ultra-sensitive device known as the bolometer. This is essentially an electrical thermometer which can detect changes of one-millionth of a degree. The result is automatically recorded on a photographic plate. The whole solar beam is measured at the same time by an instrument called a silver-disk pyrheliometer, which was developed and perfected at the Smithsonian.

Mount Montezuma presents a picture of utter barrenness that is hard to imagine unless one has seen it. The almost complete absence of rain prevents the growth of a normal covering of vegetation such as we are used to. Even the dust has long since been blown away by the continual wind on the mountain-top, leaving a weird landscape of caked, brownish-yellow gravel where no living thing can survive. It must resemble the scenery on the moon or on some of our neighboring planets that ap-

pear to be waterless. Here the Smithsonian observers live and work for a three-year stretch, which has been found to be the longest period that human beings can stand such complete isolation and desolate surroundings. Even so, the observers must have, in addition to their technical training, very special personal qualities. Dr. Abbot makes this point clear in the following quotation from an article in the Scientific Monthly: "Some years ago we asked permission of the U. S. Civil Service Commission to appoint a certain young college graduate, whom we had specially trained for two years, to be in charge of the station at Montezuma. We described the place, the duties, the isolation. We told of the use of instruments to measure the sun's heat to 0.000,001 degree, and the necessity of being able to rebuild them on the spot if damaged by earthquake. Such repairs involved the hanging of a carefully adjusted magnetic device, hardly heavier than a hair, upon a thread of quartz crystal too fine to be seen with the naked eye. We mentioned the long and intricate calculations to be made each day, the early rising and long hours, the personal hauling of supplies—even of water—and the necessity for tact to carry on without friction, both in the observatory family and among the people of the country.

"We suggested that unless the Commission felt it indispensable to hold a public examination for the place, we be permitted to appoint the young man whose qualifications had been proved by two years' experience under our immediate supervision. The Commission replied, in effect, that as angels from Heaven were unlikely to apply, they felt it futile to insist on a public examination."

Observing stations in numerous other localities have been manned by Smithsonian personnel. Among these are Mount Whitney, Mount Wilson, and Table Mountain in California; Mount Harqua Hala in Arizona; Burro Mountain, New Mexico; Mount Brukkaros in South West Africa; and Mount St. Katherine, Egypt, only ten miles from Mount Sinai of biblical fame. For one reason or another all have been abandoned except Mount Montezuma, Chile, and Table Mountain, California. At the Harqua Hala, Burro Mountain, and Brukkaros stations, increasing quantities of dust in the air vitiated the benefit of cloudless skies. Mount St. Katherine was an excellent station, but its extreme desolation and distance from any town, combined with the threat of war toward the close of the 30's, caused its abandonment. For some years the Smithsonian has been scouting for another station with perfect skies but without unbearable isolation. Such an ideal spot has apparently been discovered in Clark Mountain, California, and it is hoped that before long another Smithsonian tunnel observatory will be in action there.

Among the possible applications of the Smithsonian's half-century of solar radiation records is one of vital concern to everybody everywhere—long-range weather forecasting. A number of actual trial predictions have already been published by Dr. Abbot, the chief Smithsonian worker in this field, but he is the first to admit—in fact, to emphasize—their very tentative nature. He does claim, however, that the variation in the output of solar radiation is the primary cause of our weather changes. The Smithsonian already has more than 25 years of very reliable, almost daily records of the solar constant, to-

gether with very complete analyses of its variation. Accurate records of temperature, rainfall, and pressure are, of course, available in official Weather Bureau publications. Dr. Abbot's incredibly difficult task is to correlate the sun's variations with recorded changes in weather, and thus be able to project the relationship into the future.

What makes the research so difficult is the fact that weather is affected locally by a dozen different factors—air currents, the presence or absence of hills and mountains, the proximity of oceans or deserts, and many more. As a result, the relation of weather to solar variation would probably have to be worked out separately for each individual locality. Only very recently Dr. Abbot has worked out one specific correlation between a 6⅔-day periodic variation in the sun's radiation and a like period in the departure from normal in Washington, D. C., temperatures. He even ventured to publish a full year's prediction of the approximate dates that would have the lowest temperature in each 6⅔-day period throughout the year. This prediction was very successful, for of the 55 dates so listed, 48 proved to be approximate days of minimum temperature for their periods. Moreover, the mean difference in temperature between these minimum days and the warmer days before and after turned out to be within one degree of what Dr. Abbot had predicted.

Many other tentative types of weather prediction even up to several years in advance have been attempted with some success. It is of its very nature, however, a pioneering long-range research program with no guideposts. The future holds great promise. It would mean much, for example, if manufacturers, business men, farmers, ranchers, and many other groups

could be told that next spring will arrive very late in the Mid-West, that next summer will be excessively dry in the Northwest, or even that the third winter after the next one will be the coldest for a decade in New England. Such long-range predictions are a definite possibility as a result of the Smithsonian's continuing efforts to produce the best possible record of the rhythmic variations in the sun's energy output.

Smithsonian work along these lines has received wide publicity in the press, and Dr. Abbot receives many letters from people in all walks of life asking for specific weather predictions. He has carefully explained to such correspondents the preliminary status of the investigation, but has in a few urgent cases grudgingly offered a tentative forecast. An Army engineer engaged in river-control work wanted very badly to know the probable rainfall for three specific months. Dr. Abbot applied his complex cycle analysis to ten stations in the area, and advised the engineer that the outlook was for a rainfall 84 to 87 percent of normal for the period. He was advised later that the actual figure was just 87 percent of normal.

A farmer in South Dakota inveigled Dr. Abbot into predicting crop weather for six successive years, which turned out to be very successful. But usually the Institution regretfully declines requests for specific forecasts, feeling that the status of the research does not justify them. Furthermore, that is not the business of the Institution; its aim is only to establish the basic record of solar variation. Dr. Abbot has received a number of letters from prospective brides who want predictions of the weather to be expected on their wedding dates. He replies to each that he can predict the day will be one of the happiest in

their lives, but that his studies are not far enough advanced to guarantee that the weather on a single day in the future will be good or bad.

Another offshoot of the solar investigations is the establishment of an agency to study the effects of radiation on plants—the Division of Radiation and Organisms. Nothing could be more fundamental than this study, for it involves the world's most important chemical reaction—photosynthesis. In the presence of light, plants take up carbon dioxide from the air and through amazingly intricate chemical processes that cannot yet be duplicated in the laboratory, produce sugars and starches, the basis of the food for all living creatures on earth, including man.

The Division is planning new and more fundamental researches in the field of photosynthesis. The vital importance of such studies was recently stated thus by Karl T. Compton, Chairman of the Massachusetts Institute of Technology Corporation:

"The emphasis which modern industry and modern warfare also have laid upon physical sciences has tended to obscure somewhat in the public eye the less spectacular advances of biology and medicine. The use of atomic power for both constructive and destructive purposes has greater interest for the public imagination than that mysterious process by which green plants convert the energy of the sun into the substance of life. But who can say whether the answer to the secret of photosynthesis may not have more far-reaching effects on our lives and on those of generations to come?"

At the time the new division was created, the Smithsonian

was already badly cramped for space, so the idea was conceived of utilizing the 147-foot flag tower for offices and part of the basement for laboratories. The interior of the flag tower previously had been in perfect keeping with the architecture of the Smithsonian Building, that of a twelfth-century Norman castle. Entering at the ground floor and looking up into the great dimly lit shaft with its winding wooden staircase, the corners heavily festooned with cobwebs and bats wheeling eerily overhead, one would hardly have been surprised to see a knight in armor step onto the scene. Nor would the illusion be dispelled in the dark basement rooms, for here, set into the rough stonework, are pitch-black dungeons with heavy stone arches and iron grillwork doors that might well conceal sinister secrets of imprisonment and torture.

The transformation from medieval days to the twentieth century was abrupt; the tower was converted to a modern office building, with only one office to a floor, however. In the basement appeared chemical laboratories, constant-temperature rooms with humidity control, and all sorts of delicate and complicated apparatus to test and measure the effects of many types of radiation on plants. Much of this apparatus was without precedent and had to be designed and constructed in the Division's shops.

Among the problems investigated was the well-known phenomenon of the bending of plants toward light. It was determined that strong light destroys growth substance, so that the lighted side of the plant grows less than the dark side, causing it to bend toward the light. The same effect results in weaker light from a migration of growth substance to the dark side of

the plant, rather than from its destruction. Another set of experiments showed that radiation of the wave lengths that produce red light stimulate wheat plants to the greatest assimilation of carbon dioxide from the air, followed in order of usefulness by blue, green, and yellow, but that ultraviolet and infrared light, invisible to our eyes, have no effect whatever.

The power of certain ultraviolet rays was clearly shown in a series of carefully controlled tests using the simple plants known as green algae. Plates completely covered with the algae were exposed to ultraviolet light of known wave length. The deadly effect of certain wave lengths appeared in the form of white bands of dead algae across the otherwise green plates. Here, indeed, were death rays—at least, for green algae. Among many other fundamental investigations by the Division of Radiation and Organisms are the determination of the rate of photosynthesis under different wave lengths of light, studies of the effect on plant growth of changes in light intensity, and exact measurements of the rate of respiration of plants.

Recently the Institution has been equipping new laboratories with the most modern electronic and other devices whereby the skills of physics, chemistry, and biology may launch a concerted attack on the problem of the actual mechanics of living cell growth. Here we are approaching the innermost circle of life's secrets and even the nature of life itself. In this connection it is interesting to note the recent decrease in sharpness of the dividing line between chemistry and biology. Until this decade the distinction was clear—chemistry dealt with non-living matter, biology with living. Now that certain of the viruses—those invisible agents that cause polio, influenza,

measles, the common cold, and other diseases—have been isolated in pure crystallized form, the separation is hard to make. For some viruses are shown to be actually smaller in size than certain large molecules of non-living chemicals and exhibit properties similar to those of such molecules. Other viruses at the opposite end of an unbroken series of increasingly larger forms are of greater dimensions than what are recognized as living organisms. Yet the viruses can reproduce or multiply *within living cells.* In short, they form a transition stage between living and non-living matter, leading one scientist to conclude that life is closely connected with chemical structure and that the vital phenomenon is possessed in varying degree by all matter, living or non-living.

In connection with his many years of sun studies, Dr. Abbot became interested in the potentially very important subject of the practical use of solar energy. Even the small proportion of the sun's enormous outpouring of heat that our tiny earth intercepts would generate some two hundred billion horsepower if it could all be harnessed. The portion that strikes desert regions of the earth is completely wasted because there is no vegetation there to utilize it. If efficient collectors could be set up in such regions, vast amounts of power could be generated at such time in the future as our oil and coal supplies shall be depleted or become so high priced as to be out of reach for ordinary uses.

Dr. Abbot's first device to utilize the sun's heat was a solar cooker that he installed at the Smithsonian station on Mount Wilson. A curved mirror focused the sun's rays on a glass tube containing oil, which, as it became heated, circulated through

a reservoir surrounding two ovens. These ovens became hot enough for nearly all cooking operations including the baking of bread and the cooking of meat. Most of the cooking for the observers was done for a number of seasons with this practical solar cooker.

For power production from the sun's rays, Dr. Abbot devised a solar flash boiler. Using a parabolic cylindrical concave mirror, the sun rays are concentrated on a blackened copper boiler tube extending the length of the mirror. Water is automatically pumped into the tube in exactly the right amount to replace that which bursts into steam and is led off to operate the small engine attached to the device. Steam pressure comes on within five minutes after the sun strikes the mirror. About 15 percent of the solar energy caught by the mirror can thus be converted into useful work.

These experiments of Dr. Abbot's are, of course, only pilot tests of the possibilities. Preliminary computations of the cost of building large scale sun-power plants in desert areas, however, indicate an investment cost not too far out of line with similar costs for conventional power plants. It is reassuring to know that if the vastly increased use of our present fuels should deplete the limited reserves faster than is anticipated, there is still sun power that can be tapped—and that source is inexhaustible.

Many other researches connected with the sun and its radiation have been carried on by the Smithsonian, but they are primarily of technical interest. They have combined, however, to contribute very materially to our knowledge of that star to whose fortunes we are inseparably linked—the sun. The work

is now going forward under the able directorship of Loyal B. Aldrich, for many years assistant director before Dr. Abbot's retirement.

The solar researches are typically Smithsonian because they are basic investigations primarily for the discovery of new knowledge. Practical benefits for mankind are certain to flow from such fundamental researches—in fact, it was recently stated by Dr. John A. Hutcheson, director of Westinghouse Research Laboratories, that "industrial progress would come to a complete standstill without pure research." No knowledge could be more basic than exact records of the kind, amount, and variations of the sun's radiation to earth, for on that radiation depend all human activities and life itself.

IX. *Red Men and White*

Human sacrifices to propitiate rattlesnakes were being made secretly by the Tewa Indians in the Western United States as recently as 1912. In a South American country even today human heads are collected and shrunk by an intricate process to the size of oranges as an important part of Indian tribal activity. Within the memory of living man great "potlatches" were held by the Northwest Coast Indians, the purpose of which was to enable the men of the tribe to prove their greatness by giving away everything they owned. In the Stone Age of America, the Iroquoian tribes had a real league of nations, the main purpose of which was to maintain peace, and under which women had equal rights with men. Such are a few of the interesting highlights that have emerged from the Smithsonian's study of the American Indians.

In these halcyon days of America's greatness, it is difficult to realize that the ancestors of every single one of us who is not an Indian came not so long ago from some other country. The

only native Americans are the American Indians. A few short centuries ago they owned the Western Hemisphere, lock, stock, and barrel. And now, today, the only Indians to be found in North America are remnants of a few hundred or a few thousand individuals living for the most part on scattered reservations set aside for them by the White man.

The story of the rise and fall of the Indian empire is a fascinating one. The Smithsonian has had the privilege of taking a prominent part in the unfolding and recording of this earth drama. It first systematized and coordinated the attempts to learn the Indian story, and what it has found out over a period of several generations is recorded for all to read in thousands of pages of Smithsonian publications.

To visualize the vastness of the problem, let us imagine that we have at our disposal a time machine, which when set in operation will flash on a screen successive pictures of the Americas going backward into the past. Running slowly at first, the machine shows us frantic scenes of World War II and World War I, frighteningly close together on our time scale. American Indians fought valiantly in the Allied Armies in these wars. Back through the rapid industrial growth of America go the pictures, through the crucial Civil War days when the existence of the United States hung in the balance, back through the days of westward expansion against bitter Indian opposition to the very welding of the Nation in the crucible of the American Revolution.

Running more rapidly now, the pictures flash briefly through the Colonial period, when Indians were a very real menace to the courageous colonists with only a tenuous hold on the East-

ern seaboard. With ever increasing tempo, the images on our screen go inexorably back to the invasion of South and Middle America by the fierce Spanish conquistadores, who looted and subdued the rich Indian empires of those regions; back to Columbus, who first saw the Indians on the West Indian island where he made his landfall.

Racing further back into the past, the pictures now are different—no humans other than Indians appear. The red men are again masters of the hemisphere. We see peaceful agricultural tribes cultivating their fields in the Southwest, with a wary eye out for the marauding Apache and other tribes in adjoining regions. In South and Middle America we get glimpses of the fantastic civilizations of the Maya, Aztec, and Inca, with their Shangri-la cities, their barbaric splendor, and their amazingly good knowledge of things like mathematics and astronomy.

The pictures now go still faster. Flashing back through hundreds and thousands of years during the slow development of these indigenous cultures all over the Americas, we arrive finally at a scene dated perhaps 25,000 years ago. The picture looms dimly through the mists of antiquity, but we can now see something strange. We stop the machine and study the image. Yes, it's true—there is not a human being on the Western Hemisphere. But as we study the northwestern coast of North America, we see through the mists a small band of hardy Asiatic natives landing on the coast of Alaska. It is a thrilling moment in earth history. Man is setting foot for the first time on a vast segment of the earth's land area.

At this point we abandon our convenient time machine and start looking forward from the first landing on the shores of

Bering Strait, this time using the information gleaned by anthropologists the hard way—through long patient studies of living Indians, through the piecing together of many scattered bits of evidence found in prehistoric Indian sites, and by means of other scientific studies bearing on the problem. Anthropologists seem now to be in general agreement that America was peopled by migrants from northeast Asia who came in small groups over a long period across narrow Bering Strait to the Alaska coast. When they first started to arrive, great ice sheets covered large parts of North America, even down into what is now the United States. The hardy migrants, however, found an ice-free corridor to the south and spread rapidly over the Americas, reaching eventually even to the tip of South America.

There is at this point a gap in our knowledge of the American aborigines covering many thousands of years. The only tangible evidence thus far recovered from these American "dark ages" came when archeologists turned up some unusual projectile points and other artifacts. No especial interest was taken in these, however, until in 1925 and 1927 some of these points were found along with bones of an extinct form of bison near Folsom, New Mexico. This discovery presupposed the existence of a wraith-like race of men far back in prehistory—his type has become known as Folsom Man.

These mysterious Folsom points, distinguished from ordinary Indian arrowheads by their unusual shape and by a longitudinal groove chipped out of each side, have also been found at what is known as the Lindenmeier site in northern Colorado, where Smithsonian anthropologists worked for several seasons, uncovering large numbers of Folsom artifacts. A very thorough

geological study was made there by a Harvard geologist. As a result of his work, it was announced that the age of the deposit in which the Folsom material appeared was between 10,000 and 25,000 years, with the evidence leaning toward the latter figure. Strangely, no actual skeletal remains of Folsom Man himself have yet been found, but as this is being written, a report has reached the Smithsonian of a cave in one of the western States that contains Folsom points *and* human bones in direct association. If so, the great gap in the known history of native Americans may soon be filled in to some extent at least.

At the end of the gap in our knowledge begins the direct evidence in the form of dated inscriptions from Mexico and Central America, and of timbers in Indian house remains preserved in the arid climate of our Southwest that can be positively dated by the tree-ring method. From these earliest established records, beginning something over 2,000 years ago, down to the present, knowledge regarding the Indians naturally becomes more and more complete.

When Europeans appeared in America, Indian culture was doomed. In some areas the Indians put up a valiant resistance, but the White invaders were irresistible, and pure Indian culture in North America soon became merely something for the White man to study and record. At the time the Smithsonian was established around the middle of the nineteenth century, it was already necessary to go far west to find Indians living just as they had lived before Columbus. Created solely for the increase and diffusion of knowledge, the Smithsonian was the logical agency to undertake the systematic study of the American aborigines.

And a fascinating study it was. Here were countless varia-
tions of aboriginal culture that arose in widely different envi-
ronments, many of them as yet unspoiled by the withering touch
of civilization. Some sporadic work was done by the Institution
in its early years, and important monographs on various phases
of Indian life were published, but it was not until a few years
after the Civil War that the big opportunity came. After the
close of that tragic conflict, the Nation began to look to the
West, and several Government expeditions set out to explore
and survey the great Rocky Mountain Region. In charge of
the geological and geographical surveys was Major John W.
Powell, explorer and scientist. Although Powell was handi-
capped by the loss of his right arm as the result of wounds re-
ceived in action at the Battle of Shiloh, his great interest in the
intricate geology of the region led him to propose and carry
out a spectacular project—the first journey down the treacher-
ous and almost wholly unexplored Colorado River.

This expedition is a perfect example of what we now call
calculated risk. Major Powell knew the extreme danger of ven-
turing into a river running through a tremendous gorge like
the Grand Canyon, for he knew that eventually the party must
arrive at a point of no return—a place where sheer rock walls
would prevent escape. But he also knew how to build boats
that would bob up to the surface if capsized, and he felt that
the importance of mapping the geology of this hitherto blank
area justified the danger.

In May of 1869 the party boards four small boats loaded
with supplies and instruments and pushes out into the river.
All goes well at the start, but soon the first of the rapids are

encountered, and their troubles begin. The boiling torrent tosses the little boats around like corks, and they are often swamped and even overturned. If there is a passage along the river's edge, the men land and guide the boats with tow ropes through the most vicious rapids, but this is not always possible. Where the walls are sheer, there is nothing to do but hang on and take what comes. One boat is smashed to bits on a hidden rock, but the men manage to get to one of the other boats. At this crucial point, one man loses his courage and climbs out of the canyon. The other three boats push on, each day bringing incredible physical labor and hardship. Wherever the river traverses granite rocks, waterfalls and tortuous rapids are almost continuous. Every rain brings new dangers, for the swollen, roaring flood hides jagged rocks that add to the mounting hazards.

In the next granite area, the worst rapids yet encountered cause three more men to lose heart. After vainly attempting to persuade Powell to give up what seems to them an impossible task, the three climb out of the canyon and the rest go on. Ironically, all three of the deserters were killed by Indians while attempting to get back to civilization. The expedition pushes on, but soon another boat has to be abandoned, and with it the instruments and geological specimens.

Now only two boats remain, the provisions are nearly all spoiled, and the outcome is very much in doubt. As if to provide a last test of courage and stamina, the river produces a set of dangerous falls and rapids for which no portage is possible. The two boats dive crazily into the maelstrom, both are swamped, but the men hang grimly onto the sides and emerge

from the boiling waters. This was indeed the final test, for shortly thereafter the two boats float triumphantly out of the Grand Canyon, and the objective has been reached.

During the next decade Powell continued his geological exploration work in the West, but he was one of the more versatile scientists of a few generations ago when the men of science did not specialize so closely, and anthropology increasingly claimed his interest and attention. Starting out as a geologist, he ended up as one of the country's leading students of the Indians. He was accepted as a friend by them, and given the Indian name "Ka-pu-rats," meaning "arm-off," by the Utes and Shoshones. When the exploring of the West was organized under the Geological Survey, Indian studies were entrusted to the Smithsonian, resulting in the creation of its Bureau of American Ethnology with Major Powell as its first director.

By now it was becoming a matter of urgency to go among the Indian tribes and record their way of life before the onset of the rapid modification always brought about by White contact. The preliminary study brought out the amazing fact that in the United States alone there were some 500 mutually unintelligible Indian languages, but these could be grouped roughly into 50 linguistic families. Plans were formulated to study tribes typical of the various families. With a small staff of ethnologists and with the aid of distinguished collaborators a program of systematic work was started that has been continued by the Smithsonian to the present day.

One of the most interesting aspects of the study of the American Indians is the amazing diversification of their development and culture. The reason for this is easy to see, however, upon

considering the endless variety of environments in which the various tribes located throughout the Western Hemisphere. It would be strange, indeed, if there were not extreme contrasts in way of life between, for example, the fur-clad Eskimo wrenching a living from the snow and ice and bitter cold of the Arctic, and the naked tribes roaming the dank, sweltering rain forests of the equatorial regions; or between the Indian dwellers of the western desert regions living precariously from year to year in the haunting shadow of famine, and the hunting tribes of the Great Plains culling their fat living from the vast herds of bison that tramped up and down the prairies.

One unusual contrast in way of life is that between the head-hunting Jivaro of Ecuador who for centuries have lived for war, and the Iroquois tribes of the northeastern United States, who formed a federation for peace long before the American Revolution. Both groups have been studied thoroughly by Smithsonian anthropologists, and the results incorporated into the publications of the Bureau of American Ethnology. The Jivaro, a fierce, independent people inhabiting a great tract of some 25,000 acres of mountainous country in eastern Ecuador, have been known to Europeans for more than 400 years. In all that time, in spite of the fact that their lands are undoubtedly the source of much of the rich gold hoard that lured the Spanish conquistadores, they have resisted all attempts at conquest or subjection by the White man.

The Jivaro live scattered over this great forest area in small groups of families, each household being completely independent and subject to no rule or law. Their main business in life, beyond that of getting enough to eat and drink, is the

carrying on of endless blood-revenge feuds with the neighboring groups of their own people. The standing of a Jivaro man depends entirely upon the number of enemy heads he has taken in battle. Dr. Matthew W. Stirling, Director of the Smithsonian's Bureau of American Ethnology, went among the Jivaro in the 1930's and obtained from an intelligent Jivaro informant a detailed account of the present head-hunting raids. The following account of the procedure of a raid is based on Dr. Stirling's detailed report.

The art of warfare is drilled into young boys from earliest childhood. When about the age of six, a son is instructed by his father every morning at dawn concerning the necessity of being a warrior. He endeavors to implant in his son's mind the idea of revenge by reciting the feuds in which his particular family is involved. When a man goes to war he usually takes with him his sons of more than seven years of age. The first time a boy or young man kills an enemy in actual combat he is ordered by the others to cut off the head of his victim.

War is declared with a ceremony in which a lance is officially disinterred and carried into the jivaria—house of a large family group. Immediately following this ceremony, an emissary is sent off to notify the enemy, a part of the strange ethics of Jivaro warfare. All the warriors paint their bodies black with sua, and the hair is carefully washed and combed. All their finest hair decorations and ear ornaments are put on so that in the event their heads are taken during the battle they will have no cause to be embarrassed.

Near midnight a dance begins in which all the warriors take part. It is a weird, warlike dance that stirs the fighters into a

frenzy. At dawn the dance ends and the warriors leave, each accompanied by a woman bearing nijimanche, a drink made from manioc, in jars. When they arrive in enemy territory, they do not approach the house until dark and do not attack until the following dawn, in the meantime exchanging taunts with the enemy within the house. At the first light of dawn the exchange of words ceases and the attack begins.

The assault is made with as much rapidity as possible, the attackers shouting loudly to bolster their own courage and at the same time to terrify the enemy. As the house is rushed, guns are thrown aside and only lances are used. Once the house is entered, a scene of great confusion transpires. The dogs are barking, women screaming and crying, the fighters shouting, the old men pleading for protection and shouting advice to their defenders. Children under seven years of age are lanced and thrown aside. All the men possible are killed, as are the old women. Only the young women are spared.

When a man has killed an opponent, he takes his head as soon as circumstances permit. It often happens that the severing of the head is begun while the victim is still alive. The victorious party then mill around, shouting and wrecking everything in the house. They break the earthenware, kill the dogs, and take all the loot of value. They then burn the house and uproot the plants in the garden. Meanwhile those who have taken heads string them on bark strips, and the party is ready to return home.

The details of the process of preparing the shrunken head trophies or tsantsas are too gruesome to give in detail; suffice it to say that they are cooked, dried and shrunk with hot rocks

and sand, smoked overnight until they are black, and finally polished. They are thought to have magical power in the same general way as did the scalps taken by certain North American Indians, and are the most prized possession of a Jivaro warrior.

To view a striking contrast to this sinister picture of centuries-old blood-revenge feuds that still go on in inaccessible mountainous regions of eastern Ecuador, it is necessary to leave the gloom of equatorial jungles and journey to the home of the Iroquois in what is now central and eastern New York State. Dr. J. N. B. Hewitt, late Smithsonian ethnologist, himself part Iroquois Indian, writing just after the close of World War I, compares the White man's League of Nations with that of the Iroquois:

"After more than four years of a world war, characterized by such merciless slaughter of men, women, and children, by such titanic mobilization of men and weapons of destruction, and by such hideous brutality, that no past age of savagery has equaled them, the peoples of the earth are now striving to form a league of nations for the express purpose of abolishing the causes of war and to establish a lasting peace among all men.

"So, of more than passing interest is the fact that in the sixteenth century, on the North American continent, there was formed a permanent league of five tribes of Indians for the purpose of stopping for all time the shedding of human blood by violence and of establishing lasting peace among all known men by means of a constitutional form of government based on peace, justice, righteousness, and power or authority.

"Its founders did not limit the scope of this confederation

to the five Iroquoian tribes mentioned—Mohawk, Onondaga, Oneida, Cayuga, and Seneca—but they proposed for themselves and their posterity the greater task of gradually bringing under this form of government all the known tribes of men, not as subject peoples, but as confederates.

"The proposal to include all the tribes of men in such a league of comity and peace is the more remarkable in view of the fact that that was an age of fierce tribalism, whose creed was that no person had any rights of life or property outside of the tribe to whose jurisdiction he or she belonged, and that every person when beyond the limits of his or her tribe's protection was an outlaw, and common game for the few who still indulged in the horrid appetite of cannibalism."

The moving spirit in the formation of this Stone Age League of Nations was Deganawida, a great Indian statesman to whom the Iroquois attributed divine origin and a heavenly mission among men. Working with another able statesman, Hiawatha —not the Indian brave immortalized in Longfellow's poem of that name—and an equally clever stateswoman, Djigonsasen, Deganawida was able despite bitter opposition from his own people to bring about a peaceful revolution in the methods and purposes of the existing governments of the five tribes. The presence of a woman in this distinguished trio of Indian leaders emphasizes the fact that women had a very prominent—almost dominant—part in Iroquois affairs. Designated a matron of the ohwachira, or family group, was a woman, usually the oldest of the group. The adult woman and mothers of the ohwachira held councils, and the candidates for chief and vice chief might be nominated by the mothers alone. If the chief

deviated from the path of rectitude, the matron took the first step toward deposing him for cause.

Two of the basic practical measures put into effect as a result of the Iroquois league were the stopping of revenge murders among the tribes and legal prohibition of cannibalism. The six principles laid down by the founders of the league and which made it an effective instrument of peace were: 1, sanity of mind and health of body; 2, peace between individuals and between organized groups; 3, righteousness in conduct and its advocacy in thought and speech; 4, justice and the adjustment of rights and obligations; 5, power of civil authority; and 6, the magic power of the institutions and rituals. The cumulative purpose of these principles is described by Dr. Hewitt:

"The constructive results of the control and guidance of human thinking and conduct in the private, the public, and the foreign relations of the peoples so leagued by these six principles, the founders maintained, are the establishment and the conservation of what is reverently called the Great Commonwealth, the Great Law of Equity and Righteousness and Wellbeing, of all known men. It is thus seen that the mental grasp and outlook of these prophet-statesmen and stateswomen of the Iroquois looked out beyond the limits of tribal boundaries to a vast brotherhood and sisterhood of all the tribes of men, dwelling in harmony and happiness. This indeed was a notable vision for the Stone Age of America."

Who can say what far-reaching effects might not have sprung from this amazing Indian league of nations had not the white invaders from across the sea come to disrupt its workings?

An even more striking contrast in cultural development is that between some of the desert-inhabiting groups of our own West and the great pre-Columbian empire of the Inca in the Peruvian Andes. One of the most primitive of the desert groups was the Gosiute, a Shoshonean band living a precarious existence in the Great Salt Lake Desert region near the border of of Utah and Nevada. They were studied for the Smithsonian by Dr. Julian H. Steward, who published his findings, together with a résumé of previous records, as a Bulletin of the Bureau of American Ethnology. All observers agree in describing the Gosiute as among the most primitive of all the American Indians.

The reason is, of course, that the scarcity of food in their inhospitable desert homeland forced the Indians to spend practically all their time in merely trying to get enough to eat. Under such pressure of the basic survival instincts there was little opportunity for the development of any cultural refinements. If we wonder why human beings would remain in such an unfavorable environment, it should be remembered that the neighboring more fertile regions were comparatively densely populated, and the inhabitants resisted fiercely any attempts at encroachment by outsiders.

To get a first-hand impression of the wretched condition of the Gosiute when first encountered by white men it is interesting to study the comments of some of the early explorers. Forney, writing in 1858, describes them as impoverished, living on snakes, lizards, and roots. Captain Simpson, in an Army Engineer report of 1876, stated that they were very low and dirty, eating rabbits, rats, lizards, snakes, insects, rushes, grass,

seeds, and roots. Beckwith in 1855 wrote, "They are extremely filthy and very naked, and emaciated by starvation during the long winter, during which their supply of rats and bugs fail, and they are reduced to the greatest extreme of want."

Sometimes, in years of desperate famine, Gosiute families were even forced to leave their old and sick to die alone on the ever-waiting desert. Such a brutal abandonment of an old man was thus described by Egan, "Totally blind, deaf and emaciated, he was put in a semi-circular sagebrush windbreak near a spring, given a small rabbit-skin robe, and left to perish."

Not a pretty picture, but the Gosiute had a fierce fight on their hands to wrest from the parched earth a bare existence. The names of two of their main localities are suggestive of their desolation—Skull Valley and Sink Valley.

The desert home of the Gosiute was so extensive that there could be little cooperation among the small roving bands. The various groups did hold a few simple festivals and performed dances to encourage grass to grow. Women's standing among them was not high, for the men were reported to sell young girls and even their wives for horses. It is further reported, however, that such sales did not stick, for the women usually escaped from their buyers and ended up back at home.

The serious business of getting a wife was often accomplished in the most direct manner—by simply carrying away the woman wanted, married or unmarried. This directness of method is well illustrated by an incident cited by Egan, which refers to the case of an old, feeble man who would not allow any of the young bucks to marry his daughter. He says, "Indian Bill solved the problem, however. One afternoon he loaded his

gun. The girl was busy shelling nuts, the old man was sound asleep on the sunny side of the camp with his face toward Bill, who aimed his gun at the old man's good eye and fired, killing him instantly. The marriage ceremony was over. Bill coolly reloaded his gun, turned toward the girl and said, 'Come.' The girl picked up her blanket and followed her lord and master. All they owned on earth they had on, or carried in their hands."

From the Gosiute's struggle for a bare living in the Utah desert, with no time or opportunity to improve their standards or to attempt any cultural activities, it is a far cry to the fabulous empire of the Inca in the mountains of Peru, first encountered by the Spaniards in the sixteenth century. Yet the two peoples existed contemporaneously and must have sprung originally from the same general ancestral stock.

The Inca people, whose story is very completely covered in Bureau of American Ethnology publications, occupied the mountainous region around Cuzco, Peru. Although very close to the Equator, the climate is almost temperate along the coast because of cold ocean currents, and in the mountain valleys and plateaus the high elevation counteracts the heat that would be expected so near the Equator. For centuries before the coming of the Spaniards the Inca had been developing a high civilization in their Shangri-la-like mountain cities, paying little attention to the numerous other tribes up and down the Pacific coast except to conquer and loot any that constituted a threat to themselves. But with the crowning of the Inca emperor Pachacuti in 1438 there began an era of Inca expansion that in the short space of a century extended Inca dominion into a vast empire some 2,400 miles long and 150 to 200 miles

wide. As fast as the tribes were conquered, they were absorbed into the intricate Inca administrative scheme. Pachacuti's son and successor, Topa Inca, according to an early writer, pictured himself as ruler of the entire Andean civilization, and he very nearly saw his dream materialize.

With the aid of taxes and conscripted labor from the conquered tribes the Inca built elaborate towns, some of them on inaccessible mountain tops or steep mountain slopes where the labor involved must have been appalling. But as labor cost nothing, this item did not trouble the Inca rulers. In building the fortress of Sacsahnaman, probably the greatest Inca piece of construction, it is recorded that as many as 30,000 men worked at a time. Architects and head masons were government officials and devoted all their time to the building of the fantastic public buildings for which the Inca are renowned. These structures included not only temples and palaces, but also forts, storehouses, baths, and an intricate system of hillside agricultural terraces that in places changed the entire shape and grade of valleys for miles.

Most of the well-known Inca buildings are constructed of stone, great blocks of stone being moved by no other means than rollers and pry-bars, the motive power consisting of large crews of mit'a labor. The joints between huge stones are often so straight and perfect that it would be hard to stick a pin between them.

One of the most amazing of the spectacular Inca achievements was the system of roads that ran the length of the empire. Although used only by llama trains and people on foot,

the roads were often 12 feet wide with retaining walls where necessary and in places with streams of water channeled along the sides and trees planted for shade. Shelters and storehouses were provided at convenient intervals along the roads. Along the main roads a post service carried dispatches to and from the capital. Stationed at all times in huts a half league apart were runners trained from boyhood, who watched continually for messengers in either direction. When one appeared, a fresh runner paced him and received the oral message, running with it to the next hut. In this way the post relays covered up to 100 miles a day, carrying messages from Lima to Cuzco, a distance of over 400 miles, in three days. The Spanish mail carried on horseback in the seventeenth century took twelve days for the same route.

The barbaric splendor of the Inca court created a demand for elaborate and beautiful artifacts, including lacquered cups, excellent tapestry, beautifully painted pottery, and gold and silver ornaments. The Inca religion dominated all their activities, and many weird and elaborate pagan rites were held as a part of their worship of the Creator, the Sun, Moon, Stars, Earth, and Sea. Accompanying these rites were innumerable sacrifices. On the most momentous occasions these sacrifices were of human beings, offered to the gods to ward off famine, plagues, or defeat in war. Upon the crowning of a new emperor, the supreme sacrifice was offered, consisting of 200 physically perfect children.

Pagan and despotic though it was, the great Inca empire unified a vast miscellany of Indian tribes, some poor and

wretched, others wealthy and cultured, and improved the lot of all. The sense of solidarity thus imparted to the Indians of the Andes has carried over to modern times.

These brief contrasts illustrating the wide cultural diversification among the Indians of two continents serve to point up some of the interesting aspects of American anthropology as studied for the better part of a century by the Smithsonian Institution. It is indeed one of history's great human tragedies that the rapidly evolving Indian civilization in various parts of the Western Hemisphere had to be choked off by the White invasion from Europe. On the other hand, it is fortunate that such agencies as the Smithsonian have studied and put on record the fascinating drama of a doomed race.

In order to give an impression of the great variety of subjects studied by the Smithsonian Bureau of American Ethnology, a few titles selected more or less at random from its hundreds of publications are listed:

The Central Eskimo
The "Grand Medicine Society" of the Ojibwa
A Study of Pueblo Architecture
The Medicine Men of the Apache
Picture-Writing of the American Indian
Outlines of Zuni Creation Myths
Handbook of American Indians North of Mexico
Chippewa Music
An Introduction to the Study of Maya Hieroglyphs
Native Cemeteries and Forms of Burial East of the Mississippi
Handbook of the Indians of California
Stone Monuments of Southern Mexico
Handbook of South American Indians.

Red Men and White

It might be thought that the study of Indian culture should be about finished, but this is far from true. Although it is becoming more and more difficult to find Indians who remember the wild, free days of their grandfathers and can furnish authentic aboriginal data uncontaminated by White contact, nevertheless there is a vast harvest of information waiting to be garnered from the innumerable prehistoric sites of Indian camps, villages, burial mounds, and other remains of former days. In fact, one of the outstanding present jobs of the Bureau of American Ethnology is a nationwide survey of these ancient Indian sites, and strangely enough it is a job of great urgency.

Dr. Frank H. H. Roberts, Jr., Associate Director of the Bureau of American Ethnology and Director of the River Basin Surveys, a unit of the Bureau, writing in the *Scientific American* says: "During the past two years archeologists have been scraping away at the river basins of the United States with an anxious haste that suggests Noah's preparations for the Flood. The reason for this state of affairs is the Federal Government's nation-wide river development program. Its numerous projects for flood control, irrigation, hydroelectric power, and navigation will inundate most of the archeological sites of the United States, many of which, unfortunately, are still completely unexplored. The American aborigines, like the inhabitants of other lands, generally lived along river banks, where there were fields for raising crops and good locations for camps and villages, where fowl, game and fish abounded and where easy transportation by water was at hand. For this reason, about eighty percent of the archeological remains in this country are

199

located in places where the damming of rivers and the formation of reservoirs will obliterate them for all time.

"The archeologists of the United States have thus been suddenly presented with a problem of appalling dimensions. The construction of dams is going ahead so rapidly that they have only a few short years to carry out explorations which would ordinarily take several generations."

There was a call to arms for the archeologists of America which led to a mobilization in 1945. It was supported by the Army Corps of Engineers, the Bureau of Reclamation, the National Park Service, and the Smithsonian Institution. Several other organizations formed an independent Committee for the Recovery of Archeological Remains, which as the combined program progressed hoped to interest still others in the project. The Smithsonian was given entire responsibility for the scientific work.

Dr. Roberts goes on to say: "The diggings have already yielded important and interesting information about the little-known prehistoric peoples of North America. Among the most significant finds have been those in the Columbia River Basin of the Northwest. There the diggers have unearthed at successive levels the buried remains of villages ranging in time from 4,000 years ago to the time of the Lewis and Clark expedition in the early eighteen hundreds. From the great wealth of buried material archeologists hope to reconstruct a continuous history of the aboriginal occupation covering several thousand years. The Columbia River was the most important prehistoric travel route in the West; there is evidence of aboriginal trading up and down the river from the West Coast to the upper Mis-

souri Basin. In the Missouri Basin there have been finds of culture much older than those on the coast."

In the Medicine Creek Reservoir in Nebraska many important finds have been made. "The Medicine Creek villages," Dr. Roberts writes, "which have been excavated were probably occupied about 500 to 600 years ago. They certainly were never visited by White explorers, and so far it has not been possible to connect them with the Indian tribes that have lived in the area in more recent years. Each village consisted of a half dozen or more earth-covered, dome-shaped houses. The floors were slightly below ground level. Near the center of the large chamber in each house was a fireplace, with the smoke passing out through a hole in the roof. The entrance to the house was a tunnel-like passage, placed on the side away from the prevailing winter winds.

"Each house probably was occupied by two or more families. Small underground pits inside and outside the houses were used for storage, and later as dumps. The remains show that these people raised corn, squash, and beans, gathered wild fruits, berries, and tubers, and hunted bison, deer, antelope, and small game. They also depended a good deal on aquatic food; bone fish hooks have been found, and vast numbers of mussel shells."

And so the work goes on—all in line with the "increase and diffusion of knowledge among men," Smithsonian ethnologists and archeologists striving against time to reconstruct, recreate, and record the story of the native Americans and to rescue the remains of ages-old Indian culture from obliteration by the White man's civilization.

X. To the Ends of the Earth

Apparently everybody wants to go on an expedition. The Smithsonian was forced to stop releasing advance news stories of its field expeditions because of the number of applications from people who had the urge to see far-away places. Actually it is very seldom that anyone not a staff member leaves Washington as a member of a Smithsonian expedition. If assistance is required when the party reaches its objective, local help is hired in order to save transportation costs. If applicants were taken along, however, they would probably be rather disappointed on many expeditions. Instead of high adventure, they would be likely to find mostly hard work, often under very unpleasant conditions. The places visited by Smithsonian field parties are, as would be expected, usually inaccessible, in regions of extreme heat or cold, often infested with annoying or disease-carrying insects and poisonous snakes, and sometimes among native peoples of doubtful friendliness.

Since the Smithsonian was founded, a careful estimate re-

veals that it has sent out or participated in more than 1,600 separate field expeditions. The men who have taken part in them have, it is true, met adventure, hardship, danger, and on rare occasions, death, but their purpose in all of them has been identical—to increase knowledge of little-known regions or to collect material essential to research in progress. A few of the far-away places with glamorous names that have formed the scenes of Smithsonian field work are Easter Island, Tibet, Borneo, Tahiti, Patagonia, Greenland, the Galápagos Islands, Mongolia, Nepal, Burma, Tanganyika, Kashmir, Samoa, Algeria, Labrador, Java, and the French Congo.

In the case of the few men who have met death on Smithsonian expeditions, whose names will be inscribed on the roll of martyrs to science, the event was not connected directly with the work itself but might have occurred on any long journey or camping expedition. For example, in 1924 an expedition sponsored by Mr. R. O. Marsh explored hitherto almost unknown regions of the Isthmus of Darién, in Panama. Mr. John L. Baer of the Smithsonian was to have charge of the anthropological work of the expedition. The Choco Indians, who occupy the middle river valleys above tidewater, were first visited and studied. They proved to be a happy, carefree people, friendly if well treated, very Polynesian-like, wearing breech cloths, but decorated with beads, silver earrings, and wrist bands, and wreaths of gay flowers. The party then pushed on up the Chucunaque River, although with great difficulty because of the numerous driftwood logs across the stream. They finally struggled through to the lands of the Cunas Bravos, a tribe who were regarded as hostile. At this very critical time,

To the Ends of the Earth

Mr. Baer suddenly became ill and had to be transported immediately back to the coast. A little later the Smithsonian was advised that it had not been possible to save Mr. Baer's life.

The expedition had to go on, and Mr. Marsh found it possible to work with the Cunas Bravos without too much difficulty. After recording all obtainable data regarding them, the expedition transferred activities to the San Blas, or Tule, Indians of the Panama north coast. Among them were found hundreds of "white Indians," whose existence had been known but who had never been examined by anthropologists. Their white skin is considered to be a form of albinism. Mr. Marsh brought eight Tule Indians, three of them "white," back to the United States, where Smithsonian scientists made a very thorough study of their ethnology, language, and music.

On the opposite side of the earth W. W. Rockhill, famous explorer of the more remote parts of Asia, set out from Peking toward the end of 1891 with the purpose of traversing all of Tibet from north to south. Much of this forbidding—and partly forbidden—region was entirely unknown. His pithy description of Kuei-hua Ch'eng, his first stop in Mongolia, will give an idea of the out-of-this-world character of the whole great area:

"Fifty years hardly count in the life of an inland city in Asia, and Kuei-hua today is what it was in the days of Huc (1844)— an irregular mass of tumble-down houses built around a small central walled town. Dirty, muddy, unpaved streets, innumerable small shops, crowded streets along which loaded camels and mules and clumsy carts are moving, and where an occasional Mongol, very often much the worse for liquor, is

seen accompanied by his womenfolk in green satin dresses and much jewelry of silver and numerous strings of coral beads ornamenting their hair, neck, and ears."

Pushing on through Mongolia, Rockhill recorded valuable observations of the interesting peoples encountered and made a continuous survey of his route. On one side trip, while crossing the Yogore River, his pony broke through the ice and was drowned, he himself barely escaping the same fate. Conditions became more and more primitive as his party neared Tibet, and at one camp at the pools of Tengelik, reached after struggling through sand, mud, and brush for four days, he describes them thus:

"Life in camp in this horrible Ts'aidam is miserable indeed, and though I was used to the dirt and misery of such an existence, I had daily to use all my persuasive powers to keep myself in the belief that I would be able to stand it for six months more. The Mongols of the Ts'aidam have a saying that a Mongol eats three pounds of wool with his food yearly, a Tibetan three pounds of gravel, and a Chinese three quarts of dirt. Living in a Sinico-Mongolo-Tibetan style, I swallowed with my miserable food the dirt, the wool, and the grit, portioned by a harsh destiny to these peoples, and I verily believe that I found enough wool in my tea, my tsamba, my meat, and my bread while in Mongolia and Tibet to stuff a pillow."

Rockhill finally reached the borders of Tibet—or rather a high tableland 200 to 400 miles wide that separates Mongolia from Tibet and which was a political no-man's land, a desert waste harboring only wandering robber bands that preyed on passing caravans. In entering Tibet proper the expedition

crossed four mountain chains averaging 16,000 feet in height, between which ran shallow rivers over beds of soft sand. The mules were continually getting bogged down in these river beds. Although this part of the trip took place in May and June, they had snowstorms and hail every day. The nights were bitter cold, but in the middle of the day the thermometer read well up in the 90's. With no available fuel or grass for the animals, progress was slow. Before reaching the inhabited area their supplies gave out entirely, and the party subsisted for five days on tea.

The expedition finally reached thinly populated regions of Tibet, but from there on the journey was marked by trying episodes of being stopped by officials of the Lhasa government which was intent on keeping foreigners out of the country. The original route had finally to be abandoned, and instead of getting through to India, Rockhill hoped only to find some unexplored route that would bring him to China. Among the foothills of the great Dang-la chain of mountains, rain fell in torrents daily, the spongy ground was saturated, and fuel was unobtainable. They finally were forced to burn pack saddles to prepare their scanty meals. The party eventually reached the highroad to Lhasa in an utterly exhausted condition. A large amount of new data on the peoples, natural history, and geography of a hitherto almost unknown segment of the earth resulted from this strenuous expedition.

As Mr. Rockhill pointed out, change comes very slowly in the Oriental hinterland. More than a quarter century after his journey through Tibet, the Smithsonian sent Charles M. Hoy into the Chinese interior in the Yangtze Valley region to collect

mammals and other vertebrates needed to fill gaps in the National Museum's study series. Conditions there proved to be about as lawless and nearly as primitive in some areas as in Tibet. Furthermore, the expedition seemed to be "ridden by a jinx," as Hoy expressed it in a letter back to the Museum. He wrote in part thus:

"I suppose you have been reading in the papers about the unsettled state of affairs here in China. Things are going from bad to worse, and there is now practically no central government. Bandits are everywhere overrunning the country, and very little is being done to check them. Even those bandits that derailed a train in Shantung and captured 26 foreigners and 300 natives, whom they held for ransom, have gone unpunished. Travel anywhere through China is, of a consequence, not without a certain amount of danger, but I am going ahead with all my plans and trust to luck in getting through. If I am caught, all I ask is that nobody ransom me. I don't believe in encouraging the blighters.

"My porters arrived today, ten of them, and a right hefty-looking bunch they are. They have contracted to carry a minimum load of 100 pounds at a maximum rate of 30 miles a day for the magnificent wages of two dollars (U. S. currency) per month, plus their food. Everything in my outfit seems satisfactory with the exception of the auxiliary shells. They seem to be loaded too heavy, for about one in every twenty explodes. I have several times been temporarily blinded by the powder that blew back through the locking mechanism."

The jinx then went to work in earnest, for Hoy suffered a bad fall, laying him up for a week with a wrenched back, then ac-

cidentally shot himself through the leg with a Colt 45 by reason
of a hang-fire, and finally was stricken with acute appendicitis
and died after a quick operation. Between his misfortunes, how-
ever, Hoy had made a splendid collection of the animal life
of the region, which stands as a memorial to him in the study
series of the National Museum.

The following year, 1924, Hoy's collecting outfit was turned
over to the Rev. David C. Graham, who for several years had
been collecting natural history material for the Smithsonian
in Szechwan Province, China. He arranged a promising ex-
pedition to Songpan in the northern part of the province, a
region for which only four collections by foreigners are re-
corded. The route from Suifu to Songpan was some 400 miles,
and in order to keep down costs Mr. Graham walked prac-
tically the entire distance. The strenuous journey was accom-
plished safely, in spite of the known presence of bandits. The
party was escorted part of the way by eight Chinese soldiers.
This seemed like adequate protection except for the fact that
not one of them had a gun or a sword. Mr. Graham's collecting
was restricted around Songpan as thus explained in a letter from
him:

"The reason we could not go north of Songpan or west of
that place was that the Bolotsi aborigines are so savage and
so inclined to murder and brigandage that the Chinese cannot
control them and are afraid of them, and the officials could
not protect us in those regions. Just before we returned from
Songpan, the Bolotsis attacked a company of Chinese soldiers,
killed several of them, stole several rifles, and drove the scared
and defeated soldiers back to their barracks. I have not heard

that the Chinese have dared to go into the Bolotsi country with a punitive expedition."

Mr. Graham, although cut off by these restrictions from choice mammal-collecting regions, nevertheless sent back to the Museum thousands of specimens—insects, birds, mollusks, fishes, plants, and other forms—many of which proved to be new to the Museum and some new to science.

Smithsonian expeditions have in a very literal sense covered the earth. It would be very difficult to name an out-of-the-way locality in any sector of the globe—be it island, mountain, jungle, desert, or ice-covered sea—where Smithsonian men have not penetrated at some time during the last hundred years. Certain areas have been much more thoroughly covered than others for the simple reason that the farther a locality is from Washington, the harder it is to raise funds for an expedition there. From this obvious consideration, the regions outside the United States that appear most on Smithsonian itineraries are South and Central America, Mexico, the West Indies, and Alaska. A vast amount of new knowledge has accrued from field work in these areas, including knowledge of the present peoples and also of the prehistoric population as revealed through excavation of ancient sites. Tangible results comprise specimens and field data covering the mammals, birds, fishes, reptiles, insects, plants and other life forms, as well as minerals and the fossils that help to recreate the life of the past.

Some Smithsonian expeditions go directly to a predetermined spot and work there for the duration; others really get around. For example, Dr. Waldo L. Schmitt some years ago made the entire circuit of the South American continent—down

the east coast and up the west—in a survey of the lobster, crab, and shrimp population. Such basic studies are of great future economic value in providing a sound basis for development of seafood resources. Dr. Aleš Hrdlička covered 50,000 miles on one expedition through Europe, Asia, Africa, and Australia for the purpose of examining the important sites where the most ancient remains of man had been found. Later he traveled the entire length of the Yukon in Alaska with an outboard motor boat to record exact data on the Indians there. Alaska was the first stop for the Asiatic peoples who first populated the Americas via Bering Strait, and in order to reconstruct the story of this long-forgotten mass migration, it is essential to have all possible data on the peoples along the known parts of the route. Dr. John R. Swanton, in an investigation on the borderline between history and prehistory, traced through several States the actual route that De Soto traveled across the southern United States on the way to his famed discovery of the Mississippi River.

A very recent expedition to a very ancient and little-known part of the world was that sponsored jointly by the Commonwealth of Australia, the National Geographic Society, and the Smithsonian Institution to Arnhem Land in the Northern Territory of Australia. The Smithsonian sent four men on this expedition—Mr. Frank M. Setzler, head curator of anthropology to study the Stone Age aborigines of isolated Arnhem Land, and Messrs. David H. Johnson, Herbert G. Deignan, and Robert R. Miller to investigate the mammals, birds, and fishes, respectively.

Arnhem Land is a territory about the size of the State of

Maine set aside by the Australian Government for the black-fellow, or Australian aborigine. The population of this large area comprises about 3,000 natives and some 50 whites, the latter scattered and mostly associated with missions. Because of its isolation and the difficulty of reaching parts of the area, very little scientific work had been done there.

During the better part of a year work went on from four base camps—Groote Eylandt in the Gulf of Carpentaria, Yirrkala on the coast in northeastern Arnhem Land, Milingimbi Island off the northern coast, and Oenpelli, an inland site 50 miles up the crocodile-infested East Alligator River at the foot of the great escarpment at the western boundary of Arnhem Land.

Some of the party were taken to Groote Eylandt by plane, but other personnel and much of the equipment embarked at Darwin on a century-old 200-ton wooden vessel, the *Phoenix,* for the 700-mile cruise to Groote Eylandt. All went fairly well until in the wild Arafura Sea the *Phoenix* just before dark lumbered into a sudden storm with torrential rain and a howling wind. Laboring shoreward toward Boucaut Bay, hurried soundings suddenly shoaled up and with no warning the *Phoenix* landed squarely on a submerged rocky reef with a sickening jar. While trying to kedge her free in the stormy darkness, the chain slipped off the winch and one of the native boys caught his hand in the gears, tearing off two fingers and almost a third.

Here the party sat for days while native messengers from the nearby shore paddled leisurely 40 miles to the nearest settlement for help. Eventually a rescue plane arrived from Darwin. The maimed native was flown back to a hospital, and with an

exceptionally high tide, the *Phoenix* was worked off the reef and finally arrived five weeks late at Groote Eylandt.

Several months of work in the vicinity of each of the four base camps resulted in large and unique collections, which were divided among Australian and American institutions. Many of the mammals, birds, fishes, reptiles, insects, and other forms were of exceptional value in filling gaps in the National Museum's series. Among the unusual forms collected were the platypus and the spiny anteater, the only living examples of an archaic form of mammalian development, and the cardinalfish, of which the male is notable among fathers in the animal world —he holds the eggs in his mouth until they hatch, which requires five weeks. He is unable to eat during this period.

The most spectacular results were those in the field of anthropology. Mr. Setzler was able to take palm and finger prints, hair samples, and taste tests of hundreds of Australian aborigines, besides making anatomical plaster casts of young and adult natives for future modeling of life-size exhibition groups. Cave excavations near Oenpelli with temperatures of well over 100° and with dust masks mandatory in the clouds of powdery dust produced the largest body of skeletal material relating to the aboriginal Australians ever brought to America.

One area of the earth with which the Smithsonian has been associated through exploration work almost since the Institution was founded is Alaska, America's great northwestern continental outpost. In fact, it can be stated that the Smithsonian was in large part responsible for the purchase of Alaska from Russia in 1867. It seems incredible that this vast area—one-fifth as large as the entire United States—was bought outright

for the trifling sum of $7,200,000. And even in the face of what seems now to be a sensational bargain, Secretary of State Seward was bitterly criticized for the deal. "Seward's folly" and "Seward's icebox" were among the labels pinned on this "flagrant waste" of good American money. Yet today the seafood take alone exceeds $60,000,000 a year, not to mention the additional millions in gold, numerous other valuable minerals, timber, furs, and water power. And above all Alaska provides a priceless defense outpost only 56 miles across Bering Strait from Siberia.

In 1859 the Smithsonian sent a brilliant young biologist, Robert Kennicott on a three-year expedition to "Russian America," as Alaska was then called. He brought back such a surprising wealth of natural history specimens, information, and enthusiasm that when the overland telegraph exploring expedition went to Alaska in 1865 Kennicott headed a seven-man Smithsonian-sponsored scientific party to accompany it. This was indeed a strenuous expedition, cutting straight through the rugged and practically unknown northwestern territory. So strenuous was it that its leader, Kennicott, suffered a heart attack at Nulato and died in the Alaskan wilderness. The rest of the party carried on, and early in 1867 brought back to Smithsonian Secretary Baird the material collected and Kennicott's notes. Armed with this mass of data, Baird appeared before Secretary of State Seward and Senator Sumner, chairman of the foreign relations committee, which was just then considering ratification of the treaty involving the controversial purchase of Alaska. Apparently, practically all the specific information regarding the value of the Territory, including the

usefulness of Sitka Harbor as a base for naval vessels, was supplied either by the Smithsonian Institution or by men who had worked in Alaska under its auspices. Without the Smithsonian testimony it is very doubtful whether the Alaska purchase would have been consummated.

From that time until the present numerous Smithsonian staff members—anthropologists, biologists, and geologists—have collected or studied in Alaska. Directly or indirectly they have played a notable part in the exploration, development, and policy-making of this great new American territory.

Smithsonian explorers have worked on every continent and every major group of islands of the world. They have collected examples of the life in every one of the seven seas. Every conceivable type of environment has been tapped for Smithsonian collections—parched deserts on five continents, dripping tropical jungles where mold forms almost while you watch, the glaciers and eternal snows of majestic mountain ranges, and the depths of the Red Sea where fish thrive in 100-degree water temperatures. One of the most unusual tries at collecting—unfortunately without success—was on the edge of an underground river 260 feet below the surface of the earth.

Dr. Waldo L. Schmitt, now head curator of zoology, headed a West Indies scientific exploring expedition in 1937, using the *Joseph Conrad,* a full-rigged ship owned and fitted out for the trip by George Huntington Hartford III, of New York. Landing on Barbados, Dr. Schmitt learned of the great underground water supply. He persuaded a pumping station superintendent to put one of his traps at the bottom of one of the deepest wells in the hope of discovering some subterranean Crustacea. Later Dr.

Schmitt himself descended to the bottom of this 260-foot hole to see if he had caught anything. He describes the unusual experience thus:

"We were let down in a bucket on a steel cable, I sitting on the bucket rim with my feet inside. To get to the trap at the bottom, we had to wade chest deep in water. Retrieving it and following the water course in the opposite direction, we passed through a tunnel so low and full of water that our noses were all but submerged. On the other side of this arch or tunnel was an underground river coursing through a cleft or narrow, irregular-walled canyon in the rock that in places may have been 50 to 75 feet high. The stream, where we stood in it, was 4 to 6 feet wide. I thought that this was about all there was to see, but soon learned otherwise. Using a crazy old craft that one of our guides pulled up from the bottom of the "river" and bailed out, we went on for three or four hundred yards in stygian blackness which was only intensified by the flickering torch I held until we came to a waterfall fenced by a man-made wall, through a gap in the top of which a foot-thick stream of water poured over in a noisy cascade. It dropped down 15 to 20 feet; that is why we had to have the boat, as the water must have been nearly that deep under us. We got out on the wall for a few moments, for this was the end of our journey in the old craft, although one can go on for miles deep under the island, I was told.

"Returning to the surface was more of an ordeal than going down, because it was my turn to stand on the edge of the bucket and lay hold of the cable. After we had taken our places, one of the guides blew a whistle, the signal to haul away, but noth-

ing happened. We waited a while a little uneasily, and he blew again. This happened still another time before the cable finally tautened and we were on our way up. My rubber-soled shoes were wet and I thought perhaps too slippery for me to be standing on the thin, curved rim of a metal bucket, but slowly and inexorably we were being lifted up higher and higher. I rather hated to look up at the tiny spot of light that marked the hole through which we had to disappear to regain our freedom. I do not care to describe my feelings. Although in reverse, they were very much like the feelings you might get standing out on the edge of a frail scaffolding at the top of the highest skyscraper you could imagine. It was a relief to let go of that trembling cable and step off that slick bucket edge—so much so, in fact, that I forgot the object of my visit to the nether regions and had to be reminded of it. The trap was empty!"

However, this was about the only failure on the whole expedition, and immensely valuable scientific collections were brought back by Dr. Schmitt to the Smithsonian.

We can here give only an impression of the scope and interest of this phase of the Smithsonian's work in the increase of knowledge through exploration. Hundreds of other expeditions deserve to be mentioned—for example, Dr. Leonard P. Schultz's survey of marine life around Bikini Atoll in the Pacific before and after the atom-bomb explosion to determine the possible effect on fishes and other sea creatures; Dr. Duncan Strong's finding of new prehistoric pottery levels on the Beaches of the Dead in Honduras; Dr. Paul Bartsch's oceanographic expedition to the great Puerto Rican deep in Mr. Eldridge R. Johnson's palatial yacht *Caroline,* during which soundings were

made to a depth of 4,400 fathoms, or just five miles straight down; Herbert G. Deignan's zoological exploring trip that reached the top of 7,000-foot Doi Chiengdao in Siam, a precipitous peak previously reached by only a handful of Europeans and from which he escaped encirclement by a roaring brush fire only by climbing down a crumbling, almost vertical cliff; Dr. M. W. Stirling's archeological reconnaissance in Honduras during which he visited Copán where are found the most impressive ruins of an ancient city in the New World—while he was climbing the hieroglyphic stairway to inspect the last remaining sculptured wall of the ancient temple on top of the great mound, a heavy earthquake shook the area and collapsed the entire wall, so that he was just two minutes too late to see a unique monument that had stood for a thousand years.

So the scientific exploration of our planet goes on year after year. Science is a never-ending quest for new knowledge. In attempting to solve one problem or piece together bits of evidence, new vistas are invariably opened up and new problems are presented. Keys to scientific riddles often are to be found only in the field. The long arm of the Smithsonian reaches out continually to the far corners of the earth, bringing back new pieces to fit into the jigsaw puzzle and new treasures to exhibit to the public in the National Museum.

It is often hard to extract from Smithsonian explorers the human-interest sidelights of their expeditions. They are concerned mainly with the scientific results; difficulties and hardships, excitement and danger are purely coincidental and are usually not thought to be worthy of inclusion in published accounts of the expeditions. Some of the official reports of ex-

plorers remind one of the famous report of a coast patrol pilot during World War II—"Sighted sub, sank same." The essential facts are there, but it would be nice to know how he felt, whether he was shot at by the sub, and other human-interest angles.

For example, Dr. M. W. Stirling writes in the 1932 Smithsonian exploration pamphlet:

"A very satisfactory ethnological study was made of the Jivaros of the Upper Santiago, and full accounts were obtained of specific head-hunting raids. The Jivaros proved to be an active, intelligent people, disposed to be friendly when treated fairly, kindly in their home life and social relations, and exhibiting ferocity only in connection with the fierce head-hunting raids which have become so indelibly a part of their culture."

Satisfactory as far as it goes, but what does not appear is that as the Smithsonian representative on the Latin-American expedition, Dr. Stirling sweated and fumed for weeks in a sweltering camp beyond the Ecuadorian border waiting out interminable diplomatic exchanges before the party could cross the border; that for three weeks more they cut their own trail through dense jungle growth in almost continual drenching rain, with practically all the personnel affected with painful foot and leg sores caused by insect bites that seriously affected their health; that extreme caution and diplomacy were required in establishing friendly contact with the wild Jivaros.

Nor does the report say that after several months had passed with no word received by the Smithsonian from Stirling, rumors began to reach the Institution of trouble with tribes

reported to have cannibalistic tendencies. A cable was promptly dispatched to the point where Stirling was supposed to come out of the jungle:

"Rumor expedition has met disaster. Are you safe?"

After waiting for six anxious days with no response, Smithsonian officials were vastly relieved to receive the following cable:

"Reports my being eaten exaggerated. Sailing April 6 Grace Line Steamer Santarita."—Stirling.

And so another expedition escaped disaster and brought back to Washington much new information and fascinating exhibits of the unique Jivaro culture. And as the official report says, "A very satisfactory ethnological study was made of the Jivaros of the Upper Santiago—."

XI. *Wild Animals at Close Range*

Residents of the Nation's Capital who live within sight of the Washington Monument regularly hear the savage roar of lions and tigers and the unearthly shrieks of exotic birds. This situation occurs because former Smithsonian Secretary Langley feared that the famous American bison or "buffalo" would become extinct.

Bison and a few other animals used for taxidermist's models were sheltered in the Smithsonian back yard until Langley in 1889 succeeded in interesting Congress in a National Zoo. At that time far outside the city, the beautiful 175-acre woodland tract for the purchase of which Congress appropriated funds now finds itself in the densely populated heart of northwest Washington.

Langley succeeded in eking out enough money to put up one rather small animal house in the central area of the Park, and the same year a strange migration took place. Mr. W. H. Blackburne, a circus animal man, had been hired as keeper of the

animals. In casting about for a way of getting the miscellaneous assortment of wild creatures from the Smithsonian grounds to the new Park some four miles away, he thought of the Humane Society, which owned a specially built wagon for transporting rescued animals. Wangling the loan of this wagon, Blackburne doggedly loaded into it the reluctant beasts a few at a time and patiently traveled the eight-mile round trip until every one of the nearly 200 animals was installed in its new home. The National Zoological Park was then a reality, and its animal collection and its popularity with visitors have increased steadily ever since. Today, three and a half million people enter its gates every year, and a census of its animal population lists more than 3,500 individual creatures.

The buffalo which Langley was intent on saving from extinction was actually in grave danger of disappearing forever. There is no doubt that his interest in the matter was partly instrumental in rescuing the species. The bison story is an amazing one and one that holds a pointed moral for us today in the field of wildlife conservation. In the days of the old West, the vast herds of bison that roamed the prairies certainly totaled more than 50,000,000 individuals. It would seem impossible to exterminate such an almost incredible number of large animals, yet by the end of the nineteenth century the total bison population of the United States was carefully estimated at about 800. The biggest problem connected with building the first transcontinental railway was food for the men who built it. The bison herds offered a ready source of excellent meat, and the animals were slaughtered in countless numbers. The best-known of the hunters assigned to the job of bringing

in bison was "Buffalo Bill" Cody. In 1909 the American Bison Society succeeded in having established the National Bison Range in Montana, which was stocked with 37 animals. From that time on the species was out of danger, and today there are some 6,000 animals in this country and 30,000 in Canada. The National Zoo has a thriving herd of 14 bison, descendants of its first few animals. When the herd gets too big for its quarters, some of its members are traded off to other zoos.

Probably the question most asked of the Zoo guards is, "How do you get all these animals?" The answer is that the animal collection, one of the largest and best in the world, has been acquired in half a dozen ways. Foreign potentates present animals to our President, who, not caring to keep rhinoceroses at the White House, turns them over to the Zoo. People who think that baby wild animals make cute pets find they are not so cute as they grow older and bigger. These end up at the Zoo. A Zoo representative went to the Antarctic with Admiral Byrd, bringing back penguins that still live happily in a refrigerated cage with painted scenery that reproduces the desolation of their icebound homelands. American representatives in foreign lands send back the strange creatures of their adopted homes. But the best and most reliable methods of acquiring animals, particularly the unusual ones that zoos take pride in displaying, are field expeditions arranged for the special purpose, and the prosaic but satisfactory method of buying them from established animal dealers. And last but not least, the animals themselves assist to the best of their ability in increasing the population.

To illustrate this last point, in a recent year there were born

at the Zoo 5 tigers, 5 white fallow deer, 4 chinchillas, 4 aoudads, 3 hutias, 2 pumas, 2 Chinese water deer, 2 hybrid bears, 1 each of spider monkey, night monkey, water buffalo, Bactrian camel, pygmy hippopotamus, silky anteater, Nubian giraffe, mouflon, African buffalo, and many lesser fry. Birds hatched at the Zoo in the same year included 12 Canada geese, 10 American coots, 6 Nepal pheasants, 9 zebra finches, 5 red junglefowl, 5 ocellated turkeys, 4 silver gulls, and many others. The Zoo inhabitants are evidently cooperating fully in maintaining the collection at a high level.

Perhaps the majority of visitors to the National Zoo are residents of the District of Columbia or of nearby Maryland and Virginia. Yet a surprisingly large percentage of the total number is made up of people from other parts of the country. This fact is ascertained through a check made at the same time every day by Zoo police of the license plates of all the cars parked in the grounds. The latest year's totals show the following percentages: District of Columbia, 26.9; Maryland, 26.4; Virginia, 20.5; Pennsylvania, 4.4; New York, 2.5; North Carolina, 2.0; Ohio, 1.7; West Virginia, 1.4; New Jersey, 1.3; Massachusetts, .9; Florida, .9; California, .8. The remaining 10.3 percent is made up of licenses of every State of the Union, and also of Alaska, Bahamas, Canada, Canal Zone, Chile, Cuba, Guam, Hawaii, Honduras, Italy, Japan, Mexico, Netherlands, Newfoundland, Poland, Puerto Rico, Sweden, Trieste, Trinidad, and the Virgin Islands.

The nearly three and a half million visitors entering the Zoo gates in this same year included 1,844 groups from schools in 25 different States, some of these school buses coming from

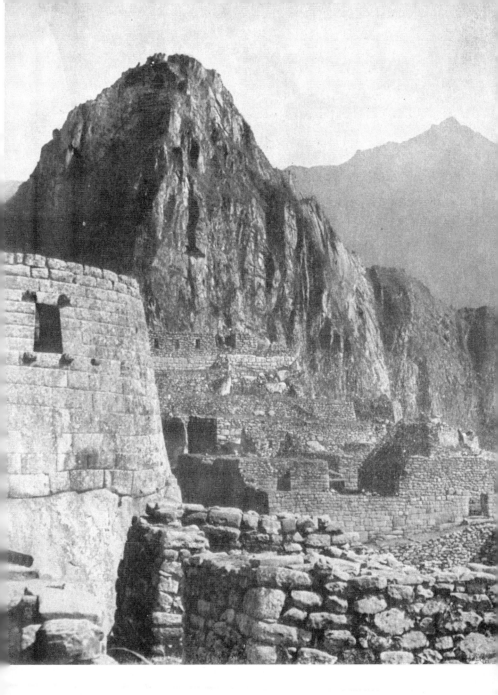

49. Ruins of the fabulous prehistoric Inca city of refuge, Macchu Picchu, in the Urubamba Valley of Peru. These mountaintop Shangri-la cities involved an incredible amount of slave labor.

50. *Above:* A Smithsonian fossil quarry in Idaho. Plaster-encased fossil horse bones are being dragged out for shipment to the laboratory in Washington. Innumerable such field expeditions have added greatly to our knowledge of the life of past eons of time.

Below: The desolate and dangerous wastes of the Rockefeller Mountains in the Antarctic. The Smithsonian was represented on the last United States Antarctic Expedition which took in this area.